LEFT BANK OF THE HUDSON

LEFT BANK OF THE HUDSON

JERSEY CITY AND THE ARTISTS OF 111 1st STREET

DAVID J. GOODWIN

Empire State Editions

An imprint of Fordham University Press

New York 2018

Visit us online:
www.empirestateeditions.com
www.fordhampress.com

Library of Congress Cataloging-in-Publication Data

Names: Goodwin, David J., author. | Gibson, D. W. (David-William), writer of foreword.
Title: Left Bank of the Hudson : Jersey City and the artists of 111 1st Street / David J. Goodwin ; foreword by D.W. Gibson.
Description: First edition. | New York : Fordham University Press, 2017. | Includes bibliographical references and index.
Identifiers: LCCN 2017022692 | ISBN 9780823278022 (hardback) | ISBN 9780823278039 (paper)
Subjects: LCSH: Gentrification—New Jersey—Jersey City—History—20th century. | Gentrification—New Jersey—Jersey City—History—21st century. | Artists' studios—New Jersey—Jersey City—History—20th century. | Artists' studios—New Jersey—Jersey City—History—21th century. | Lost architecture—New Jersey—Jersey City. | Jersey City (N.J.)—Buildings, structures, etc. | Jersey City (N.J.)—Economic conditions—20th century. | Jersey City (N.J.)—Economic conditions—21st century. | BISAC: SOCIAL SCIENCE / Sociology / Urban. | HISTORY / United States / State & Local / Middle Atlantic (DC, DE, MD, NJ, NY, PA). | ART / History / Contemporary (1945–).
Classification: LCC HT177.J5 G66 2017 | DDC 307.7609749/270904—dc23
LC record available at https://lccn.loc.gov/2017022692

Printed in the United States of America

20 19 18 5 4 3 2 1
First edition

Contents

Foreword

Gentrification is a difficult phenomenon to define. Since the word entered the vernacular in 1964, it has acquired a lot of baggage as each person comes to understand it according to individual experiences. It is always an idiosyncratic idea, reframed city by city, neighborhood by neighborhood, home by home. For those being pushed out of a neighborhood, gentrification is displacement; for those capitalizing on new development, it is opportunity; for those in government planning the city of tomorrow, it is the chance to bring infrastructure and amenities to underserved communities. The effects of gentrification are always determined by the person or organization facing localized circumstances. Yet so much of the political discourse about gentrification is abstract and theoretical; it tends to fall along very certain ideological lines, unleashing fierce emotions, belying the complex human nature that truly defines the phenomenon. This is a structural problem with how we talk and think about gentrification—and it often stands in the way of better understanding.

In most dictionaries, the headword is "gentrification," the noun. It should be something that we can touch—a person, place, or thing. Any attempt to better understand how gentrification affects communities must be grounded in these tangible components. In *Left Bank of the Hudson*, David Goodwin does exactly this by grounding us at 111 1st Street in Jersey City, New Jersey, just across the Hudson River from New York City.

While conversations about gentrification in the greater New York City area became more exigent at the end of the twentieth century, as

the city applied strong policing tactics in an effort to encourage new investment, the process of gentrification has been playing out along the Hudson since the man for whom the river is named entered the area and seized much of the land from the Lenape people who already called it home. Even if the sixteenth century didn't articulate the idea of gentrification, some of the phenomenon's most notable hallmarks—chiefly, increased economic activity and displacement—have been around since Europeans arrived in North America. The importance of the unbroken line of increased economic activity and displacement over the centuries is not lost on Goodwin.

One of the most common misperceptions about gentrification is that it happens in one big wave: One day the casual observer looks up at the church on the corner only to discover it is now a coffee shop. But in reality, gentrification plays out in wave after wave of activity, each affected by what came before, each affecting what will follow. By starting with the construction of 111 1st Street in 1866, Goodwin is not just providing a comprehensive history of one address; he is recognizing the full dynamism of gentrification, yanking us from a theoretical space in order to submerge us into one tangled, complicated story capable of deepening our understanding of gentrification.

As with most gentrification narratives, the story of 111 1st Street starts with the capitalization of land. Gentrification is never, strictly speaking, about new restaurants or tobacco factories or artists' studios: It is always about extracting money from the soil. A building is constructed in order to generate money, and it often outlives its original use, evolving to suit different interests and needs over several decades. But money, always restless, has a tendency to move on—a better opportunity materializes in a new neighborhood or in a new city—and the building that was once monetized becomes neglected. Often enough, artists looking for an affordable place to live and work sniff out the neglect and make use of the empty space. What artists lack in hard currency they make up for in cultural capital: They bring cachet and cool, tempting the people who buy their work to follow them to their epicenter of activity. Soon the money comes charging back, clasping the coattails of cool, and developers are not far behind, promising a skyscraper with world-class design. With talk of revenue and prestige, they convince a municipal government that *tabula rasa* is the way forward: Demolition follows, wiping away the past and destabilizing the future. Too often the promised skyscraper never materializes.

In *Left Bank of the Hudson*, Goodwin synthesizes the economic and the

cultural analysis of gentrification. Yes, there is the story of how 111 1st
Street has been capitalized across generations, but there is also the story
of how it has affected the lives of the people who worked and lived there.

In the end, gentrification is defined by the confluence of all possibil‐
ities that a noun presents: *People* and *place* compose the story of this *thing*
called gentrification. As Goodwin captures with the story of 111 1st
Street, gentrification plays out in a physical space where lives and interests
intersect and compete with one another. The actions of these people in
this space define gentrification over time. Readers might not necessarily
know the address, but they will certainly recognize the complicated story
that emerges when a place is taken away from the people who give it life.

DW Gibson

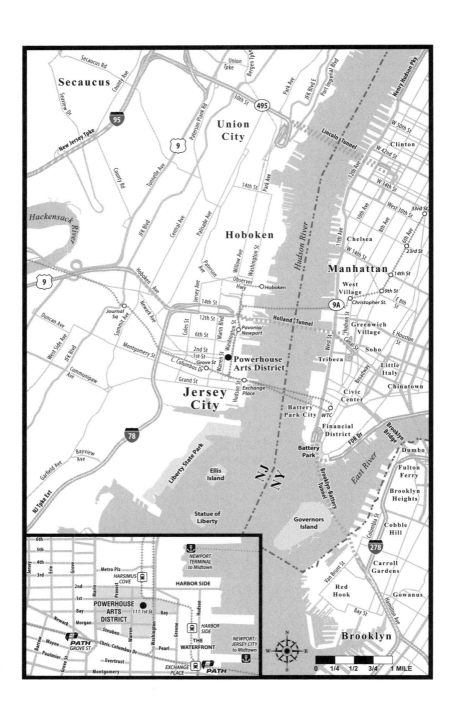

Introduction
Why Does 111 1st Street Matter?

I
n the late spring of 2015, a Jersey City blogger, Charles Kessler, posted a confession detailing his strained relationship with the city's artistic community and his own self-imposed exile from it and, more sadly, from his own art. Looking back on his life, Kessler dated the birth of his alienation and his sense of failure as January 2005 and its source as the loss of 111 1st Street, the center of the Jersey City cultural world at that time. For years, he had worked to raise the profile of 111 1st Street and its neighborhood and to preserve both as havens for artists and art. The artists of 111 1st Street were evicted in 2005. Two years later, in 2007, the building itself was demolished. After those two events, Kessler abandoned his career as an artist and isolated himself from his colleagues and from the social life of Jersey City. Thankfully, Kessler's story had a happy ending: He gradually reengaged with the arts and cultural scene in Jersey City, started a blog, and recently enjoyed a career retrospective exhibition.[1] Nevertheless, 111 1st Street haunted his memories and his imagination. The building had held so much potential, so much promise for Jersey City.

Many artists who worked or lived at 111 1st Street echoed sentiments and memories akin to Kessler's: They recollected a fertile, colorful, and sometimes chaotic collection of painters, sculptors, musicians, photographers, filmmakers, and writers. Their time at 111 1st Street was a treasured period in their professional careers. Some even viewed their experiences at 111 1st Street as the pinnacle of their very lives. Other residents, especially more recent arrivals to Jersey City, have little memory of the

building and its community. If approached about the topic, most city residents—even those who consider themselves members of the local creative class—will likely answer with a tilted head and a quizzical look. The building at 111 1st Street is largely forgotten, if it was ever known at all.

For most of its life, 111 1st Street was the P. Lorillard Tobacco Company warehouse, a site of work and production (arguably, the artists continued this tradition). The building was erected in 1866 as the headquarters of the Continental Screw Company. The Lorillard Tobacco Company moved to the building in 1870 and operated manufacturing and storage facilities there until 1956. The company figured prominently in the industrial history of Jersey City. By the end of the nineteenth century, Lorillard was the largest manufacturer of tobacco products in the United States.[2] Noting the centennial of Hudson County in 1940, an article in the *Jersey City Observer* claimed that "[n]o industry has been more completely identified with Jersey City throughout the years than Lorillards [*sic*]."[3] The centennial also "furnishe[d] the occasion for paying tribute to this family which has done so much in an industrial way to put Jersey City on the map."[4]

After Lorillard closed its operations in Jersey City in 1956, 111 1st Street fell into neglect and disuse. Various light manufacturers, storage companies, and other businesses cycled through 111 1st Street over the next thirty years. Finally, a handful of artists priced out of Manhattan and desperately needing affordable studio space discovered the building and Jersey City in the late 1980s. They crossed the formidable Hudson River and braved the urban wilderness of the Garden State. Maybe, just maybe, Jersey City would become the next bohemian scene with their newfound home at 111 1st Street as its epicenter. More artists joined them, and a community slowly emerged at 111 1st Street and its surrounding neighborhood, a wasteland of abandoned warehouses and silent factories. From their studios at 111 1st Street, the artists could glance from their canvases and gaze at the Manhattan skyline. They had access to the excitement and opportunity of New York but with the benefit of solitude and the luxury of cheap rent, both found in Jersey City.

During this same period, the economic climate, reputation, and desirability of the New York City region—which includes Jersey City—improved after the dark decades of the 1960s and 1970s, when employment, neighborhoods, and population declined and crime spiked. The building at 111 1st Street was sandwiched between the booming Jersey City waterfront—the Exchange Place and Newport neighborhoods—now a cluster of offices, retail, and housing built upon the ruins of railyards and

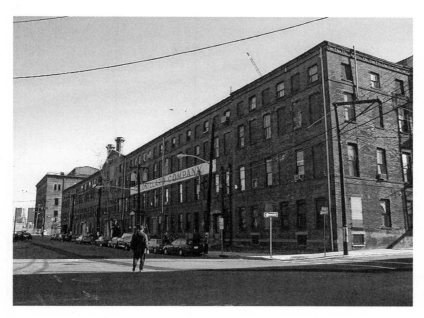

The P. Lorillard Tobacco Company warehouse at 111 1st Street, Jersey City, New Jersey, January 2002. Note the Hudson & Manhattan Railroad Powerhouse in the background. (Courtesy of Charles Kessler)

shipping docks, and the picturesque brownstone neighborhoods of downtown Jersey City. Simply put, 111 1st Street was suddenly a very valuable and a very attractive piece of real estate. After several years of fighting with the building's management and owner, the artists were forced from 111 1st Street in 2005.

To students and scholars of urban history, 111 1st Street might read like a too familiar story of gentrification and displacement. At first blush, there might seem to be nothing unusual or remarkable about it. Why, then, is the story of this one building—111 1st Street—so important to the people and the history of Jersey City? Beyond its former residents and few local preservationists, who would care to read about it? Why does it matter?

The torrid web of local politics; the transition to a new economic model; and the social, demographic, and even physical changes undergone by Jersey City in the past three decades can all be witnessed and explored through the history of 111 1st Street. More specifically, 111 1st Street fig-

ured greatly in the minds and careers of the mostly unnamed artists who dreamt and toiled within its labyrinthine halls. When I began this project several years ago, I believed I would have trouble locating enough willing sources, let alone any with valuable and intriguing information. Instead, I was surprised at how many individuals were waiting for someone to reach out to them, listen to them, and chronicle their shared past. They all had something worthwhile to say. The story of 111 1st Street deserved to be written and preserved for these reasons alone.

As a historian, I feel compelled to document the narrative of 111 1st Street as an act of cultural preservation. Jersey City has changed dramatically in the last several decades, and it continues to grow and evolve, as any healthy, vibrant city does, yet buildings, places, and memories are lost and forgotten during such an ongoing and now increasingly rapid and radical process. The artists who worked or lived in the building have scattered. Future generations of Jersey City residents and lovers of history and culture should be able to read about 111 1st Street and speculate on what it might have become.

If an accurate story of 111 1st Street is not written, then a narrative verging on the apocryphal may very well take its place. Because of its tradition of colorful political figures and an insular culture, Jersey City (and Hudson County) is a fertile ground for tall tales and local legends. The arts community, especially the remaining veterans of 111 1st Street, is not immune to this local predilection. Although exaggeration might infuse a story or an anecdote with mirth and playfulness, it just as likely might darken it with vitriol and ugliness. The latter seems to be happening in the retelling of 111 1st Street.

In the spring of 2013, I introduced a documentary ostensibly on 111 1st Street at the Jersey City Free Public Library. Not having seen the film nor knowing anything of its content or thematic structure, I summarized the history of 111 1st Street and then articulated the hope that its destruction might lead to a heightened awareness of architectural preservation in Jersey City. The documentary was named *111 First Street: From Paris to Jersey City, They Showed No Love,* and it was directed by a filmmaker with the *nom de plume* Branko. As a film, it was rather amateurish and consisted of little more than haphazardly edited footage. The movie began with a montage of images and television news clips from September 11, 2001, and a not very cryptic insinuation that Lloyd Goldman, the then (and still current) owner of 111 1st Street, was involved in the attacks on the World Trade Center complex. This segment bled into an equally strange screed about the deceased American Jesuit theologian Cardinal Avery Dulles and

Vatican City.[5] In effect, this film suggested that a wealthy real estate inves-
tor, Goldman, plotted with the Catholic Church to attack lower Manhat-
tan and Washington, D.C., in order to trigger a decade of military action
in the Middle East—all for no specified reason. Who could have guessed
that a single former factory, 111 1st Street, would figure so prominently
in geopolitics and the machinations of world powers? Within just a few
minutes, the film sullied its narrative with an ugly anti-Semitic and anti-
Catholic element. If I had been aware of this content in the documen-
tary, I would have declined the invitation to introduce it.[6] After the film
screening, a former tenant of 111 1st Street asked me about my thoughts
on the supposed connections between Goldman and September 11. I
politely voiced my skepticism. This was not my first time encountering
this conspiracy theory.

Aside from my own personal fascination with the subject and my pro-
fessional aspirations, this anecdote provides another compelling reason for
documenting the life and death of 111 1st Street: setting the facts straight.
An accurate and fully researched history would provide the strongest
counter-argument to any falsehoods on the subject and dispel the more
bigoted rumors and innuendo.

When I moved to Jersey City a decade ago, I enjoyed riding the Hudson-
Bergen Light Rail to gain a sense of the city. From my seat, I watched 111
1st Street being demolished. Although I did not know the significance
of the building at that time, I wondered why such a historic and visually
intriguing building was not being repurposed. Its destruction seemed
very shortsighted. Several years later, I read an article on 111 1st Street
and its arts community in a local magazine. I wanted to know more. I
had to know more. Who worked in the building? What happened within
its walls? Why did Jersey City squander this opportunity to compete
with the exploding arts and music scene in Brooklyn? A few more years
passed, and I briefly discussed 111 1st Street in a graduate seminar paper.
Later, I served as a commissioner (2010–14) and chairman (2011–13) of
the Historic Preservation Commission of Jersey City. During my ten-
ure, the body voted to landmark several of the remaining warehouses in
the neighborhood of the former 111 1st Street, and I encountered other
people who cared about such buildings and spaces. I wanted to tell the
greater, richer story of 111 1st Street. When I started this project, I looked
through the fence surrounding the empty lot that had been the mythi-
cal 111 1st Street and stared at the piles of trash, forgotten construction
equipment, sprouting trees, spreading vegetation, shredded plastic blowing
in the wind, and the carefully arranged piles of bricks salvaged from the

demolished tobacco warehouse and displayed like trophies from a bloody, hard-fought war. Today, a parking lot sits at 111 1st Street.

In order to accomplish this goal, I reviewed scholarly and popular literature, conducted archival research, and, most important, interviewed various individuals associated with the building. In the course of my research, I contacted fifty-one individuals or entities. These parties included artists and residents of 111 1st Street; nonprofits, civic institutions, and community activists; government officials; and area businesses servicing artists or related to the local arts community. Twenty-seven artists or residents of 111 1st Street were contacted; thirteen artists and residents were interviewed. Four businesses were contacted; two businesses were interviewed. Nine government officials were contacted; three government officials were interviewed. Eleven nonprofits, civic organizations, and community activists were contacted; five nonprofits, civic organizations, and community activists were interviewed. In total, twenty-three parties agreed to interviews. These interviews occurred between May 2011 and September 2011 and between July 2013 and September 2013. I held additional conversations and exchanged follow-up e-mails with certain sources. Such communications were not counted as unique or separate interviews; nonetheless, the citations include the actual date of the interview. Table 1 offers a complete analysis. Several individuals declined to meet with me.

Several artists and former residents of 111 1st Street complained of psychological and spiritual wounds from their struggle for the building and voiced no desire to revisit their memories. All sources were interviewed with the assurance of confidentiality, which explains the lack of attribution to many quotations throughout the book. Such quotations are noted with an interview date but without a named source. While conducting my research, I believed I would achieve more success if I promised confidentiality. I still believe this. However, as this book neared publication, I contacted many of the sources—especially the artists of 111 1st Street—and asked if their names and identities could be included in the text. Nearly all those I contacted agreed to my request. Those who granted me permission are now fully part of the story of 111 1st Street. I thank them for helping me one last time.

Businesses, nonprofit organizations, and community activists all presented me with their stories, observations, and impressions concerning 111 1st Street and the arts in Jersey City. Aware of the controversial decisions made regarding 111 1st Street and, even more important, fully com-

Table 1. Statistics of sources contacted and interviewed
(May 2011–September 2011; July 2013–September 2013)

Category	Contacted	Interviewed
Artists and residents	27	13
Businesses	4	2
Government agencies and officials	9	3
Nonprofits, civic institutions, and community activitsts	11	5
Total	51	23

prehending the long and rich history of political malfeasance and corruption in Jersey City and Hudson County, I was pleasantly surprised by the willingness and general helpfulness of county and city officials to speak with me and assist me in this project. However, past and present elected officials were far less responsive. Indeed, several promised to speak with me and then failed to reply to my queries or simply broke appointments.

This narrative will follow a simple chronological structure. The first chapter details the history of the P. Lorillard Tobacco Company, the business and the industrial interest that occupied 111 1st Street for the majority of its working life. Chapters 2 through 5 explore the history of 111 1st Street as an arts community. Chapter 6 chronicles the battle to preserve 111 1st Street as a historic structure. Chapter 7 unpacks the lessons to be drawn from the loss of 111 1st Street. The Conclusion looks at the present state of the neighborhood of 111 1st Street and offers final speculations and thoughts.

As noted, very little has been written about 111 1st Street, and no scholarship has documented the building and its community. After years of legal and even physical combat, the final residents left 111 1st Street in 2005, and the community scattered. Some of the artists still reside in Jersey City and remain active in the local arts and culture scene. Other artists still live in the surrounding area or elsewhere in New Jersey. Some artists settled in New York City. Some residents even packed their possessions and left for perceivably more welcoming environs throughout the United States. With 111 1st Street demolished and its community dispersed, the site as a physical entity and its significance drifts further into the past, and the danger of its being forgotten exists as a very real possibility. Many of the records and documents concerning the building have been lost or de-

stroyed. William Rodwell, sculptor, photographer, and former 111 1st Street resident, recounted:

> Years ago, in order to purge his house of the countless documents he'd accumulated over the years (boxes and boxes of them) [my friend] offered them to me but what was I going to do with them? . . . Regrettably, I turned him down. I believe that he chucked them in the garbage, a fitting end to an era of betrayal.[7]

Tris McCall, a local musician, author, and all-around New Jersey booster, concluded his interview with the remark that "now nothing is left but bricks. That's the whole story."[8] This book aspires to disprove that assertion. As many of the interviewed artists stated: "The spirit of 111 lives on."

1

The Lorillard Legacy

Long before artists braved the exotic lands of the state of New Jersey, 111 1st Street stood as a place of work and production and represented a city (and even a nation) caught up in rapid and often scarring industrialization, yet increasingly confident of its place on the world stage and certain of its own progress in the later decades of the nineteenth century. The P. Lorillard Tobacco Company occupied the facilities at 111 1st Street for the majority of the building's existence. The history of the building and the business it housed brought an intangible yet absolute value to the property. It deserved to be saved from the wrecking ball, not only because artists and other creative individuals had wandered through its corridors but because the story of the building itself alluded to the layered past of Jersey City. In fact, the founding of the P. Lorillard Tobacco Company in 1760 predated that of the United States itself by a full sixteen years.

In 1866, a year after the conclusion of the Civil War and amid the contentious years of Reconstruction, the Continental Screw Company commissioned a four-story facility at the address of 111 1st Street in Jersey City, New Jersey. New York City architect Charles Morrill designed the building in the Greek Revival style.[1] Constructed as the new headquarters of the wood screw manufacturer, this timber-and-brick frame building spanned a full block of Washington Street and an estimated 200 feet of 1st Street and faced the Hudson River. An interior wing contained boilers and chimneys for the machinery of the factory. (This original footprint was much smaller than the final shape of 111 1st Street at the

time of its occupation by the artists beginning in the late 1980s.) Shortly thereafter, the American Screw Company purchased the Continental Screw Company, forming one of the early manufacturing conglomerates in the United States. The arrival of the American Screw Company also marked the first national business's choosing to locate in the area of Jersey City known today as the Powerhouse Arts District, initiating an era of light industry, shipping, and storage for that part of the city.

In 1870, the P. Lorillard Tobacco Company moved its production and warehouse facilities from the present-day borough of the Bronx, New York, to 111 1st Street in Jersey City, New Jersey. The Lorillard Company built additions following the established architectural pattern. In the inner courtyard of the property, a five-story structure and a 180-foot chimney were built. Ultimately, the property would consist of six interconnected buildings and four courtyards. Lorillard manufactured cigarettes, cigars, snuff, and pipe tobacco on the site. The company maintained operations in the building until 1956. The P. Lorillard name remained on the building until its destruction in 2007, a visual reminder of an industrial heyday and a largely forgotten family, fading against inclement weather and general disuse.[2] The story of the Lorillard family and its business is important when considering 111 1st Street and its role in Jersey City.

The joined histories of the P. Lorillard Tobacco Company and the Lorillard family were intertwined with forces sweeping through the forests and fields and the towns and cities of the metropolitan region and America itself over the course of nearly two hundred years. In the same way, the history of the area and the country might be viewed through the Lorillard family and its enterprise. The Lorillards were a Huguenot family. A minority Calvinist sect in Catholic France, the Huguenots faced forcible conversion or expulsion following the Edict of Fontainebleau in 1685. As members of this imperiled Protestant denomination, the Lorillards fled France in the mid-1700s, escaping a lifetime of persecution. Following the pattern of the English Pilgrims, the Lorillards first emigrated to the Netherlands and finally to the New World.

Drawn by promises of religious tolerance and freedom of worship, several thousand Huguenots abandoned France for the relative security of the Dutch and later English colonies in North America. Some settled throughout what would become the New York City region beginning in 1624, notably founding the city of New Rochelle in Westchester County and a community on the south shore of Staten Island, today the neighborhood of Huguenot.[3] The decision of the Huguenots and the Lorillard family to adopt the New York colony as their home was not likely

by chance or luck, for New York already had established a reputation for itself as a welcoming port for ethnicities, religions, and eccentrics, at least, by seventeenth-century and eighteenth-century standards.[4]

Pierre Lorillard arrived in New York City on an uncertain date in the mid–eighteenth century and established a tobacco factory and shop on Chatham Street (now Park Row) in lower Manhattan in 1760. This modest business was the first in the United States to manufacture finished tobacco products, circumventing the mercantilist system of exporting raw commodities to Great Britain and importing the finished goods to the American colonies. This small shop in Manhattan would eventually grow into the nationwide P. Lorillard Tobacco Company. Because of his support for American independence, Pierre Lorillard was driven from his home in British-controlled New York City during the early days of the Revolutionary War. In 1776, a prison break occurred near Lorillard's business. Depending upon the account, Pierre Lorillard was killed by a prisoner or by Hessian soldiers attempting to foil the escape plan. A romanticized history published by the P. Lorillard Company claimed that Pierre Lorillard was executed by Hessians for his patriotic and revolutionary fervor. Nearly a century later, in 1882, his heirs still considered Lorillard's death a murder.[5] However, no objective source documents or verifies this proud family legend.

The newly widowed Anna Catharine Lorillard (née Mohr) assumed the management of the factory and the shop until her two eldest sons, Peter and George, came of age. A woman running a business and an industrial operation was far from ordinary in the eighteenth century (and in some quarters today), raising intriguing questions about the personal character, determination, and grit of Anna Lorillard. Unfortunately, documentary evidence on the Lorillard matriarch remains scant, thus allowing little more than guesses. In 1790, Anna Lorillard transferred ownership of the businesses to Peter and George Lorillard, then respectively twenty-six and twenty-four, and she appeared to disengage herself from the family's professional affairs.[6]

Already expensive, increasingly dense, and rapidly urbanizing by the closing years of the eighteenth century, Manhattan limited the ability of the Lorillard brothers to expand their tobacco workshop on Chatham Street. As their commercial ambitions grew, the brothers developed a method to grind raw tobacco into snuff using stones, allowing them to transform a labor-intensive and manual process into a mechanized one. In order to apply and maximize the grindstone production method, the Lorillards needed access to a waterway in order to generate hydropower.

The firm's desire to expand and to invest in this new technology required their leaving Manhattan. In 1792, Peter and George Lorillard purchased a grist mill, a dam, and fifty acres with water rights along the Bronx River. The property previously had been seized from a Loyalist landholder and sold at a public auction. With their storied family history, the Lorillard brothers may have derived a vengeful pleasure from that knowledge. After the brothers refitted the mill, they closed down the plant in Manhattan and hauled its operations north to the Bronx. The Chatham Street retail shop remained open as the commercial and public face of the Lorillard Company.[7] The facilities situated along a "very wooded and extremely beautiful" stretch of the Bronx River would produce the many popular flavored tobacco products of the P. Lorillard Company until the Jersey City plant at 111 1st Street opened in 1870.[8] With the relocation of the Lorillard facilities from lower Manhattan to the Bronx, the transition of tobacco production from the work of craftsmen to one of mechanized assembly occurred. This localized decision belonged to the larger industrial revolution reshaping the Western world and its concepts of space, time, and work.

The Lorillard family left a lasting and visible legacy in the Bronx. A family estate of a mansion with grounds grew alongside the original and two later successive water mills on the banks of the Bronx River. Although a large section of the property was dedicated to tobacco production—that is, early industry—the family preserved an old-growth hemlock forest and scenic river gorge with "splendid falls."[9] In 1885, the New York City government purchased the Lorillard estate from the three surviving daughters of Peter Lorillard, and that land was incorporated into the New York Botanical Garden in 1891. In part, the Garden owes its existence to the Lorillards' land preservation on their estate. Today the old-growth forest—"the magnificent stand of hemlocks"—is known as the Thain Family Forest.[10] The Lorillard Company constructed its final snuff mill on the estate in 1840, and that building eventually served as a carpentry shop for the New York City Parks Department and later the New York Botanical Garden until renovations took place in 1952. That mill was declared a National Historic Landmark in 1976 and underwent a multi-million-dollar renovation in 2010.[11] Today, the mill houses administrative offices for the New York Botanical Garden and catering facilities for events. A street named Lorillard Place runs through a neighborhood near the Garden and Fordham University, another reminder of the family's local prominence.

Following the Civil War, a more robust and massive industrialization

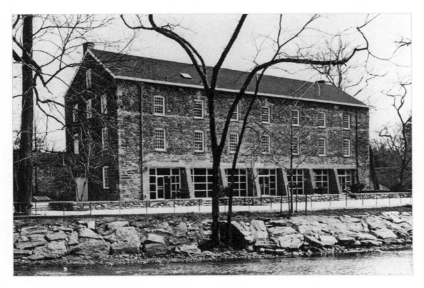

Historic Lorillard Snuff Mill, New York Botanical Garden, Bronx, New York, 1956.
The Bronx River runs alongside the mill and provided it with power. (Courtesy of
the LuEsther T. Mertz Library of the New York Botanical Garden)

began in the northeastern and the Great Lakes regions of the United States,
ushering in the era of sprawling, smoke-belching factories, cramped tene-
ment apartments, and successive waves of immigrants. Work became more
mechanized, more routinized, and more stratified. Urban areas, both small
and large, emerged as centers of American industry, drawing capital and
people from the rural areas of the United States and from European coun-
tries. New York City and its surrounding smaller urban areas in New York
state and New Jersey grew into cauldrons of industry and production.
Earlier, in the late eighteenth century, Lorillard had embraced the nascent
technology of the first period of industrialization when it moved its fa-
cilities to the Bronx for both the physical space and the riparian power
provided by the Bronx River. Now the company needed to reorganize
its methods and integrate modern technology to compete in the shifting
economic landscape and hold its position as the premier tobacco manu-
facturer in the United States. This required access to resources and infra-
structure unavailable or too expensive in the Bronx.

Charles Siedler, a German immigrant and a future mayor of Jersey
City (1876–78), joined the board of directors of the P. Lorillard Tobacco

Company in 1868, and he likely hinted at the abundant advantages of Jersey City to his fellow board members.[12] This industrial area of Jersey City (today known as the Powerhouse Arts District) then bordered the railyards and the shipping docks on the Hudson River, allowing the company multiple avenues to access raw materials and to transport its finished goods. Jersey City was soon to merge with smaller adjacent townships along the Hackensack River (Jersey City is a peninsula wedged between the Hackensack and Hudson rivers), creating a larger city with a more stable tax structure and stronger finances. As a figure in the local political scene, Siedler was undoubtedly aware of the ongoing local and state political negotiations aimed at accomplishing municipal consolidation. Meanwhile, a stream of immigrants, largely German and Irish, were settling in Jersey City, thus furnishing the Lorillard Company with a ready labor pool. Jersey City also offered a municipal water system, which the company could utilize for manufacturing and for a sprinkler system to protect its goods. Stockyards and slaughterhouses operated near the Jersey City waterfront, guaranteeing a necessary ingredient for snuff tobacco—animal bladders. Convinced that Jersey City promised a modern infrastructure—railroads, port facilities, and waterworks—a deep labor supply, and a streamlined government, the P. Lorillard Tobacco Company believed it could ambitiously expand and solidify its position as a dominant tobacco manufacturer in the United States by crossing the Hudson River to New Jersey. In 1870, the P. Lorillard Tobacco Company moved its industrial operations to 111 1st Street in Jersey City, New Jersey.[13]

In the latter half of the nineteenth century, industry fascinated a reading public eager to comprehend the forces radically changing the rural and urban landscapes. Published tour guides prominently featured local industries and industrial operations, suggesting that travelers might fit scheduled factory or mill visits into their itineraries.[14] A travel guide from the 1890s describes two major industries in Jersey City, the Colgate plant and the P. Lorillard Tobacco Company, in its chapter on the state of New Jersey. An article published in *Scientific American* detailed the operations of the P. Lorillard Tobacco Company at 111 1st Street and included an illustration of the entire manufacturing process. The author described Jersey City as "a workshop of the metropolis of no little importance" with extensive shipping and an array of industries, including soap works, sugar refineries, and steel mills. With annual sales of 24 million pounds of tobacco and 2,500 employees (men, women, and children) on its payroll, the P. Lorillard Company ranked as the largest tobacco firm in the world.[15]

By the 1880s, the Lorillard workforce had expanded to between 3,500

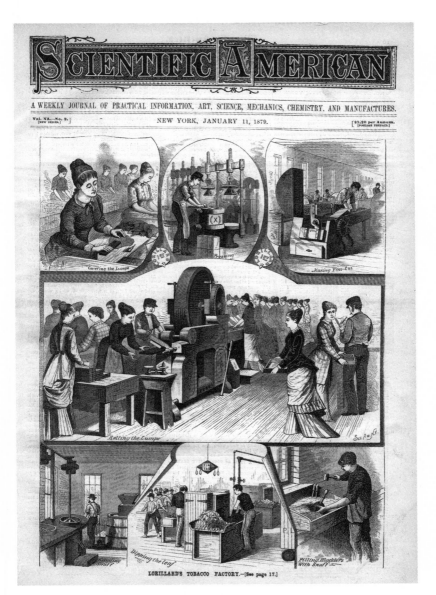

This cover illustration displays the multiple steps involved in the manufacturing of tobacco products at the Lorillard plant at 111 1st Street, Jersey City, New Jersey. (*Scientific American*, January 11, 1879)

and 4,000 employees, and the company refurbished its factory in the shape and form largely familiar to the artists of 111 1st Street more than a hundred years later. A monograph on the industries in northern New Jersey contained a detailed illustration of the factory, admittedly embellished with a mixture of local boosterism and artistic license, yet close to the image sketched by artists and preservationists in the last years of the building's life. In this illustration, horse carts and pedestrians parade by the massive complex encompassing an entire large block. Smaller inner structures stand within the courtyard, and the iconic smokestack pierces the skyline. The 111 1st Street complex dwarfs the surrounding warehouses, factories, and tenements. A church steeple and a line of wooded hills, likely the southernmost tip of the Palisades and the present-day Heights neighborhood of Jersey City, break the horizon.[16] The church and the factory were the two dominant institutions in industrial working-class neighborhoods in the late-nineteenth- and early-twentieth-century city.

The paternalistic relationship between Lorillard and its employees also garnered the attention of journalists and magazines. The Lorillard Company crafted a rather enlightened and admirable array of services and benefits for its largely immigrant workforce. An article in *Frank Leslie's Illustrated Newspaper* reported on a five-room school and library operated by the company for the education and betterment of its employees at Booraem Hall on Newark Avenue, within walking distance of the factory. (Because of development and urban planning, Newark Avenue no longer runs to the likely address of Booraem Hall.) The library held more than 8,000 volumes "all selected with unusual care," including biographies, histories, scientific treatises, and novels. Subscriptions were maintained for daily newspapers and fifty weekly and monthly magazines. The bookshelves bulged with dictionaries, gazetteers, atlases, encyclopedias, and other trusted reference sources, and colorful maps decorated the walls. The illustration in *Frank Leslie's* newspaper depicts a well-stocked and cheery reading room. A cast-iron stove stands in the center of the library, welcoming its patrons into a warm, cozy chamber. Men sit reading in comfortable plush chairs, and a pair of gentlemen exchange comments (in, one would like to believe, low, courteous whispers). Standing behind the wooden bannister separating the collection from the reading room, a librarian passes a volume to a patron and appears to be discussing the requested publication. Full bookshelves line the walls, and framed prints fill the gaps. Two chandeliers illuminate this beautiful and inviting library.[17] In the late nineteenth century, many municipalities still lacked a public library, and printed material was a luxury likely beyond the finan-

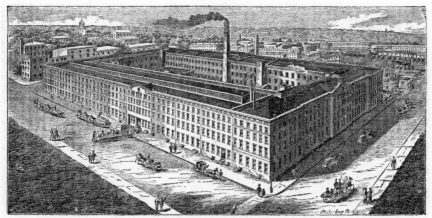

P. LORILLARD & CO.'S TOBACCO MANUFACTORY.

P. Lorillard Tobacco Company, 111 1st Street, Jersey City, New Jersey, circa 1883.
(Richard Edwards, *Industries of New Jersey: Hudson, Passaic, and Bergen Counties* [1883])

cial means of many immigrant factory hands. The library was a true gift
to the employees and their families by the Lorillard Company, presenting
them with the materials to expand their minds, cultivate their interests,
and escape their humdrum world.

The company organized a school at Booraem Hall as well. The school
held free night classes for Lorillard employees, many of whom were chil-
dren. By the 1880s, New Jersey child labor law mandated day or night
school for all children under the age of sixteen. A percentage of the Lo-
rillard workforce comprised children and teenagers of both sexes, and
many families relied upon the wages of their children for the basic sur-
vival of the household. This fact seems horrifying today, but child labor
was largely legal and unregulated in late-nineteenth-century America.
Unfortunately, Jersey City failed to offer a public night school; thus, in
order to comply with the state law and maintain a child labor force,
Lorillard opened a school for its employees.[18] In addition, immigrants
made up the bulk of the labor force of the company, and many of these
immigrants were uneducated, illiterate, and possibly barely conversant
in English. A modern, industrial factory as that which operated by the
P. Lorillard Company needed literate employees possessing a rudimentary
education, if it aimed to succeed in the long run.

Ten teachers educated approximately 350 children, and a principal of "recognized ability" managed both the school and the library.[19] The article on the Lorillard Company in *Frank Leslie's* newspaper also contained an illustration of the working schoolroom at Booraem Hall. In this image, a large group of well-groomed and primly dressed girls and young women listen to a schoolteacher pointing at a blackboard and emphasizing the night's lesson. Most of the students attentively watch, yet several look bored, and one girl with her back to the reader appears to be nodding off on the left side of the frame. Because all the female students likely worked a full day at the Lorillard factory, the nineteenth-century reader might have excused them for failing to muster up the energy for a long evening of lectures and classes. Just like the library, the classroom looks spacious, neat, and warm, thanks to a cast-iron stove. In the background, a small pile of books rests on a desktop.

The Lorillard library and school were the creations of Dr. Leonard Gordon, the chief chemist for the company and a prominent philanthropist and civic leader in Jersey City. A New York City native and a Civil War veteran, Dr. Gordon moved to Jersey City to complete his medical training as an intern at the Jersey City Charitable Hospital. After practicing medicine for several years, he accepted a chemist position at the P. Lorillard Company. During his years in Jersey City, Gordon greatly contributed to the culture of Jersey City, spearheading the drive to commission *The Soldiers, Sailors, and Marines Memorial* monument by Philip Martiny in front of City Hall and founding the Jersey City Free Public Library.[20] Today, a picturesque yet neglected park with a rocky, rolling landscape and a view of the Meadowlands marshes and the Newark skyline bears the name Leonard J. Gordon Park.[21] The involvement of a central figure in Jersey City's cultural and civic history with the P. Lorillard Tobacco Company further underscores the relevance and importance of the now-demolished 111 1st Street.

In addition to the school and library, the Lorillard Company furnished a club of sorts with smoking and game rooms in Booraem Hall. Employees could pass their leisure time with "cards, chess, checkers, and dominoes" and socialize with their fellow workers in a clean, comfortable, and sober setting. The club undoubtedly served as an alternative to the taverns, which were the working man's clubhouse of the late nineteenth century, and the club likely was viewed as a vehicle for encouraging more "moral" workers and cutting back on absenteeism resulting from a bout of drinking.[22] With the quarters in Booraem Hall, the Lorillard Company seemed to offer its employees the tools to assimilate to American

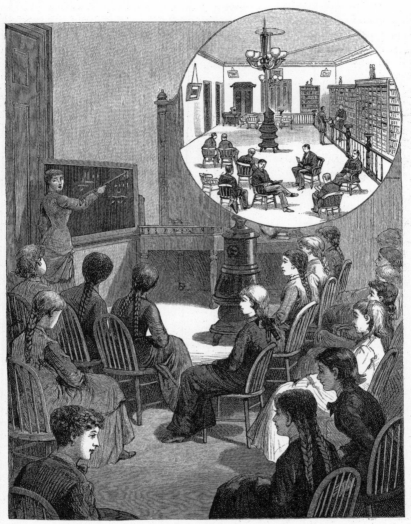

NEW JERSEY.— LORILLARD & CO.'S FREE LIBRARY FOR THEIR EMPLOYÉS IN JERSEY CITY — A CORNER OF THE SCHOOLROOM.
FROM A SKETCH BY A STAFF ARTIST.— SEE PAGE 11.

The picture in the foreground depicts the night school offered by the Lorillard Company; the picture in the background portrays the employee library. (*Frank Leslie's Illustrated Newspaper*, February 21, 1886)

life and culture, the fundamentals of literacy and education, and the resources to pursue personal intellectual interests. The Lorillard Company felt "justly proud of being almost the pioneers looking to the betterment of the working classes."[23]

In 1885 the New Jersey state legislature recognized this beneficent relationship between the Lorillard Company and its employees and the company's apparently genuine care for their well-being. In a report on New Jersey industries and labor, the legislators remarked, "The care and interest manifested in the physical, mental, moral and financial status of their employes [sic] by the Messrs. Lorillard & Co., is worthy of more extensive imitation by manufacturers in other branches of industry through the State."[24]

The state report summarized and praised the library and school facilities funded and managed by the Lorillard Company and detailed other employee benefits. For instance, the company chartered several steamboats and paid for employees and their families to take an annual summer trip to Long Branch, New Jersey, with complimentary food and medical check-ups. A staff physician ensured a "sanitary condition" at the factory and offered on-site medical care.[25] The company even provided its employees with Christmas bonuses and a pension.[26]

Years before the activism and reforms of the Progressive Era in the first two decades of the twentieth century and decades before the safety net and social programs woven during the New Deal in the 1930s, the P. Lorillard Company fashioned a mini–welfare state within the brick walls of its complex at 111 1st Street. The Lorillard family and its company initiated a benefits program during a period that saw the worst excesses and cruelties of Gilded Age America. With its focus on the education, safety, health, and welfare of its employees, the P. Lorillard Tobacco Company stood ahead not only of its own time but also of our own time in twenty-first-century America in a very real and specific way—it offered free daycare in its facilities starting in 1885.[27]

From the late nineteenth century and well into the post–World War II era, the tobacco factory continued at 111 1st Street with a combination of labor unrest, humming assembly lines, changes in ownership, and regular rumors of its sale or closing. In 1911, the Lorillard Company opened a new factory complex in the Marion section of Jersey City, all the while retaining a much smaller workforce at 111 1st Street. In 1956, Lorillard closed both its plants in Jersey City and relocated all its operations to Greensboro, North Carolina.[28] This loss followed the pattern of busi-

nesses, industries, and people leaving older, industrial northern cities in the United States for southern and western states. Manufacturing technology changed, making buildings such as 111 1st Street inadequate and obsolete. Additionally, the Jersey City transportation infrastructure was not designed or built for the changing manufacturing base. The P. Lorillard Company permanently severed a nearly century-old relationship with Jersey City in 1956. History did not seem to figure into the calculation. An employee interviewed by the local paper on the day of the announced closing wistfully remarked: "It's the price of progress."[29]

The history of 111 1st Street following the closing of the Lorillard plant and the company's divesture of its assets and properties in Jersey City remains somewhat murky. Scant records document the occupants and the ownership of the building from the closing of the Lorillard line in 1956 to the arrival of the artists in the late 1980s. A published source opaquely noted that "a variety of commercial ventures, including storage, retail stores, and factories," operated out of 111 1st Street during those roughly thirty years.[30] The usage of the building during that timeframe attracted no attention from the local press, most certainly because of the fact that 111 1st Street was just one of many underutilized or abandoned industrial buildings in Jersey City reminding its blue-collar residents of better jobs and better days. Municipal property tax records reveal changes in ownership over the decades, but they say nothing about the actual tenants or businesses at 111 1st Street.

A collection of local business directories, one of the very few sources detailing the life of 111 1st Street during this period, reveals a tenant base shifting from industrial businesses and uses to those now labeled as creative industries. The directories list the commercial tenants in the building from 1974 until 1986.[31] The tenants included: metal working and fabricators, storage and warehousing operators, novelty makers, textile and fabric companies, freight shippers, plastic covering manufacturers, screen printers, and several companies with ambiguous names that could represent almost any type or manner of business. Today, a commercial print shop would be viewed as a creative and desirable industry and hint at a tidal change for a given building or neighborhood. Even in New York City, the clothing industry still straddles vastly contradictory environments: grueling sweatshops and loud machinery on one side and glamorous design studios and niche producers on the other.

A sign reading "P. Lorillard Company" remained on the building's façade. Although the sporadic home to an assortment of business and

light industries for the next thirty-odd years following the departure of Lorillard, 111 1st Street sank into decay, a pitiful monument to the city's industrial heyday. The building no longer seemed to serve a purpose and symbolized the dispirited psychology of Jersey City and many older American cities during those decades. Then, the first artist discovered 111 1st Street, marking a very new and novel chapter in the building's and the city's history.

2
Crossing the Hudson

New York City stands as one of the centers—if not the epicenter—of talented, ambitious, dreamy, and sometimes delusional artists in the United States. More than a century's worth of literature, film, music, photography, television, and painting have fashioned a seductive yet frustrating mythology of life in Manhattan (and now Brooklyn) streets. Artists continue to flock to New York. Some fail. Some succeed. Some give up. Some settle down. One factor remains constant across the decades: Artists—especially the young, the penniless, and the struggling—want and need cheap housing.

The majority of the latter half of twentieth century had not treated New York City well. Poverty and unemployment appeared to be endemic to certain neighborhoods and even entire boroughs. Crime rates rose with no foreseeable plateau; hard drugs ravaged the underclasses. The city bled middle-class individuals and families. Oddly, such a lamentable state of civil and social affairs proved to be fertile ground for artists, writers, actors, and other creative professionals. Cheap spaces and cheap housing abounded. Artists and bohemians scouted out new neighborhoods. The settlement of artists in the South of Houston Street (SoHo) neighborhood in Manhattan and its subsequent commercialization have been carefully documented and scrutinized.[1] Music and visual arts flourished in the East Village neighborhood in the 1970s and the 1980s. The squat tenement blocks of the Lower East Side attracted artists and other creative types, who opened cafés, galleries, and clubs there in the 1990s.[2] Next, artists

traveled over the East River into Williamsburg in Brooklyn.[3] Today, this tide of migration presently seeps deeper into Brooklyn. The artists moved for affordable rents. Then, the housing prices crept upward. The artists moved again, continuing the cycle.

During this same period, artists, intellectuals, and other creative types engaged in another and rather unsung regional migration. They crossed the storied Hudson River into the Garden State of New Jersey, specifically settling in two of its waterfront cities, Hoboken and Jersey City in Hudson County. This movement occurred in several successive waves. In the 1970s, artists and later professionals discovered the grand yet worn brownstones of Hoboken. A decade later, the same demographic groups ventured into the downtown neighborhoods of Jersey City and initiated a similar process.

Both Hoboken and Jersey City sit along the Port Authority Trans-Hudson (PATH) train line (formerly known as the Hudson Tubes); indeed, Jersey City has five PATH stations, and Hoboken has one. Operated by the Port Authority of New York and New Jersey, the PATH train is a subway train line that connects, respectively, Sixth Avenue and Wall Street in Manhattan with cities in Hudson County (Hoboken, Jersey City, and Harrison) and in Essex County, New Jersey (Newark). The train line allowed New Jersey residents easy access to Manhattan for jobs, leisure, shopping, and entertainment and an entrance for curious individuals beyond New Jersey to wander the picturesque streets of Hoboken and downtown Jersey City. A short subway ride hinted at a higher quality of life at a comparatively bargain price.

Possessing the first stop along the PATH line in New Jersey, Hoboken witnessed the initial settlement of artists and creative professionals. By some accounts, artists began working in vacant factory buildings in Hoboken as early as the late 1960s.[4] This influx continued throughout the next several decades. In addition to the robust and cheap public transportation, Hoboken contained a variety of empty or underutilized industrial and commercial spaces, lending itself to a quick transition to art spaces in the form of studios, lofts, and galleries. Hoboken was and remains a small, walkable city of tight blocks of row homes and brownstones. Italian delis, bakeries, and restaurants dotted the neighborhoods as did innumerable workingmen's taverns. Historically a blue-collar town and a hub of shipping and light manufacturing, Hoboken was relatively safe and free of street crime. In a sense, Hoboken resembled a traditionally ethnic stronghold or, if you will, an urban village only a few minutes away from the bustling city. People had the proverbial best of both worlds. In time,

Wall Street employees discovered the convenience of Hoboken and transformed it from a small city of Italians and Puerto Ricans with a visible substratum of musicians, painters, and "weirdos" into an expensive ZIP code. Hoboken experienced radical gentrification as a result of this influx of affluent professionals and serious investment by developers and other interests. But that is another story.

Beginning in the 1980s, the downtown neighborhoods of Jersey City next experienced a population influx and the first spurts of gentrification, albeit at a much slower and spottier pace. Downtown Jersey City consists of several distinct neighborhoods, and their boundaries shift and their names change according to the strategies of the local real estate industry and the cultural and social aspirations of their residents.[5] Several neighborhoods (Paulus Hook, Van Vorst Park, Hamilton Park, Harsimus Cove, and the Village) make up the current downtown area. Most likely, the first bohemians and other intrepid urban explorers were those priced out of Manhattan and then finding Hoboken slightly too expensive. After riding the PATH train a little deeper into Hudson County, they found another area where they could rent spacious apartments or even buy homes for a fraction of the cost of those found in New York. Certain features of downtown Jersey City resembled the geography and aesthetic composition of Hoboken. A PATH stop anchored the neighborhood and served as the gateway to Manhattan. Several historic and unkempt parks (they would be beautified as the fortunes of their respective neighborhoods improved), specifically Van Vorst Park and Hamilton Park, centered their neighborhoods and namesakes. Architecturally significant and aesthetically pleasing buildings, apartment houses, and homes lined the streets. Remainders of Irish, Polish, Italian, and Puerto Rican populations—"old-timers"—imbued the downtown with urban character and color. Unlike Hoboken, downtown Jersey City held an infamous reputation for drugs, crime, dirt, and poverty. When individuals or families of the aforementioned ethnic groups achieved middle-class status, they fled downtown for better neighborhoods in the Heights or Greenville sections of the city (these neighborhoods themselves deteriorated over time, especially as the downtown changed and the city redeveloped its dormant waterfront), the nearby suburbs, or the storied Jersey Shore. Jersey City was genuinely dangerous. This equaled cheaper rent and cheaper real estate costs, attracting artists, writers, and others seeking a bohemian lifestyle. In time, cafés, restaurants, bars, and other businesses opened to cater to the consumer and leisure tastes and demands of this new population.

Although artists and associated creative professionals were moving into downtown apartments and fixing up long-neglected brownstones, the arts center of Jersey City existed within the borders of a declining warehouse district, just beyond the downtown boundaries. This area, really no more than a dozen square blocks, was sandwiched between the downtown and the Jersey City waterfront, a former epicenter of shipping, rail, storage, and light industry. Both the warehouse district and the waterfront suffered from the ravages of deindustrialization and the changes in shipping and storage methods and technology. Nonetheless, amid this decay, signs of hope and rebirth emerged, offering an example of how Jersey City might reimagine and reshape itself in the coming years. Beneath the shadow of a hulking former PATH train power station with its rusting smokestacks and within earshot of the steady tides of the Hudson River eating away rotting wharves, a single building drew artists from the frenetic streets of Manhattan and beyond, convincing them to brave the unknown environs of the Garden State. This building was 111 1st Street, the former P. Lorillard Tobacco Company warehouse.

The beginning of 111 1st Street as an arts center and community resembles myth more than fact. This trait seems to be shared by many histories of utopian enclaves and biographies of artists, writers, actors, and other ambitious men and women hoping to change their spheres of the world. Dates and facts are cold. Myths make far more engaging, relatable, and entertaining stories. Reportedly, artists began gravitating toward 111 1st Street in the late 1980s, when a quasi-anonymous musician known as "Gennaro" rented a practice studio on the third floor of the former tobacco warehouse, earning him the designation as the first arts tenant.[6] William Rodwell recalled: "Legend has it that the first 'arts' tenant in the building was a musician who had a studio on the 3rd floor, a guy by the name of Gennaro. This was back in 1987–1988."[7] This statement alone establishes a creation myth for 111 1st Street: An unknown troubadour moves into a largely abandoned building, serving as a beacon for other individuals craving a space of their own. No written record of this initial residency has been uncovered, only whispers and rumors.[8]

For the next two years, artists and musicians continued to hear about the low rents and large spaces to be found at 111 1st Street. Some of them moved to the building and planted the seeds for a large, physically insular community in Jersey City. Artists, students, gays, and other risk-oblivious populations are often considered to be the shock troops of gentrification: They have initiated change—positive or negative, depending on the source—in many neighborhoods and commercial areas. However, during

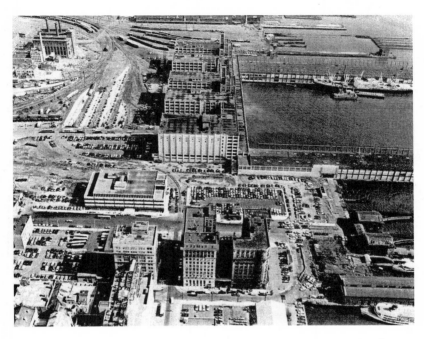

Jersey City waterfront, circa 1965. Notice the Hudson & Manhattan Railroad Powerhouse and the eastern section of the now–Powerhouse Arts District in the upper-left corner. (Courtesy of the New Jersey Room Collection of the Jersey City Free Public Library)

the late 1980s and early 1990s, the language and concepts analyzing and describing this demographic and economic trend—what commentators and critics would classify as gentrification—had just begun to develop.

It is important to remember that American cities were stigmatized as dangerous, dirty, and failing by the general American public and mass media in the 1980s and even into the early 1990s. Choosing to live an urban life was a daring if not rebellious act and a rejection of the prevailing image of the American dream. Arguing that any group, especially a marginal population with slight economic influence and purchasing power such as artists, could alter the trajectory of an urban area, let alone a city, seemed rather far-fetched. At the time, the artists of 111 1st Street (and artists in other urban areas) most likely did not view themselves as a transformative element or a tonic for urban ills. In fact, the initial artists of 111 1st Street believed the small manufacturers and blue-collar or "dirty"

businesses would remain their neighbors in the building and the area for the foreseeable future.

When looking backward and discussing the history of 111 1st Street, former residents themselves of 111 1st Street were cognizant of the gentrification process and their role in it. Henry Sanchez, a multi-media artist, art school professor, and environmental activist, described the relationship between artists and neglected and often urban spaces:

> Artists gravitate to places where they can get cheap rent, with studio space, without the distraction of overdevelopment, chain stores, or suburban comforts. Neglected older neighborhoods tend to be good places for such new migration. They want a sense of adventure by moving to a place that can serve as a proving ground for experimentation in a number of areas. In a sense we like being pioneers or homesteaders, especially in an urban location, sometimes rural, but not exclusively in major cities.[9]

Another artist, one of the more commercially successful alumni of 111 1st Street, more succinctly characterized the role of artists in gentrification: "Typically, artists go to the worst areas, clean it up, make it safe for yuppies."[10] Simply put, artists, in particular, first move into a given area and imbue it with a sense of cultural cachet and, in time, economic value.[11]

The owner, New Gold Equities Corporation, and the management of 111 1st Street certainly hoped that the incoming artists would play such a role. The building stood amid neglected warehouses, silent railway tracks, cobblestone streets, and the former Hudson & Manhattan Railroad Powerhouse, a dominating structure that formerly provided energy for the PATH trains. Aside from the growing cluster of artists as well as the homeless and a certain criminal element, no one lived in the dying industrial neighborhood. Any gentrification was largely of an economic variety: Light industry (small manufacturers, storage, and shipping) was slowly giving way to artistic production.[12] The owner of 111 1st Street expressed a similar vision for the building in 1990, noting that "[a]nywhere artists go seems to enhance the community."[13] The 111 1st Street building was to become a genuine, functioning arts center with studio and galleries. At least, that was the stated plan.

Into the early 1990s, the building still continued to house several small light industrial firms, a historical driver of the economy in the Jersey City warehouse district and waterfront, including several garment and textile workshops.[14] (Interestingly enough, such businesses today would be seen as a vital segment of a local creative economy. For example, New York

City is struggling to preserve the historical collection of tailors, textile workers, wholesalers, and retailers in its Garment District.) The nascent arts community—itself a component in the local economic engine— voiced enthusiasm for the diversification within the building and the surrounding area: "The good thing about the building is that it's not all artists, but woodworkers too. . . . It helps break up that 'all arts concept'— too much purity is not good."[15]

The initial batch of artists did not view the neighboring light industrial inhabitants as their rivals for space and position at 111 1st Street. (How much industry remained in the area is a legitimate question that has not been satisfactorily answered.[16] The lack of reliable records explains the inconclusive answer to the question.) Just as the residents valued the presence of industry, they considered the aesthetic of the area essential to their identity and creativity.

This section of Jersey City remained very rough with an ever-present whiff of danger during the first years of 111 1st Street. Kelly Darr, a painter, famous for wearing rollerskates at gallery openings, evoked a strong visual image of the neighborhood:

> There was no road (now Washington Boulevard) from the Power-house to Newport. . . . You could hear the foghorns at night. . . . The waterfront was astoundingly beautiful—sandy shore, tumble-weeds, packs of wild dogs, view of World Trade Center right in your face. . . . Next to 111 was an open landfill full of artifacts, like old bottles and glass. People had metal detectors and would go scavenge. . . . [The area] was a chromium-filled wasteland. Men in white suits would tell them not to dig in the earth. . . .[17]

William Rodwell applied similar language to describe this area of Jersey City in the late 1980s and early 1990s: "For the first year or two, what is known as Washington Boulevard did not exist; it was mostly sand dunes that were frequented by tumbleweeds, the occasional rabbit, and feral dogs. Newport was being developed. . . ."[18]

Another former resident quite graphically and succinctly described the vicinity surrounding 111 1st Street and the neighboring warehouses: "[U]rban hell, cars on fire, mob dumped bodies there."[19]

Where others saw desolation, one artist found a pastoral quality to the post-industrial geography. Margo Pelletier, a documentary filmmaker, waxed: "Personally, the dusty streets, the tumbleweed rolling on the sand toward the visible Hudson River, the quiet, handsome factories with their oversized timbers, all of this was very inspirational."[20]

All the interviewed artists and residents spoke nostalgically, almost gleefully, of the grime, the grit, the danger, and the decay of that area of Jersey City during the beginning of their tenure at 111 1st Street. Scholarly and media discussions have long classified artists as chronically risk-oblivious regarding the selection of their workspaces and homes. One factor for this disposition may be the overlooked fact that most artists fall into the stratum of the low-income and possess little disposable wealth. The lives of artists are largely those of voluntary poverty.[21] Their lives are not as glamorous and as free as those held by the public imagination. In her study of arts neighborhoods in Toronto, Alison Bain noted that "[t]he backdrop of everyday life for [the] artist consists of violence, immorality and deprivation."[22] However, this only partially answers the question as to why artists glance longingly at buildings such as 111 1st Street and locales such as Jersey City.

Speculation aside, New Gold Equities and the management personnel of 111 1st Street were marketing the building solely to artists by late 1990. A press packet dated November 6, 1990, rechristened the building "The Arts Center on First, Inc." The release repeated the refrain of a spontaneous and mythical beginning for 111 1st Street as a magnet for artists: "In the spring of 1989 a local artist inquired if he could rent space to paint in The first artist arrived and word of mouth set other artists to the 100 year old P. Lorillard cigarette factory at 111 First Street."[23] Then, the release methodically touted the following assets: the concentration of artists (eighty artists and artisans at that date); the variety of studios; 10,000 square feet dedicated to a future gallery; the continuous twenty-four-hour access and security; utilities and services; the nearby PATH stations; and, of course, the site's close proximity to the art capital of the world—New York City.[24] The packet also contained an advertisement, likely for placement in magazines, newspapers, and other print publications.[25] The emphasis on the attraction and the retention of artists as tenants and residents figured prominently in the later history and the final conflict over the fate of the building. The owner—albeit in the self-promoting and always suspect medium of a public relations notice—described itself as:

> . . . arts oriented; though the opportunity came to them [the owner and management] unplanned, they are looking forward to all the challenges and personal rewards that will be there in the future. It is one project that New Gold and the city of Jersey City will take pride in seeing through to fruition.[26]

This advertisement was part of a marketing campaign to attract artists as tenants to 111 1st Street in the late 1980s and early 1990s. (Courtesy of the New Jersey Room Collection of the Jersey City Free Public Library)

In the early years of the building's life as an arts community, the relation-
ship between the owner and the artists appeared to be mutually respectful
and beneficial, if not outright symbiotic. Only later did this relationship
decay into an antagonistic and finally destructive dynamic.

A month earlier, in October 1990, approximately twenty-eight artists
at 111 1st Street opened their studios and showcased their work in the
Second Annual Artists Open Studio Tour. (This tour continues to the
present in Jersey City. As to be expected, the tour is now a more formal
event and is organized and funded by the county and municipal govern-
ments and corporate, local business, and nonprofit sponsors.) The 111 1st
Street space was the marquee of the tour, and a reported 1,500 people
visited the building. The then–mayor of Jersey City, Gerald McCann,
toured 111 1st Street and purchased a piece of art.[27]

The successful turnout generated by the Open Studio tour stirred a
feeling among the owner and the artists that the building could become
a significant space for the local and—dare to dream—the national arts
scene.[28] This sentiment was held by people beyond the community at 111
1st Street. Richard McAllister, the owner of an art gallery just off nearby
Van Vorst Park, expressed optimism for the then-burgeoning Jersey City
arts scene:

> I just knew that if I built it [Van Vorst Art Gallery], people would
> come. . . . Until now, Jersey City has been thought of as a poor
> stepsister to the Hudson County art scene. . . . It is time that Jersey
> City artists started getting more exposure to the public through
> exhibits in their own community.[29]

The ebullient commentary by the art gallery proprietor revealed just how
much of an outpost Jersey City was in relation to the larger arts and
cultural world of the metropolitan region. Indeed, Jersey City seemed to
be ancillary even in Hudson County, a watered-down substitute for the
then-dominant local art scene in Hoboken.

The presence of 111 1st Street undoubtedly contributed to this con-
fident chatter among the local cultural class and triggered a clustering
effect. As early as 1991, a reporter from the *New York Times* rode the
PATH train across the Hudson River to investigate and chronicle the na-
scent art scene, wondering whether the seeds of a new SoHo were ger-
minating along the decaying industrial shoreline of Manhattan's smaller
sibling. Several galleries popped up, and an estimated four hundred artists
honed their craft within walking distance of 111 1st Street.[30]

At roughly the same time, the ownership of 111 1st Street changed

hands in one of the stranger and murkier episodes in the building's long, tangled history. In October 1988, the New Gold Equities Corporation signed a lease on 110 1st Street and 111 1st Street with an option to purchase both properties. The real estate company was owned by Steven Romer, an area businessman and attorney. In May 1989, New Gold agreed to sell its purchase rights for $18.4 million to an unnamed party. However, the deal collapsed over a bounced $500,000 deposit check, and New Gold filed a lawsuit against the would-be purchaser. These transactions paralleled the marketing of 111 1st Street to artists and the very crude rehabilitation of the building for arts studios. New Gold and Romer exercised their claim to buy both warehouses in the summer of 1990 for $11 million. Tracking down the origin of those funds revealed an opaque and tangled record of finances.[31]

By late 1990, New Gold and Romer were required to make two hefty interest payments to an entity known as Bridgehampton Estates, "a company affiliated with a well-known Manhattan real estate entrepreneur."[32] New Gold and Romer aspired to refinance their debts, allowing them to free up liquid cash, pay off the loans, and renovate 111 1st Street. Romer personally shopped around for a deal to recalibrate the financing behind the two buildings, entering discussions with a Los Angeles–based development company for a refinancing package worth $19.3 million and a multi-million-dollar insurance policy on his own life. This deal collapsed.

On New Year's Eve 1990, Romer disappeared with an estimated $15 million of clients' funds. Romer eventually surrendered himself at the offices of the Manhattan District Attorney on February 25, 1991, claiming that a representative of "X Corporation" had kidnapped him at a stoplight in Queens, New York, on New Year's Eve. Later, Romer somehow miraculously escaped his captors and went "underground" at an undisclosed location in the continental United States. In his statement, Romer said that he had incurred the wrath of X Corporation when he attempted to start an electric car company in the 1970s. For the next twenty years, this shadowy entity stalked Romer and later hacked into his bank and computer accounts and stole funds from his clients and personally from him. Romer suggested that the X Corporation was in fact General Motors or General Electric. The prosecution, under the aegis of longtime district attorney Robert Morgenthau, uncovered Romer's suspicious involvement in a Sierra Leonean gold mine and his West African mistress kept in a Manhattan apartment. A jury summarily convicted Steven Romer on fourteen charges, including first-degree grand larceny.[33] The true identity and the doings of the X Corporation remained unknown.

Former residents of 111 1st Street recalled an even less tidy account of the events surrounding the change in ownership of the buildings in the early months of 1991. Several residents, in fact, spoke of running gun battles at 111 1st Street and the presence of Mafia-affiliated goons during the tussle over the ownership.[34] William Rodwell summarized the events as such:

> For a month following [Romer's] disappearance, BLDG Management, owned by multi-billionaire Lloyd Goldman, moved in to protect its investment. (Goldman had lent $400,000 so the absconded lawyer could buy 111 First and 110 First.) He sent three men to take over the office and one of them had a handgun. Two different "owners" were now competing for our rent. This lasted several weeks until it was resolved in court in Goldman's favor.[35]

Other sources offered similar suggestions of nefarious doings by the now-warring management firms. No independent news accounts corroborated any of these anecdotes. However, events occurring later in the history of 111 1st Street suggested, at the very least, a tolerance of a criminal element within the building. Interestingly enough, a 1991 news article exploring the growth of a local arts scene in Jersey City made no mention of the weird, scandalous events surrounding the change in ownership of 111 1st Street, merely noting that a new real estate management firm had recently taken over operating the building.[36] The rather strange change of the ownership and the artists' very colorful accounts of the episode contributed to the unique narrative of the building and further illustrated the residents' attempts to weave an alluring myth around it.

Rumor and possible tall tales aside, the disappearance and later bizarre resurfacing of Steven Romer initiated a complete turnover in the ownership of 111 1st Street. Lloyd Goldman, who lent large sums of money to Steven Romer to purchase 110 1st Street and 111 1st Street, scooped up both properties in bankruptcy court in March 1991 for $3.4 million and then assumed full ownership of the buildings.[37] The ownership and management of the building was now constituted under a corporate entity by the name of New Gold Equities. (The actual name of the corporate entity largely owned by Lloyd Goldman is confusing and appears inconsistently in print and interviews as BLDG Management and New Gold Equities. Recent publications refer to the body as BLDG Management. For the sake of simplicity and in order to avoid more confusion, this book will use New Gold Equities as the company's name.)

From a historical perspective, the entrance of Lloyd Goldman as the

primary owner of 111 1st Street altered the building's trajectory. Lloyd Goldman was (and is) one of the largest and most powerful real estate moguls in the New York City region, with a portfolio estimated at $2 billion. When Larry Silverstein bid on the lease on the World Trade Center in 2001, he looked to Goldman for funding.[38] An investor of Goldman's caliber purchased the property with both short-term and long-term strategies to maximize profit. In the short term, this strategy seemed to involve the artists of 111 1st Street; however, in the long term, far more money could potentially be reaped from the redevelopment of the site than that generated by a tribe of hardscrabble bohemians.

Oddly enough, the first years of Goldman's ownership of 111 1st Street were a honeymoon period for both the artists and the landlord and for the overall artistic community of Jersey City. New Gold Equities, in fact, petitioned the city government to alter the zoning of the structure, changing its designation from a manufacturing site to artists' work studios in 1993. This push met with a warm reception from the municipal bureaucracy and the zoning board, which unanimously approved the application. The attorney for the ownership stated that 111 1st Street would be entirely converted to studios of various sizes and rented exclusively to artists. The Jersey City planning director remarked that the zoning change and the artist colony were "step[s] to bring the warehouse district back to life."[39]

Thanks to events such as this zoning change, artists continued to view their place and their future in Jersey City with both optimism and excitement. *Potential* and *possibility* appeared to be the watchwords of the day. This period of mutual enthusiasm and growth coincided with the broader resurgence of Jersey City, notably its decades-dormant waterfront, and the movement of artists to 111 1st Street and Jersey City must be viewed within this historical context.

In the first half of the twentieth century, Jersey City stood as a hub of shipping, transportation, storage, and industry. This rough environment found cinematic expression in the 1954 film *On the Waterfront*, a story of longshoreman and organized crime filmed in Hoboken. Immigrants—mainly, Irish, Italian, and eastern European—flocked to Jersey City and the surrounding cities and townships of Hudson County for plentiful blue-collar jobs. The Irish began arriving in Jersey City before the Civil War and eventually dominated municipal and county politics, reaching their apotheosis with the infamous Frank Hague, who served as mayor from 1917 to 1947.[40] Following the Second World War, Jersey City suffered a troublesome decline, following the pattern of other older northeastern cities. The population contracted and became poorer and

less middle-class and less white. Once-mighty factories such as Colgate, American Can Company, Ticonderoga Pencil, and others were shuttered. The railroad tracks fell silent and the docks rotted and fell into the Hudson River. Jersey City seemed fated to become another Camden or Newark, other formerly muscular manufacturing hubs written off by investors and businesses and allowed to slip into long, painful, and violent deaths.

In the mid-1980s and the 1990s, Jersey City's prospects began to improve. Real estate interests began to develop property along the waterfront, constructing an expanding cluster of office and residential towers. Banking, insurance, and financial firms looking for cheaper rents and new facilities looked to Jersey City to house back-end operations. The waterfront neighborhoods, Exchange Place and Newport, collectively earned the moniker "Wall Street West." Individuals priced out of Manhattan and later Brooklyn discovered the PATH trains and New Jersey Transit bus routes providing easy and reliable access to New York City. The 1990 census recorded the first increase in the Jersey City population since approximately 1930. In 1992, Bret Schundler won a special election to fill the mayor's office, becoming the first executive not affiliated with the political machine in decades and the first Republican mayor of Jersey City since Mark Fagan left office in 1917.[41] Housing values ticked upward, city services improved, and taxes stabilized in this period as well. Overall, Jersey City appeared to be moving away from the precipice and toward a sunnier future.

Meanwhile, a nonprofit organization named Pro Arts formed to advocate for the needs and interests of artists and arts-related businesses in Jersey City. The existence of such a group testified to the strength of the arts community and its belief in the city. Kay Kenny, a photographer, painter, and past president of Pro Arts, stated that "[t]he nucleus of artists in [111 1st Street] also gave rise to an interest in creating a member-based professional arts organization. An earlier group who organized exhibits in the building itself were founding members of Pro Arts."[42] Indeed, the continual clustering of artists at 111 1st Street deserved partial credit for the emergence of Pro Arts.[43]

The artists of 111 1st Street, its owner, and the municipal government seemed unified over the goals and vision for the building and the surrounding warehouse district at this time. The city government, prodded by local artists and by Pro Arts, discussed altering the zoning of the area and creating an arts district encompassing the warehouses desired by artists and their fellow travelers. This project was named Work and Live District Overlay (WALDO).[44]

On June 26, 1996, the Jersey City council unanimously passed the

zoning ordinance creating WALDO. Mayor Schundler signed the legis-
lation on June 27, 1996, thus making the creation and promotion of the
district the official policy of the zoning department and the elected gov-
ernment. This legislation also created an artist certification board to serve
as a peer review committee, determining whether applicants for resi-
dency in WALDO were, in fact, practicing and professional artists. The
WALDO ordinance demarcated a roughly seven-and-a-half-block area
as the new arts zone. This included the cluster of warehouses and 111
1st Street. The district's borders ran west to east from Luis Muñoz Marin
Boulevard to Washington Boulevard and north to south from Second
Street to Morgan Street. The ordinance changed the zoning and allowed
for art studios and work/live studios in the warehouses and buildings fall-
ing within the district. It also permitted arts-related retail, such as art-
supply stores, galleries, framing shops, and performance spaces for theater,
poetry, and dance.[45]

The WALDO zoning ordinance served as an overlay to the preexisting
zoning designation of industrial usage. The language of the ordinance
clearly stated that property owners could elect to continue to utilize
buildings and land within WALDO for their historical and industrial
uses. Likewise, owners could embrace the WALDO zoning and redevelop
their property for artists and art-related businesses. The city appeared to
be devising a flexible and multi-pronged development strategy: encour-
aging the development of the arts and the development of property for
that economic and cultural use, while providing property owners with the
option to retain and attract traditional industrial tenants. In fact, the ordi-
nance allowed owners to use a portion of a parcel for the arts and another
portion for industry.[46] The Jersey City planning director reaffirmed this
strategy: "We don't want to make [WALDO] too chi-chi. . . . We want
to keep it on the funky side. So what goes in has to be industrial strength:
galleries interspersed with truck-loading docks."[47]

Effectively, the city was instituting a mixed economic policy and a
mixed zoning policy, experimenting with a loosening of the single-use
zoning philosophy that had dominated planning and government think-
ing since the early twentieth century. The godmother of American ur-
banism, Jane Jacobs, herself strongly criticized the devotion and, more im-
portant, the impacts of traditional zoning.[48] Two distinct business models
with very different customers and clients would be able to operate and—
so was the hope—thrive in the WALDO district, allowing Jersey City to
keep one foot in its industrial past while transitioning to the emerging,
yet still hazy post-industrial future. The city expressed a desire to retain
an industrial economic base in the city and to allow for the reintroduction

of industry and manufacturing. City officials viewed the arts as a single component of a larger economy—not a new, emergent economic sector supplanting an older, contracting one.

The artists of 111 1st Street and the general arts community of Jersey City expressed both an affinity and an appreciation for the policies and the politics of Bret Schundler, who served as the mayor of Jersey City during the 1990s; the WALDO discussion; and the tripartite *détente* between the arts, the ownership of the building, and the city government.[49] During his reelection campaign in 1997, an informal artists group promoted and supported Schundler's bid and distributed flyers to hundreds of fellow artists attacking Schundler's rival in the race and touting the mayor's accomplishments in the arts and culture sphere.[50]

On the issue of the arts and the government's role in the arts, Republican Schundler and his Democrat opponent, Jerramiah Healy, expressed policy positions diametrically opposed to the accepted dogma of their respective parties. Healy clearly stated in a candidate forum at the (now-defunct) Jersey City Museum that the government should not support the arts. Later, he qualified that statement by saying that "[t]here is nothing more opposite than artists and government. Government has always been the [*sic*] anathema to artistic expression."[51] Healy also attempted to boast his own cultural cachet by claiming that he "read more fine novels, plays or great films than anybody in [Schundler's] organization."[52] Schundler, on the other hand, listed his administration's increased funding for the museum, its channeling of grants for neighborhood murals, its organization of an arts summit, and its rezoning of the area around 111 1st Street. Schundler's rationale for promoting the arts and nurturing a local arts scene deserves note. Schundler believed that "[m]aking [Jersey City] more beautiful through the sponsorship of public arts [was] very important" and that the city should flaunt its vibrant cultural scene.[53]

Schundler saw intrinsic value in the arts for their own sake. He attributed arts and culture as a principal draw for individuals and families with financial and social means. Cities could do this better than suburbs or rural areas. Schundler's devotion to the arts continued after his successful reelection. He did not simply regard the arts as another cog in the economic machine or as little more than a tool for spurring growth and increasing property values and tax revenues. In his view, art imbued Jersey City with a sense of life, attraction, and imagination. This is an unusually enlightened philosophical and policy position for a politician of any stripe, especially a then-ambitious member of the Republican Party.

In hindsight, some interviewed artists believed that Schundler sup-

ported the arts to allow for an easier redevelopment of the waterfront and nearby areas. Other sources argued that some of the blame for the demise of 111 1st Street belonged to Schundler for his refusal or inability to broker a deal between the owner of the property and its artists in the 1990s.[54] (This might have been possible before the real estate bubble grew (and later burst) in the 2000s.) Regardless of Schundler's political motivations or missteps, he embraced an extremely forward-thinking view of the arts and its positive impact on the redevelopment of Jersey City. His position on the arts and his keen understanding of the intangible quality-of-life value of the arts in a community predated discussions about the creative class and that theory's acceptance by a wide spectrum of policy wonks and politicians. Schundler believed that a strong and vibrant arts community brought positive attention and cachet to Jersey City.

During this period, 111 1st Street emerged as the center of the arts community in Jersey City and, by extension, a focal point for the arts community throughout New Jersey. The reputation of 111 1st Street emerged from the underground arts world and became a subject of the local media. In addition to occasional articles in *The Jersey Journal*, the local Jersey City daily newspaper; *The Newark Star-Ledger*, New Jersey's premiere newspaper; and *The New York Times*, several television stations carried stories on the community at 111 1st Street. New Jersey Network (NJN; now owned by WNET, the New York PBS affiliate, under the name NJTV) aired a feature on the opening of a building-wide exhibition on November 24, 1995.[55] New York's WPIX-TV broadcast a story on the development and the state of the arts community at 111 1st Street, entitled "The New SoHo," on November 11, 1996.[56] *State of the Arts*, a program on NJN exploring the arts and culture of New Jersey, aired a segment on the studio tour of 2000, entirely focusing on the resident artists of 111 1st Street.[57] These new stories pushed the idea of Jersey City as the arts center of the state and a Garden State alternative to New York City.

Former residents and artists painted a thrilling, seductive, and almost mythic portrait of the action and activity contained within 111 1st Street during this fertile, ebullient era. One artist described the building as:

> the epicenter of the art world in Jersey City. . . . So cool, worth checking out every year. . . . One-half [of two hundred] artists opened their studios—everyone tried to have better parties to compete with one another. . . . [There were] large, open studios, parties, acrobats. . . .[58]

Another past resident, Tyrone Thomas, a dancer and an information technology professional, fondly recalled:

Cachet [of 111 1st Street grew] with the studio tour. Underground parties drew people. . . . People had parties to improve their space—rent parties. . . . My roommate and I would rollerblade around the building until we found a party. . . . Russians and Eastern bloc immigrants threw the best parties.[59]

Edward Fausty, a successful photographer who had a studio in the building, likened 111 1st Street to a *de facto* arts institution or museum:

It was an informal community that through proximity and available space functioned as a kind of unofficial arts institution. Because of this, outsiders come to 111 the way they would gravitate toward other institutions; they came to see the artwork, to fraternize with interesting people, to be entertained by art, music, and other performance.[60]

The words of another former resident, Bill Rybak, a sculptor, printmaker, and photographer, captured the unique nexus of creativity and mystery within the building:

Open any door along the warren of funky passages and you entered another world: loft-size artists' studios, workshops, live/work residences, exhibition spaces, a yoga studio, a recording studio, more than one small film studio, scenery and prop shops, mysterious spaces filled with long-ago abandoned machinery of all sorts, and some places where nobody was sure exactly what was going on.[61]

In certain ways, 111 1st Street resembled an artistic collective or colony:

The community was composed of artists who lived and worked or just worked there. There were small businesses such as wood shops or fabricators. There were filmmakers, art printers, commercial photographers, computer technicians, events planners, milliners, dressmakers, stage production fabricator[s], musicians, sound engineers, etc. Businesses often collaborated [with] or worked for each other. Some bartered services or products. For many years it was a loose community where people lived and worked together. Many were friends, close friends or familiar to each other.[62]

Tris McCall, a regular visitor to the building, expressed amazement and wonder at the gathering of knowledge, skills, and people housed under a single roof, essentially all the raw ingredients for an urban homestead:

Everything necessary for urban survival was contained in that build-
ing. You needed a carpenter for your house? Well, there were excel-
lent carpenters in that building. You needed somebody to cook, to
show you how to do yoga, to teach your kids about civics, to build a
stage or a sewage pipe or start a motor. . . . Remember always these
people were taking raw space and refashioning it to serve their own
proclivities and desires. They were sorcerers.[63]

Elaine Hansen, an artist and yoga instructor, mourned the lost connec-
tion with a community and friends:

[111] had its own internal social structure within the city block–
sized building, and it could function outside normal working hours.
You could walk over and visit a friend anytime. People felt free to
do whatever they wanted.[64]

Other artists, such as Bill Rybak, similarly described a community-
oriented environment in which artists and other residents were able to
benefit from and take advantage of the collective knowledge, skills, and
resources of their fellow tenants:

It was also a unique repository of technical information, where I
could find advice and assistance for almost anything. I got to know
many people who remain my friends to this day. It was also a place
to network, to organize, to sharpen your skills, see the work of
other artists, share information and to publicize and find out about
events in the arts community.[65]

For one artist, Kelly Darr—and likely many, if not hundreds of, other
artists who passed through the maze-like halls of the building—111 1st
Street allowed her to "100 percent pursue [my] dream as a creative indi-
vidual in environment that allowed it."[66] Such a positive outlook appeared
to be wholly prevalent concerning the building, its community, and the
Jersey City arts scene and the city from the mid-1990s until the early
2000s. The conditions—the slow yet steady press coverage, the public
policy coming from City Hall, the rapidly growing arts community and
its increasing reputation—all seemed to foretell an intoxicating and pro-
pitious future for 111 1st Street and its collection of ambitious artists and
craftspeople.

3

The Spaces in Between

In the late 1990s, the artists of 111 1st Street nurtured great hopes for their community and for the arts in Jersey City. Maybe, just maybe, Jersey City would become the next regional destination for artists, transforming the city into a bastion of creative individuals and cool lifestyles and eclipsing the arts scene then percolating along the Brooklyn waterfront in Williamsburg.[1] The owner of 111 1st Street and its artists expressed similar enthusiasm and goals for the building and its role in a changing Jersey City. This positive dynamic and relationship was damaged, if not broken, sometime in 2000 and 2001. What changed?

Former inhabitants of 111 1st Street all emphasized that the relationship between the building's residents and its owner soured and quickly become poisonous, even violent, sometime around 2000. No one could point to a single exchange or an event as the turning point or the source of this mutual animosity. As noted earlier, the switch in ownership from Steven Romer to Lloyd Goldman in 1992 might be viewed as a pivotal point—thanks to the always immeasurable benefit of hindsight—but other factors played just as significantly into the decay of the relationship between the parties. Something changed dramatically between the years 1998 and 2001. Accounts and news stories prior to 2001 all underscored and promoted the gathering of artists and the related growth and renewal of 111 1st Street and its surrounding neighborhood.[2] After 2001, new stories from the same outlets and publications communicated a growing pessimism among the artists and the residents and their increasingly inse-

cure status in the building. As early as October 2001, newspaper stories reported on the artists' dissatisfaction with the management of the warehouse. Artists dramatically complained about a threatened curfew for 111 1st Street, declaring that the building "seemed like the [u]topia for artists, but it's like hell."[3]

Artists typically do not adhere to a strict nine-to-five regimen: Unorthodox work schedules and habits are often associated with the profession and lifestyle. Whether this popular romantic stereotype and image bear any reflection of reality is another question. The majority of long-term successful artists in various forms and media (painting, literature, music, etc.) exhibit a strong work ethic and a dedication to craft that requires creating art throughout long stretches of time with little recognition or financial reward.[4] A curfew imposed upon an arts studio (or a vast complex of studios, in the case of 111 1st Street) would stand as a great deterrent to the production of art. Practically speaking, many of the artists working out of the warehouse did not live on commissions and sales of their art: They maintained full-time jobs and practiced their preferred vocation in the evenings and on weekends. Another and often underappreciated reality about artisans and artists is that they are small-businesspeople. A curfew would have directly and negatively affected their ability to function successfully in that capacity.[5] While discussing their travails at 111 1st Street, several artists and others associated with the community specifically noted their increased inability to operate commercially.

When the artists of 111 1st Street first raised an outcry over the possible curfew, the owner and management wavered over its implementation and explained the reasoning behind it as a safety issue: "We think that there may be some people there at night who shouldn't be, including people who may be living there. It's something that we're going to try to stop."[6] This sudden concern over residency requires closer examination. The owner's issue with artists' actually living in the building rather than simply using the space as studios—a direct violation of the zoning for commercial property—was aired publicly for the first time in 2001. In fact, the cited Jersey Journal article is the first mention in print of the owner's problem with illegal residents in the building. For many years, the artists' living situation in the building was an open secret, if it was a secret at all. Many earlier news features on 111 1st Street mentioned this arrangement. More important, former residents attested to this fact. Kelly Darr elaborated:

[There was an] unspoken agreement [between the management and the residents], you couldn't admit to living there. The owner installed sinks, bathrooms. People had secret knocks. The fire inspectors [were] always trying to catch them [living in the building]. [We had] secret walls to hide things. Artists from the former USSR would say, "This [is] like Russia."[7]

Another former resident bluntly declared the owner's or, at the very least, the site manager's, complicity in the illegal use of the studios as residencies: "Goldman's agent would build toilets and showers—proof of residency."[8]

As the local media began covering the growing dispute between the owner and the residents, a general narrative developed, explaining that the thorny question of the artists' residency and the threatened curfew sparked this increasing public argument. In reality, the battle for 111 1st Street likely began several years early. In the late 1990s, just as the city devised and later passed the WALDO overlay plan and as 111 1st Street and Jersey City itself tempted artists priced out of Manhattan and the more convenient parts of Brooklyn, New Gold Equities methodically began to weaken the foothold of the artists in the warehouse. As early as 1999, the expired leases of some artists were not renewed.[9] By the winter of 2001, some artists were not granted annual leases but month-to-month leases, a contract far more beneficial to property owners than to tenants.[10]

In New Jersey, annual leases automatically convert to month-to-month leases if an annual lease is not renewed by either party. New Jersey tenant law allows a landlord to terminate or alter a month-to-month lease at the conclusion of each month. In theory, a landlord–tenant dispute could arise each and every month; however, a landlord cannot make to the lease non-monetary changes that the landlord knew would result in an unnecessary hardship to the tenant, such as changing the collection date for the rent, knowing that it fell before the arrival of a tenant's paycheck. Additionally, New Jersey law states that a landlord cannot raise rent at an "unconscionable" rate. Such an "unconscionable" rate rests on the facts of each specific case, and the burden of proof belongs to the landlord or property owner if the tenant fights the increase in court.[11] Nonetheless, this dynamic allows for a large degree of discretion for a ruling judge in defining an "unconscionable" rate. The artists held commercial—not residential—leases for their loft spaces at 111 1st Street. Although New Jersey, much like New York state and New York City, is strongly pro-

tenant, commercial tenants possess far weaker rights than an individual renting an apartment or a home.[12]

New Gold Equities also filed a legal challenge to an expansion of the WALDO ordinance—a fact that had gone unreported during the original spate of enthusiastic and positive articles on the new arts district.[13] The owner of 111 1st Street specifically attacked the provision mandating 51 percent of warehouse space in the district be dedicated to artists' studios. The initial reporting on the WALDO ordinance in the late 1990s makes no mention of this mandate, but it appeared to be legislated around 2001.[14]

These facts alone fail to explain the landlord's seemingly sudden interest in the goings-on at 111 1st Street, his actions to curtail the number of artists residing or working in the former warehouse, and his apparent worry over the city's interference in his management of the property. Several other events—although seemingly ancillary—might well have contributed to this changing position of New Gold Equities and the increasingly volatile dynamic between the owner and the artists. A longtime city official directly engaged with 111 1st Street suggested as much: "Big factors seemed minor. . . . Stuff at the edges, just as interesting. . . ."[15] What was the "stuff at the edges"? What were these interactions, relationships, or events unnoticed by the local press that might have altered and even determined the life of 111 1st Street?

In 1999, the city government demolished a loading dock behind 110 1st Street in order to widen 2nd Street and make that corridor and the adjacent properties more attractive to development and prospective businesses. Presumably, eminent domain was utilized to undertake this action. In addition to 111 1st Street, New Gold Equities owned 110 1st Street. The owner claimed that the city acted illegally in its demolition of the loading dock and initiated legal action against the city. Ultimately, New Gold Equities won the court case and was awarded approximately $5 million for the wrongful destruction of its property. This settlement greatly exceeded the combined purchase prices of both 110 1st Street and 111 1st Street by New Gold Equities as stated in bankruptcy court in 1991.[16] This event more than suggests a strain—if not outright antagonism—budding between the owner and the city government, and the lost court case might have tempered the city's desire to confront New Gold Equities in the future.

The seizure and demolition of the 110 1st Street loading dock by the Jersey City government strongly hinted at a fracturing in the relationship between New Gold Equities and the city. The city acted in this manner to widen 2nd Street for prospective and current retailers in a recently

constructed shopping center. This decision reveals that the city was deciding upon a development policy—at least, in the vicinity of 110 1st Street and 111 1st Street—to make the land usage and zoning agreeable and welcoming to retail and chain stores, even if that policy negatively affected private-property owners. This clash between the city and the owner first demonstrated that New Gold Equities possessed the resources, capabilities, and will to challenge the city and win. Again, this fact becomes increasingly important as the history of the building and its artists unfolds.

The relationship between New Gold Equities and the city government underwent further tension with the election of a new mayor in 2001. That year, Bret Schundler concluded his second and final term as mayor of Jersey City. Although supportive of culture and the arts, Schundler was a classic urban booster and economic liberal.[17] Under his leadership, the mayor's office aimed to fashion a pro-business and pro-development environment within Jersey City and presented the municipal government as a willing partner in a local growth coalition. This general tenor altered with the election of Glenn Cunningham. A longtime figure in Jersey City and Hudson County politics, Cunningham was a former Marine, police officer, U.S. marshal, county freeholder (the equivalent of a county legislator in other states), and city councilman. Cunningham ran his campaign on a populist platform and initially voiced support for 111 1st Street's remaining an artists' enclave.[18] However, Cunningham's own position vis-à-vis 111 1st Street would become more complex and difficult over time.

Crime also complicated the dynamic of 111 1st Street. Various residents alluded to questionable or illegal activities occurring within the halls and rooms of 111 1st Street: drug usage and drug dealing, prostitution, squatting tenants, an immigration ring, a sadomasochistic dungeon, and extortion (possibly at the hands of the building manager and superintendent). Most of these activities seemed to contribute to the allure of the building as an outlaw environment and an alternative to mainstream society and culture. Memories and recollections of such behavior seemed essential to the nostalgia of the building and its community. This longing for grit and danger appears to be a key thematic ingredient to many narratives of arts communities.[19]

A much more violent, although largely unknown, altercation might explain the sudden concern over the safety of 111 1st Street by the management and the owner. As already noted, former residents hinted at a criminal element conducting business in the warehouse with the tacit approval and possible assistance of the building manager (purportedly, the

manager bragged to tenants that he earned tens of thousands of dollars from graft).[20] An episode threatened to bring this compromising arrangement to the attention of the public and, more dangerously, law enforcement.

Sometime in 2000 or 2001, a fight erupted between two tenants of the building. One tenant—a Russian immigrant—seriously injured the other party or, as a former resident colorfully stated, "beat the holy shit out of the guy."[21] In fact, the man suffered two broken legs and later threatened to sue New Gold Equities for a lack of security within the building.[22] One source stated that the injured man had been shadowing his fellow tenant's activities.[23] This assailant was reportedly affiliated with the Russian mafia. The building manager would rent vacant space to this individual. In turn, the mob associate would sublet the space to Russian families. Whole Russian families began living in the building. More nefariously, this man established ecstasy and prostitution rings within the warehouse. Presumably, this "underworld thug" attacked and injured the other tenant as a physical warning: Keep quiet, mind your own business, and leave the building.[24]

However, this unnamed victim failed to heed the very loud and brutal message issued by the purported gangster. On July 4, 2001, the attacker and at least one of his criminal associates found the man and his girlfriend in the halls of 111 1st Street and proceeded to make good on his past threat. Both the man and his girlfriend were savagely beaten. According to a news report on the incident:

> The [girlfriend] suffered a broken arm and nose, smashed teeth, a cut to a bone in her left knee and crushed vocal cords as she tried to protect her friend when the pair was jumped. . . . [She] was hurled down the stairs and her friend suffered a serious brain injury.[25]

At the time of the crime and the media attention it garnered, roughly thirty immigrants from Russia and the former Soviet republics worked and lived at 111 1st Street, proudly commenting that the building was "the only place in the world where people 'from all the -stans' get along."[26] (The "-stans" refers to various former Soviet republics—Kazakhstan, Kyrgyzstan, Tajikistan, Turkmenistan, and Uzbekistan—all of which became sovereign nations following the demise of the U.S.S.R.) A population essentially living illegally in commercial lofts would present a ripe target for a motivated criminal organization. One former artist recalled regularly meeting with a police officer with whom he established a congenial relationship. The officer let him know that he was investigating a "Brighton Beach connection" in the building in November 2002.[27] (At

that time, Brighton Beach was a stronghold of Russian organized crime.) This detail suggested that the presence of a criminal group remained entrenched even after the brutal attack on the woman and her boyfriend.

The two related assaults alone should have prompted a cursory investigation by local authorities and by any responsible property owner. In this case, the female victim was Katalin Pota, a minor actress who, ironically, played Tony Soprano's maid in the successful cable television drama *The Sopranos*. This fact attracted local and national media attention to the crime and to 111 1st Street. The artists, mindful of their relationship with the building's management and ownership and, more important, wanting to continue living and working at the warehouse, mostly refrained from speaking to the press and getting themselves entangled in the melee.[28] Nonetheless, the attack and the subsequent spotlight shone on the building by the press might have contributed to New Gold Equities' sudden attention to the physical security of 111 1st Street and the personal safety of its residents. Several artists believed that the attack triggered the proposed curfew and subsequent scuffle between the tenants and the owner.[29]

September 11, 2001, changed Jersey City in a very concrete way overlooked in much of the discussion of 111 1st Street. Rightfully frightened after the terrorist attacks and recognizing the vulnerability of such a highly centralized, Manhattan–based financial and banking infrastructure and workforce, more investors and firms looked to Jersey City as a site for growth and expansion. Suddenly, already valuable property and real estate became even more lucrative and desirable. The building at 111 1st Street occupied a geographically well–situated parcel of land. Former resident Margo Pelletier recognized, possibly in hindsight, these demographic and development trends: "Of course one has to figure in the growing expense of living in NYC and certainly the events surrounding 9/11 as bringing in new people to JC."[30]

The continual redevelopment and reshaping of Jersey City would have happened over time; September 11, 2001, just accelerated the process. Finally, the emphasis on security in the wake of the terrorist attacks of September 11, 2001, must be taken into account. This fact and its influence cannot be adequately judged or measured; however, it must be considered when weighing the worsening atmosphere of 111 1st Street. Several former residents or individuals intimate with the building mentioned September 11, 2001, during their respective conversations with me.[31]

The events detailed above formed a broader context and environment within which 111 1st Street existed. Inevitably, other elements and factors played into the drama of the building and its residents and artists; how-

ever, the ones examined feature prominently and are more widely known. Unlike in the plot of a novel or the storyline of a film, the path of history is rarely determined by a single and solitary act, event, or moment. In our hyper-mediated age, it is seductive to view and interpret history through the facile frameworks and melodrama seen in television programs and popular films. However, history evolves within a shifting context of human institutions and actors and unseen events. Economics, politics, technology, science, and culture all affect the course of history arguably with the same force—albeit, often more quietly and subtly—than a war or a shocking event. Historical changes result from a series or collection of actions and figures. The story of 111 1st Street should be understood within these parameters.

4
Who Owns a Space?

The threatened curfew and its feared outcomes alarmed the artists and residents, increasing their worries and anxieties over the building's owner, their livelihoods and callings, and their very status and future in 111 1st Street and Jersey City itself. Sometime in 2000 or 2001, the artists formed a tenants' association to increase their bargaining power with New Gold Equities and to present a unified voice to it and, possibly, to the local media, government, and public.[1] William Rodwell provided more detail:

> In 2001, while I was busy curating my first art exhibition, we began hearing ominous rumors that things at 111 could be changing. We heard the landlord . . . was thinking about demolishing the building and throwing us out. Our response was to form a very loose "tenants' association" to see if we could thwart the landlord's plans. When the rumors increased, we got more serious and held elections for officers. . . . For the next four-and-a-half years, we did all we could to get public opinion on our side, obtain the support of the local politicians. . . .[2]

The tenants' association chose to fight the proposed curfew, marking the first outright battle in the war over the future of 111 1st Street.

Although the management and the owner of 111 1st Street originally warned of a curfew in October 2001, they now seemed to retreat from their initial stance, explaining that a curfew stood as one of multiple options being explored to increase the security of the building. However,

their determination to impose a strict and—according to the artists—harsh and punitive curfew arose again several weeks later. On November 21, 2001, a set of rules and regulations was distributed to all the tenants throughout the building. This document explicitly spelled out the hours when 111 1st Street would operate and function as a commercial structure: The building would be open from 6:00 A.M. to 10:00 P.M. on weekdays and from 9:00 A.M. to 6:00 P.M. on Saturdays, and it would be closed on Sundays and holidays. The new hours would go into effect on December 10, 2001.[3] Moreover, the memo warned:

> Any individual found in the building after Dec. 10, after the building is closed to the public, will be trespassing and therefore subject to arrest.[4]

Upon initially hearing of the curfew in October, the artists stressed their need to work at unusual times and hours. Many of the residents maintained second or full-time jobs to supplement their artistic vocations and relied upon time in the evening, weekends, and the occasional holiday to create their art. Such a rigid operating schedule for 111 1st Street would obviously limit their studio access. Many of the long-term tenants first signed leases in the building with the guarantee of twenty-four-hour and seven-day access to the building. Now, the management and owner did much more than constrict the hours of operation and the ability of the artists to work: They raised the threat of arrest and implicitly the termination of leases for any tenant violating the newly published rules and regulations. By distributing such a memo, the owner fundamentally shifted its arrangement with the tenants. One artist labeled the curfew and its accompanying threat a "frontal assault."[5]

By late 2001, the artists of 111 1st Street and the tenants' association approached the city and pressed for its support in the fight over the curfew. The association contended that the curfew harmed not only the livelihoods of the artists but also the entire WALDO district project. The Jersey City corporate counsel received a copy of the memo and remarked that it "caused concern in the [Cunningham] administration."[6] Whether the memo was provided by the management or by the artists remains an unanswered question.

While the tenants' association began maneuvering through the channels of government to broker a solution with the owner, some artists decided upon a more flagrant and confrontational stance. On the night of December 10, 2001, when the curfew officially was to be implemented, a group of artists flouted the new policy and hosted a nighttime party:

We're going to throw a party. . . . It starts at 10:00 P.M. Monday night. There should be more than 100 people there. Let 'em arrest all of us.[7]

Such bold contempt for the proposed operating policy for 111 1st Street and the authority of the owner most likely did not aid the nascent negotiations between the tenants' association and the owner and did not place the artists in a good light with the city. This lack of discipline within the ranks of the artists might have served as a worrying harbinger of the course of the struggle for the building and its ultimate outcome. However, aside from the ability and the willingness to protest, what other resources did the average artist of 111 1st Street possess?

Just before Christmas 2001, members of the tenants' association accompanied by their lawyer and representatives of New Gold Equities met at City Hall with mayoral officials. At this meeting, these officials informed both parties that the Cunningham administration—effectively, the government of Jersey City—supported the arts community and the artists of 111 1st Street and urged both sides to amicably resolve the problems with the operating hours and the security of the warehouse.[8] The attorney for New Gold Equities described the meeting as "positive" and noted that "everything [was] on the table."[9]

Several blocks to the east of 111 1st Street, the Jersey City waterfront—a former shipping district—was undergoing massive redevelopment. Glittering office towers and architecturally bland residential buildings sprouted like summer crops. To the west, the brownstone neighborhoods clustered around City Hall and the Grove Street PATH station were experiencing their own blend of gentrification. Although slow and fitful, the downtown gentrification exhibited elements and patterns of gentrification noted in the traditional literature on the subject.[10] Today, downtown Jersey City best resembles Park Slope, Brooklyn, albeit on a smaller scale.

Interesting enough, even at this early stage in the battle for what the artists would characterize as the soul of 111 1st Street, the residents perceived that the essence of the fight was not only for the overall character and future of their own building but also for the surrounding warehouse district. The warehouse district, rechristened WALDO, preserved the few remaining physical relics of Jersey City's industrial heyday along the waterfront and existed almost as an archaeological site of a way of life and a way of work dimming in memory and history.[11] The artists viewed themselves as fighting to save these remnants from the wrecking ball and the insatiable forces of "progress": "It's like the 'Last of the Mohicans' around

here. . . . The developers and the yuppies are circling the wagons, and I guess we'll see what happens."[12]

This language deserves cursory examination. The imagery and words associated with the American frontier chosen to describe the gentrification process unfolding in Jersey City match the linguistic observations noted by scholar Neil Smith in his study of the East Village neighborhood of New York City.[13] Nonetheless, the meaning has subtly shifted in the context of 111 1st Street. In the case of Jersey City, the artists "settled" in the "frontier" long before the developers and the more affluent classes appeared on the landscape. The artists—not a minority or an impoverished population—were the Native Americans or "the savages" to be rooted out, and the developers and the affluent classes were the settlers staking claims on the land and cultivating it for maximum and "proper" usage. However, the former residents and artists described themselves as "pioneers."[14] Others familiar with the building used the same terminology to describe them. A now-retired municipal employee lamented the contemporary lack of such "pioneers" in Jersey City and other urban environments: "Someone needs to be a pioneer. Pioneers crossed this country. People need to take a chance. But, people just want to [stay] in their own little area now."[15] This self-identification as both "native" and "pioneer" is an interesting paradox.[16]

In several studies of artistic communities, artists flocked to a declining or dilapidated neighborhood of a city and reinvigorated it. In this process, other populations and businesses are displaced as a result of a combination of zoning changes, rising rents, and escalating property values. First, the influx of artists and creative types and later public policy gradually, yet effectively, pushed industry from SoHo in Manhattan in the 1960s and 1970s and from Williamsburg, Brooklyn, in the 1990s and 2000s. In the East Village and Lower East Side of Manhattan between the 1970s and 1990s, ethnic, immigrant, and minority populations suffered the pressures of gentrification spurred by the original artistic "pioneers." The discovery of Wicker Park by Chicago's artists in the 1990s led to the diminishment of eastern European and Puerto Rican populations in that neighborhood. These are only a handful of documented examples, and an exhaustive list of such neighborhoods and their changing ethnic and racial dynamics and histories would require several volumes. (Admittedly, gentrification delivers benefits to the members of such groups remaining in gentrified neighborhoods, and individuals have expressed as much.[17]) One consistent fact exists in all such studies: The artists are inarguably "pioneers" and typically the first wave of "pioneers."

The case of 111 1st Street complicates this accepted narrative of gentrification and corroborates the theory that all gentrification is partially local in nature. The artists and residents of the building viewed themselves as "pioneers" of Jersey City, specifically of the collection of warehouses surrounding 111 1st Street. Unlike most artistic colonies, 111 1st Street did not initiate the displacement of other urban residents. The building known as 111 1st Street sat in a purely commercial or industrial zone of Jersey City.[18] No cold-water flats or buildings with railroad apartments (in which all rooms are connected lengthwise and without a hallway) were located in the vicinity of 111 1st Street. As described earlier, several industrial tenants might have existed in the building or in the area at the beginning of the influx of artists.

Within a decade, these "pioneers" of 111 1st Street became the "natives" or "savages" to be pushed off their land by a more affluent population and the machinations of developers. How does the usage of this language and imagery by the artists and former residents inform the study and conceptualization of gentrification? In the instance of 111 1st Street and Jersey City, the artists were the unruly population, the undeserving poor, or the suspect group scaring investors and the wealthy away from the urban landscape.

Artists as a group possess limited funds, influence, and means.[19] In these aspects, they resemble the working class and the poor—demographic groups that are often victims of gentrification. However, unlike many in the working class and the poor, artists usually have a high degree of education and an appreciation of culture. Additionally, artists generally express a radical set of political beliefs and a social and sexual libertarian philosophy, setting them well apart from the majority of the middle class and upper class.[20] This places them in a strange, almost neither-nor position. Artists straddle distinctive elements and classes within American society.

Although the battle lines between the artists and the owner of 111 1st Street were hardening and becoming clear, both parties appeared to be negotiating in good faith through December 2001 and into January 2002. Following the suggestion of city officials, a representative from New Gold Equities held a meeting with members of the tenants' association in January 2002 to discuss the prickly and difficult security issues. The tenants' association presented several solutions to address and partially solve the legitimate security concerns: an intercom system, a monitored elevator, and an artists' review panel.[21] This panel would fully vet all rental applications and ensure that all future tenants were indeed practicing and professional artists—and not floaters, partiers, addicts, criminals, or others simply sniff-

ing around for cheap rent. (As noted earlier, the building management was likely complicit in much of the illicit activity within 111 1st Street, because the building supervisor would rent vacant units to questionable parties, presumably without the knowledge of the owner, New Gold Equities.[22])

New Gold Equities largely ignored these recommendations by the tenants' association. Instead, building management installed push-bar alarms on the two primary doors leading to the main elevators of 111 1st Street. Presumably, these alarms would be turned on during the curfew hours imposed upon the residents and the building, as established in the memo distributed in late 2001; therefore, any resident or visitor attempting to break the curfew would trigger the alarm system and alert a private security company or the Jersey City police. Hours after the initial installation of the alarm system, the push bars were torn from the doors and thrown to the floor, obviously by the residents. The building management reinstalled the push-bar alarms several times, but the pattern repeated itself. Although no tenants explicitly admitted to the sabotage of the alarm system, the implication was that the residents perceived the vandalism as a legitimate act of protest against the management and the owner. Soon thereafter, New Gold Equities stopped enforcing the curfew.[23] For the time being, the artists had won.

While the residents and owner of 111 1st Street attempted to forge an uneasy *détente*, the Jersey City government under the Glenn Cunningham administration forged policy favoring artists, such as the full implementation of the WALDO ordinance and maintaining 111 1st Street as an arts hub. Although the city passed the WALDO ordinance in 2000 with much fanfare and press coverage among the cultural and arts communities, little movement occurred toward realistically developing and, more important, securing the area as a functioning and vibrant arts district.

Amid the rising tension between the artists and the owner, Mayor Cunningham's administration seriously attempted to craft a policy to manage the WALDO ordinance and settle the future of the area and 111 1st Street. Cunningham sought and secured a $110,000 grant from the state of New Jersey to contract the Urban Land Institute to interview residents and businesses about the stalled WALDO neighborhood and to produce a feasibility study detailing possible and realistic plans for the area.[24] The Urban Land Institute is a nonprofit dedicated to the "open exchange of ideas . . . to creat[e] better places" and "exploring issues of urbanization, conservation, regeneration, land use, capital formation, and sustainable development."[25]

Cunningham justified the grant and the study by the Urban Land In-
stitute: "While the formulation of plans for the district have been handled
in-house, we have sought outside counsel to provide an unbiased view of
the feasibility of our plans for the WALDO area."[26] The city hoped that
an outside study published by a third party, disengaged from and inde-
pendent of the political squabbles of Jersey City and with no economic
or personal interests in the interpretation and execution of the WALDO
ordinance, might neutralize the issue of the district—and, possibly 111 1st
Street—and allow all involved parties to accept the municipal policy and
finally move forward with needed development and investment.

The Urban Land Institute launched its study with a cocktail party
held in the lobby of one of the newly constructed office towers along the
Hudson River waterfront, hoping to introduce the Institute to various
constituencies in the city and to build a sense of goodwill around its
project. The setting symbolized the ongoing transformation of Jersey City
over the preceding fifteen years. A glitzy skyscraper stood where once a
dirty railway had sliced through the cityscape. Attendees included art-
ists, developers, planners, transportation officials, and municipal officers,
including Mayor Cunningham. During the launch party, the Institute's
members assured their guests that the final report would be neutral in its
methodology and its conclusion.

An artists' advocacy group distributed shirts to the Urban Land Insti-
tute advisors, causing one guest, the disgraced yet not ashamed former
Mayor Gerald McCann, to remark that the conclusions and suggested
recommendations of the study were "pre-ordained."[27] McCann offered a
cynical yet surprisingly insightful comment concerning 111 1st Street and
the entire WALDO district: "This was proposed six years ago and what
do we have after six years? Nothing. If you want affordable housing you
have to subsidize it."[28]

McCann was speaking about the mandate that 51 percent of the hous-
ing units in WALDO be reserved for practicing artists. No subsidy was
written into the original plan. This lack of financial support for the arts
and artists was a concern often voiced during the lifespan of 111 1st
Street. The municipal government under various administrations declared
the integral position of fertile arts and culture communities within Jersey
City, yet all government offered was little support in terms of financing
and it wavered in its commitment in the face of developers and real es-
tate interests.

However, McCann's comments likely were rooted in his political ri-
valry with Mayor Cunningham and McCann's own attempt at currying

favor with real estate interests—not in a spirit of altruism toward artists or in a move to position himself as a stronger advocate for them. Years earlier, McCann had defeated Cunningham in Cunningham's first run for mayor, and now McCann signaled his support for the interests of large property owners and developers over those of artists.[29] Additionally, McCann was shopping himself around as a potential congressional candidate for the 2002 midterm election.

The Urban Land Institute released its report on March 10, 2002. The report concluded that Jersey City should develop an arts district with a combination of market-rate and subsidized housing, galleries, performance spaces, restaurants, and retail. Coincidentally, arts proponents and 111 1st Street artists had been promoting such a development plan for some time, even preceding the codification of the WALDO district in 1996. However, the Urban Land Institute offered an ambitious and optimistic strategy for the city.[30]

In this plan, the historic Hudson & Manhattan Railroad Powerhouse, listed on the National Register of Historic Places, would anchor the WALDO neighborhood and be redeveloped into a multi-use arts and entertainment destination. The Powerhouse, constructed in 1909, once generated the electricity for the PATH trains linking New York and New Jersey. In 2002, it stood as a hulking, potent symbol of the post-industrial landscape of Jersey City. The report urged the city to scrap WALDO as the name of the area and rechristen it "the Powerhouse Arts District" in order to link it symbolically with the industrial centerpiece of the neighborhood. In the end, this would prove to be the only prescription embraced and executed by the city.[31]

Furthermore, the report tallied up the infrastructure resources of the PATH trains and the Hudson-Bergen Light Rail and the enviable demographics—35,000 employees and 80,000 residents (in 2002)—of the district and the surrounding neighborhoods. Finally, the report noted the high concentration of artists in the New York City metropolitan area, especially in Hudson County overall and specifically Jersey City (5,000 and 1,600 respectively in 2002). As noted earlier, the Urban Land Institute's development strategy advocated mixed-use housing to preserve the arts community and to ensure that future artists might be able to afford to live and work in the area. The Urban Land Institute supported this statement by detailing the modest income levels of full-time artists in the metropolitan area (72 percent of artists in 2002 earned $35,000). Such a small income would place most housing and studios beyond the reach of the average professional artist. Although he presented himself as backer of the

arts and 111 1st Street, Mayor Cunningham failed to appear at this public presentation of the Urban Land Institute's report.[32] That was telling. The absence of a politician sometimes says far more than any stem-winder or heart-tugging speech. It conveys a lack of commitment and priority.

The report of the Urban Land Institute adds another wrinkle to the position of 111 1st Street within the gentrification narrative. Although a registered nonprofit often pressing for admirable development policies—smart growth and mass transportation, for example—the Urban Land Institute is a creature of the real estate industry and a partner in the urban growth coalition. Its report was embraced by the local arts community and the municipal government, but the property owners within the Powerhouse Arts District (né WALDO) took an adverse stance toward the report. Specifically, New Gold Equities pressed forward with its lawsuit over the WALDO ordinance and its restrictions over the development of 110 1st Street and 111 1st Street.

Following the release of the Urban Land Institute report, 111 1st Street garnered little coverage from the local media for the rest of 2002.[33] After much fanfare and public commentary, none of the recommendations presented by the Urban Land Institute appeared to gain any traction or initiate any legitimate policy discussions within the municipal government. Additionally, the bickering between the tenants and the owner of 111 1st Street appeared to abate in 2002. There are no anecdotes or evidence offering a reason for this temporary lull in the battle for the building, but it is surprising.

On November 2, 2002, 111 1st Street gained the unwelcome attention of city officials after a fire broke out in a studio on the warehouse's fifth floor in the early morning. The sprinklers flooded sixteen studios. Many artists' works and belongings were destroyed, and a large area of the building was damaged. The artists who accidentally started the fire were severely burned. Following the incident, inspectors from the Jersey City Fire Department began regularly visiting the building, attempting to prove that artists were living in their studios. Tenants were expressly prohibited from living at 111 1st Street, as the structure was zoned for commercial usage only. However, the owner, the city, and the tenants played a game of mutual denial: All parties knew that many tenants were living in their studios, and the local media published articles stating this fact. Nonetheless, the fire and the real threat that flames could have jumped to nearby buildings or could have killed illegal tenants at 111 1st Street forced city officials to act. They ordered the Fire Department to exercise enforcement measures.[34] The artists perceived this action as an in-

trusion by the city and, by extension, New Gold Equities. In reality, the city could have levied stiff fines against New Gold Equities if any artists were officially found to be living in the building, and the building itself was likely not up to current building and fire codes, especially for habitation. A municipal employee articulately placed the public safety issue in perspective: "If a warehouse in the Heights [a largely residential neighborhood in the northernmost part of Jersey City] was filled with undocumented workers, it would be shut down in five minutes."[35]

Meanwhile, the temporary truce between the owner and the artists continued—in public, at least, into early 2003. During this period, the artists expressed more concern over the health of the local arts scene and the viability of the Powerhouse Arts District as an art nexus than their status vis-à-vis 111 1st Street. (For the sake of clarity and simplicity, the area surrounding 111 1st Street will be referred to as the Powerhouse Arts District [PAD]. After the report by the Urban Land Institute, the city, the property owners, the press, and the public dropped the WALDO moniker and named the area the Powerhouse Arts District.) The general optimism and energy previously emanating from 111 1st Street and Jersey City seemed unfocused and weakening. A news story in *The Record* embraced this theme: "[T]he buzz was that this could be Jersey's answer to SoHo. . . . It never quite happened. . . ."[36]

In the same article, Ron English, another artist based at 111 1st Street, echoed this sentiment: "There are tons of artists here. The potential is all here. Now we just need to connect the dots, somehow."[37]

William Rodwell remembered that critics from the *New York Times* would brave crossing the Hudson River to review an opening or a show at 111 1st Street or a gallery elsewhere in downtown Jersey City in the late 1980s and the 1990s. Now, many of those galleries were closed, and the press coverage had largely disappeared. Rodwell had thought, "Wow. This [111 1st Street and Jersey City] is really going to take off. But it's sputtering now."[38]

In 2003, Jersey City continued to attract the offices of many financial and banking institutions, and many of those businesses sponsored annual studio tours and displayed work by local artists in their lobby spaces, yet this infusion of jobs and an influx of a more affluent population did not coalesce into a community of art collectors or art connoisseurs.

Why was there little headiness about 111 1st Street and the local arts scene at this time? Several reasons might explain this change. The arts scene in Williamsburg, Brooklyn, percolated roughly at the same time as 111 1st Street in Jersey City in the late 1980s and throughout the 1990s.

By the early 2000s, the hipster image of Williamsburg had spread beyond the borders of the metropolitan area and begun seeping into the collective imagination of self-identified creative and counterculture types throughout the country.[39] Williamsburg was the ascendant bohemia with its own emerging brand; Jersey City remained in stasis, if not decline. Another possibility was that the regional and the American economies were far from booming in 2003. At the local level, the vacillating policy and the erratic support for the arts by the Jersey City government could not have helped.

Later in 2003, the energies of the artists shifted away from the overall health of the arts scene and returned to their hold on the building itself. New Gold Equities began raising the rents of artists at an unspecified point that year. Because the residents held individual leases (some of the leases were month-to-month; others were annual), the rent changes most likely did not fall on a uniform date. All the tenants received notices of rent increases ranging from 50 percent to 200 percent by September 2003, and the local press began reporting on the increases in February 2004. Interestingly enough, New Gold Equities had previously delivered notices of rent increases to the tenants in late 2002, but the Cunningham administration quickly intervened and successfully pressured the owner to retract them.[40] A municipal employee elaborated on the seemingly sporadic, but obvious strategic, move by the owner to periodically threaten the artists of 111 1st Street with astronomical hikes: "Goldman would double, triple the rents. The mayor's office would pressure him. Goldman would back off and then again raise rents a few weeks later. War of attrition against the city and the artists. . . ."[41]

New Gold Equities and Lloyd Goldman pursued a clever, tested, and often successful strategy used by property owners and business interests in the exploitation of land and buildings in gentrifying or gentrified areas and neighborhoods: regularly escalate the rents on longstanding and low-paying tenants, frustrate those tenants with legal tactics, retreat if pressed by government officials, and, then, return to the original plan with a steady, savage determination. The tenants will eventually vacate, leaving the building empty and ripe for redevelopment and a massive return on the initial investment. In the case of 111 1st Street, New Gold Equities perceived its back-and-forth with the artists and, to a lesser degree, with the city as a component in its long-range plan. The artists might get discouraged and they might even win a few rounds, but ultimately, New Gold Equities possessed a seemingly infinite amount of resources in terms of funds, personnel, and expertise. Over time, New Gold Equities believed that it would win.

However, the sudden and dramatic rent increases at 111 1st Street attracted the attention of the municipal government and local politicians. Assemblyman Louis Manzo voiced strong support for the artists of 111 1st Street: "How can you allow 200 percent rent increases? . . . The approach of having an arts district has been a plus for the city, but one thing you need for an arts district is artists."[42] Manzo vowed to research New Jersey state law and hoped to find a path to resolve the rent issue in favor of the artists. Nonetheless, 111 1st Street was technically a commercial structure, and its residents were legally commercial tenants; this allowed the ownership to skirt rent control laws, and the tenants lacked the protection of those laws.[43]

Louis "Lou" Manzo is another recurring character in Jersey City politics. Manzo ran five unsuccessful campaigns for mayor in 1992, 1993, 2001, 2004, and 2009. In his first campaign, in which he was the anointed son of the Democratic machine, his own brother ran against him. Lou Manzo aired commercials with his mother stating that Lou was the better son and the better choice for Jersey City. It many ways this scenario sums up the absolutely ridiculous entertainment that is Hudson County politics. Manzo was also arrested in a massive FBI sting, Operation Bid Rig, in 2009, largely targeting Hudson County politicians and government employees.[44] He successfully fought the federal charges; they were dropped in 2012. Manzo later penned a book attacking Governor Chris Christie.[45]

The head of the Division of Cultural Affairs of Jersey City, Greg Brickey, attributed the growth of the arts in Jersey City directly to the concentration of artists in 111 1st Street and seemed confused by the actions of the building's owner: "[Goldman] should be proud. He's got some of the best known professional artists in the tri-state area."[46]

Mayor Cunningham had lobbied the building's owner to refrain from such large rent increases and had asked the owner to negotiate a permanent resolution with the artists; nonetheless, as the tone grew more shrill between the parties, Cunningham felt more public pressure to address the matter. Specifically, Cunningham was forced to publicly disavow a major supporter of and fundraiser for his 2001 mayoral bid and 2003 state senate bid, Matthew Burns.

During the increasingly public fight over 111 1st Street and the Powerhouse Arts District, New Gold Equities retained attorney Matthew Burns to represent them in their suit with the city government. Cunningham released a public relations statement in which he expressed his disagreement with Burns over 111 1st Street and "that he would try to help the

Chimney of 111 1st Street, Jersey City, New Jersey. This was an architectural feature treasured and fondly remembered by many former residents of the building and local preservationists. (Courtesy of William Rodwell)

tenants."[47] Goldman and New Gold Equities likely presumed that placing Burns on their payroll might gain the support of the mayor and the city in their fight with the artists. The hiring of a favored legal firm to gain position or influence has been a well-known practice not only in Jersey City and Hudson County but in many political arenas as well.

Talk of partial or full demolition of 111 1st Street reemerged in 2003. This was rooted in far more than paranoia and rumors. In July 2003, the tenants' association and several other interested parties met with Lloyd Goldman in his Manhattan offices. At this appointment, Goldman revealed computer-generated plans for both 110 1st Street and 111 1st Street. The former would be demolished, and a seventeen-story apartment complex built on the site. The plans for 111 1st Street called for the demolition of a five-story section that bisected an inner courtyard and the iconic hundred-eighty foot chimney of 111 1st Street. The chimney of 111 1st Street was an architectural feature treasured by the building's artists and residents as an emblem of the past industrial might of the warehouse and Jersey City. The proposed plan would have gutted the interior structures and courtyard of 111 1st Street and then constructed a twenty-four-story apartment building within 111 1st Street's courtyard. All the artists and tenants would be forced to vacate the premises during the demolition and construction and purportedly allowed to return after the completion of the new structures and the renovation of the warehouse's outer sections. Goldman asked the tenants' association to accompany him in lobbying City Hall to accept his plans for the two properties. The association declined.[48]

The year had begun with only minor discussion of the artists at 111 1st Street but then quickly descended into a scramble set off by a threat of a hefty increase in rents. As 2003 neared its end, events confirmed the artists' worst fears: New Gold Equities not only wanted them out of their studios and their homes—it connived to destroy their artistic Eden and their sanctuary from the world. The final battle in the war for the soul of 111 1st Street approached.

5
When a Dream Dies

By the beginning of 2004, the tenants' association and the artists of 111 1st Street had realized that Lloyd Goldman and his company intended to develop the property and that their community would become collateral damage. Goldman nursed a long-range strategy for the property. According to a municipal official, Goldman even reminded the artists that "time [was] still on his side and he could wait out all politicians."[1] As far as Goldman and his company New Gold Equities were concerned, the artists had served their usefulness: 111 1st Street, long a derelict parcel of land in a largely abandoned swath of a moribund city, was now a valuable property near a bustling neighborhood in a city undergoing a renaissance. The artists had played a crucial role in the transformation of the Powerhouse Arts District from a grim, slightly terrifying cluster of warehouses and crumbling industrial relics into a center of investment, construction, and new housing. A source employed by the Hudson County government stated as much: "Would developers [have] invested in high rises and sold or rented to tenants if there was not the cachet of a local arts scene?"[2]

Bill Rybak offered an eloquent and precise explanation of the process occurring within the building, the surrounding neighborhood, and other areas of Jersey City:

> The pattern is a familiar one to artists and real estate professionals. A bodega, a café, a bar, a restaurant, art galleries, maybe a frame shop, an art supply store, a hardware store. The neighborhood acquires an artsy cachet, becomes trendy, and the gentrification begins.

Meanwhile artists, small businesses, local residents and landlords benefit from the new growth. At the other end of the cycle the real estate speculators take over, property values, taxes and rents begin to soar, and the artists are priced out of their own neighborhood, they leave for more affordable studio space and the cycle begins anew somewhere else.[3]

The community at 111 1st Street was determined that it would not become another victim of such a cycle. The artists had worked and lived in the building for more than a decade and clearly understood that they were unlikely to reap the benefits of the improving neighborhood. The artists were tenants: They had not purchased the building. The artists rented studios for genuine work and for illegal living. The artists were outsiders, misfits, not respectable businesspeople or taxpaying home-owners. However, 111 1st Street was their home, their urban village, and their extended community. In their opinion, the cavernous, jumbled warehouse belonged more to them than to a corporate entity headquar-tered in a Manhattan office. To the artists, 111 1st Street was not a line on a spreadsheet or a canny investment: 111 1st Street was a magical place, an epicenter of creation untainted by the cares and vagaries of the world.

Kelly Darr described 111 1st Street as a "miracle, blessing, phenom-enon" and believed that "something opened up and allowed us to be [there]."[4] To put it succinctly, the artists felt that they had found and built something amazing in 111 1st Street. They would not easily give it up. Although the odds were against them, the artists of 111 1st Street vowed to fight the owner. Really, what other choice did they have? Walking away from their colleagues, their friends, their homes, and their art was never an option.

The artists of 111 1st Street began nurturing their own plans to com-pete with the cookie-cutter proposal being shopped around by the build-ing's owner in late 2003. The tenants' association searched for an inves-tor to purchase the building from New Gold Equities and to redevelop it according to the Powerhouse Arts District guidelines, while remaining cognizant of the needs and desires of the current residents. Meanwhile, the artists commissioned their own design to retrofit 111 1st Street. These blueprints presented a vision of preserving the building's exterior and the visible historic architecture, scale, and form of 111 1st Street on its original footprint. The interiors would be changed and upgraded for working studios, lofts, and artist housing.[5]

In recent years, the concept of retrofitting has spread well beyond the

Architectural plans for 111 1st Street commissioned by the tenants' association, circa 2003–4. (Courtesy of Bill Rybak)

confines of the urban landscape dotted with gargantuan industrial complexes. In fact, many forward-thinking suburban communities are exploring the architectural and planning models and ideas of retrofitting to enliven their communities and shape them into more humane, livable spaces. This is not a foreign concept—even in Jersey City. The Dixon Mills pencil factory, the former Majestic Theater, and the Jersey City Medical Center are a few prominent successful local examples.

The artists pitched their plans to Mayor Cunningham and compared them to the computer model revealed by Goldman to the tenants' association. Unfortunately for the artists, Cunningham expressed admiration for Goldman's architectural renderings, asking, "How come nobody ever showed me these plans before?"[6] The group also sent their proposals to the respective directors of the Housing, Economic Development, and Commerce Department and City Planning Department of Jersey City, but they never received a response. Undaunted by the weak support coming from City Hall, the artists and the tenants' association continued to contact architects, engineers, and other real estate professionals to build a rival confederation to purchase 111 1st Street from Goldman and then more sensitively and aesthetically develop it.[7]

How to explain the rather lukewarm reception by figures in City Hall to the artists' redevelopment ideas for 111 1st Street? Obviously, there was no love lost between the city government and the owner of the building. New Gold Equities fought against the WALDO ordinance and later the Powerhouse Arts District plan drawn up by the Urban Land Institute. Other property owners pushed against these zoning regulations as well, but none as vociferously and steadfast as New Gold Equities. In the past, the city government, especially under the Cunningham administration, typically sided with the artists in disputes and pressured New Gold Equities to resolve such disagreements amicably. What changed this dynamic?

A city employee pointed out that the artists engaged themselves in local politics as the fight for 111 1st Street grew more intense, more volatile, and more crucial to their future in the building. Some of the artists invited unspecified enemies of Mayor Cunningham into the debate and involved themselves in issues unrelated to the building.[8] For instance, one artist wrote a letter to the *Jersey Journal* lambasting a bond issuance being pursued by Cunningham and City Hall. The perennial mayoral candidate (and later a candidate running against Mayor Cunningham's wife for a state senate seat) Assemblyman Louis Manzo expressed interest in the future of the building. Manzo was likely not an individual beloved by Cunningham and his camp, and he might have been one of the unnamed

enemies. Because of the artists' involvement in Jersey City politics, Cunningham may have placed 111 1st Street on the back burner. The municipal employee further corroborated: "I always warn artists about staying out of politics. Politicians will always help constituents. But if they view you as a rival, a combatant, they'll destroy you. Politics is a bloodsport in Hudson County."[9]

The attempt by the artists to become actors in this brutal, internecine environment revealed a certain degree of naïveté and ignorance regarding the realities of the local political world. The politicians of Hudson County had earned their collective reputation as a hardnosed, merciless, and sometimes corrupt bunch well over a century before. Confronting them without tact, nuance, and respect remains a perilous and foolish endeavor.

However, by the spring of 2004, Mayor Cunningham and his administration understood that their personal engagement in the struggle for 111 1st Street was essential to the ability of artists to continue to work and live in the building. Other ambitious politicians—such as Manzo—exploring the issue also possibly rekindled the administration's interest. The dramatic escalation in rents and the likely resulting departure of many tenants sparked Cunningham's reemergence as an advocate for the artists and an arbiter between the parties. Cunningham affirmed his support for the artists of 111 1st Street and his goal of fostering a compromise between the artists and New Gold Equities:

> The artists have helped change the image of Jersey City. My goal is to protect [them]. We need a thriving arts community to fulfill the promise of Jersey City. . . . I'm looking at some means of compromising, so the owner can do good things . . . but so the artists who are there are protected.[10]

The director of the (now-defunct) Jersey City Museum validated Cunningham's statement concerning 111 1st Street: ". . . [T]here's no concentrated location like the 111 building. It's where all the action is occurring. It's the point of reference for the arts community, from where everything else flows. Everything."[11]

The Cunningham administration and its allies did not wish for the destruction of the city's most known, revered, envied, and productive arts community to occur during their tenure.

The threatened and much-feared higher rents were scheduled to begin on May 1, 2004. Many of the artists knew that they lacked the financial ability to pay the increased rents for their loft and studio spaces. In order

to attract a public audience to their predicament and to galvanize the public's attention and support, the artists organized a May Day Festival on May 1, 2004. During the festival, forty of the artists' studios were opened to the public for self-guided tours, and artistic workshops and musical performances occurred throughout the serpentine halls and nooks of 111 1st Street.[12]

The selection of May Day as the date of the festival merits attention. May Day, also known as International Workers' Day, is a worldwide holiday celebrating labor unions and the labor movement throughout Europe, Asia, the Middle East, and Central and South America in commemoration of the Haymarket Massacre in Chicago, Illinois, in 1886. (Labor Day is celebrated on the first Monday in September in the United States.) By setting the festival and their public protest over their rental increases on that date, the artists identified themselves as belonging to a militant labor movement—and a working-class tradition of dissent. Workers of the nineteenth century fought for safe working conditions, humane hours, fair wages, and basic respect and dignity in the workplace; the artists of 111 1st Street fought not only for the right to a specific space but also for the right to belong to an evolving cityscape and for the very survival of their community.

The May Day Festival at 111 1st Street again underscores the perplexing place of artists in the larger gentrification movement. Artists are straddlers of sorts.[13] Although they are generally well educated and cultured as both a social and as a professional group and they usually possess enviable reserves of cultural capital, artists very rarely earn large incomes. In fact, most artists just barely cling to the lower-middle-class or the working-class rungs of the economic ladder. According to economic measurements, artists belong more to the working class than to the middle class and may be even more vulnerable to the forces of gentrification than are impoverished citizens. Economically needy residents living in public housing, receiving housing vouchers, or facing the threat of higher taxes are protected by legal precedent and court rulings, government authorities and institutions, and various public interest groups and community development corporations. However, if they bear consideration at all, artists are viewed by the general population as privileged and able to absorb new financial demands. They are elite. Weird. Lazy. This perception bears little resemblance to reality.

The following months witnessed another unfortunate event in the fight for 111 1st Street. Mayor Glenn Cunningham died of a heart attack on May 25, 2004. Cunningham was a supporter of the artists of Jersey

City and had built a tenuous alliance with the tenants of 111 1st Street. Although irritated by the engagement of the tenants' association in the larger political sphere of Jersey City and Hudson County, Cunningham publicly expressed support for the artists and fought New Gold Equities for their right to remain at 111 1st Street. He crafted public policy aimed at building an actual living arts community in the Powerhouse Arts District, and he hoped to preserve a piece of this Jersey City landscape for the arts and for artists. Such an accomplishment would have been a remarkable public legacy. At the time of his death, Cunningham was quietly negotiating leases for the artists with Lloyd Goldman and New Gold Equities. When Cunningham died, those talks ended. The untimely and sudden death of Cunningham resulted in the loss of the most powerful and influential advocate for the artists of 111 1st Street: "Cunningham died and 111 went into freefall and [it was] down in a few months."[14] At the moment of Cunningham's passing, few realized that the fate for 111 1st Street was effectively predestined.

After Cunningham's death, the Jersey City Council president, a popularly elected official, ascended to the mayor's office until a special election could be held in November 2004. L. Harvey Smith held the Jersey City Council president seat. Smith stands out as another perennial figure in Jersey City and Hudson County politics. In no certain order, he has served as a state senator, a councilperson, an acting mayor, a county undersheriff, an assemblyman, and a multi-time mayoral candidate. Smith was arrested in the FBI's sting of New Jersey politicians in 2009; he was eventually acquitted of all charges.

However, when he assumed his new office, many of the artists and tenants believed that they had found a much more vocal and muscular supporter in Acting Mayor L. Harvey Smith.[15] William Rodwell declared that "[Smith] was the only mayor to have 'put his money where his mouth was.'"[16]

At a summer rally-*cum*-festival in the grounds in front of City Hall, Smith voiced his solidarity with the artists of 111 1st Street: "You guys are like cats. You have nine lives. 111 First Street is going to live. You can count on it and you can count on me."[17]

Earlier in the summer of 2004, the city council under the leadership of Smith had introduced an ordinance to designate the Powerhouse Arts District as a historic district. Additionally, Smith and his allies in the City Council began discussing exercising eminent domain to acquire 111 1st Street and preserve it as an arts community.[18]

However, a municipal employee involved with 111 1st Street from its

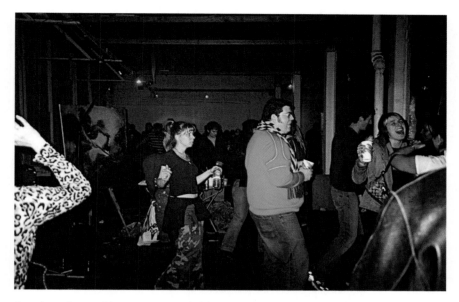

Snapshot of one of the many parties held at 111 1st Street, date unknown. (Courtesy of William Rodwell)

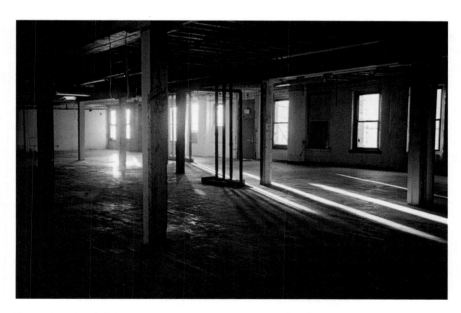

Empty interior, 111 1st Street, January 2005. (Courtesy of William Rodwell)

Edward Fausty, *Art Machine, Kelly Darr Studio at 111*. An insight into the many creative worlds at 111 1st Street. (Courtesy of Edward Fausty)

Edward Fausty, *Bill's Bed, William Rodwell Studio at 111*. This photograph illustrates the borderless state between the artists' lives and work at 111 1st Street. Many literally lived and slept among their art. (Courtesy of Edward Fausty)

Edward Fausty, *Catacombs, Reuben Kadish Foundation at 111.* (Courtesy of Edward Fausty)

Edward Fausty, *White Elephant outside Ens/Sloan Studio at 111.* Hallway in 111 1st Street. (Courtesy of Edward Fausty)

Edward Fausty, *Sleeping Dog, Lowenstein/Malak Studio at 111*. The napping dog and reflection of a washing machine dispute the claims that tenants were not living in their studios. (Courtesy of Edward Fausty)

Edward Fausty, *Window to Courtyard, 3rd Floor at 111*. This photograph gives a private view into an unnamed artist's studio. (Courtesy of Edward Fausty)

Hall window looking toward the Hudson & Manhattan Railroad Powerhouse, date unknown. (Courtesy of William Rodwell)

Boarded-up doors of empty studios during the final months of the artists' battle with the building's owner, fall 2004. (Courtesy of William Rodwell)

The partially demolished building at 111 1st Street and the Hudson & Manhattan
Railroad Powerhouse. (Courtesy of William Rodwell)

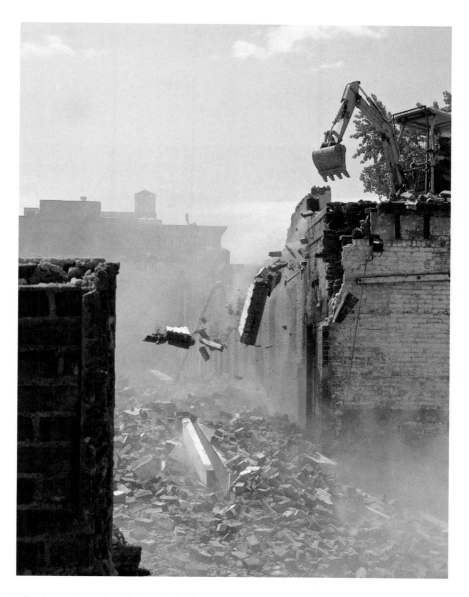

The destruction of the P. Lorillard Tobacco Company warehouse at 111 1st Street, circa May–July 2007. (Courtesy of William Rodwell)

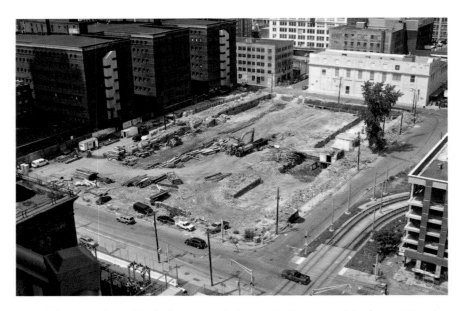

The empty lot at 111 1st Street reveals the massive footprint of the former P. Lorillard Tobacco warehouse, circa July 2007. (Courtesy of William Rodwell)

was off-duty."[24] The artists' complaints about the supposedly off-duty police would increase and would largely prove to be justified during the course of the year.

As detailed earlier, following the death of Glenn Cunningham, the city government announced its intention to explore and to exercise eminent domain in order to purchase and save 111 1st Street. The city informed all property owners in the Powerhouse Arts District that the city planned to landmark not only 111 1st Street but also the other industrial sites and warehouses clustered in the district. New Gold Equities began the demolition of 110 1st Street within days of learning of the city's intentions.[25] It remains unclear whether New Gold Equities had secured the proper authorization and permits to start demolition of 110 1st Street at that time.

Following the August rally in front of City Hall and the support voiced by various public officials, New Gold Equities purchased a full-page ad in the *Jersey City Reporter*, a weekly newspaper, in the form of a letter signed by Lloyd Goldman. In the letter, Goldman noted his company's and his own longstanding commitment to the arts and to Jersey City and touted the construction jobs that would be created by the redevelopment of 111 1st Street.[26] Goldman claimed that his company had been operating at a loss on the property for some time and that a redevelopment of the property would be necessary for its long-term viability and its continuous ability to serve as commercial site—that is, a collection of studio spaces. Goldman stated that the current tenants would need to move elsewhere within the structure during construction, but that they would not be forced to leave. The most revealing sentence in the letter reads: "The building itself needs extensive investment and we propose to fund that investment by redeveloping the core of the property as new residential space at current market rates."[27]

Did 111 1st Street require physical improvement? Most certainly. Yet New Gold Equities expressed little interest in improving the space until the real estate bubble swelled on the Jersey City waterfront and the downtown neighborhoods. Essentially, the property would now furnish New Gold Equities with a far greater return on its investments by wholesale redevelopment and by attracting much more affluent tenants than by falling into disrepair and being rented to ragtag artists. In an attempt to garner public support for its project, New Gold Equities inadvertently revealed its true goal: money. The artists were simply a mechanism in maximizing the company's initial investment.

In October 2004, the elected officials and certain elements of the professional staff of the Jersey City government appeared to coalesce behind

Crowd outside of 111 1st Street during an Open Studio Tour, October 2004. The building management attempted to bar visitors from entering the building. Many people stayed and waited to attend the studio tour in the building. (Courtesy of William Rodwell)

the artists and the movement to preserve 111 1st Street as a community, a physical structure, and a vital piece of the city's architecture and history. The city council unanimously voted to landmark the building and later followed with another unanimous vote to adopt the Powerhouse Arts District plan in early October. This plan designated that all structures falling within the Powerhouse Arts District must be rehabilitated and not demolished and that all projects and new construction emphasize the attraction and retention of artists. Additionally, this plan mandated that 10 percent of housing units be subsidized for practicing artists and established specific zoning guidelines regarding the height and mass of new buildings.[28]

Not surprisingly, the legal representation for New Gold Equities questioned the technical legalities of the vote and promised immediate litigation over the legislation. New Gold Equities complained that the city was favoring artists—specifically those of 111 1st Street—over property owners. Acting Mayor Smith shot back that Goldman and his company had profited for years as a result of the artists' presence in the building.[29]

Was the swift action by the city government due to frustration with the owner and a genuine solidarity with the homegrown arts community? Possibly. But only the most naïve observer of America politics would fail to question the motives of these elected officials. A special election for the mayor's office was scheduled for November. The acting mayor was on the ballot. The downtown councilperson faced a primary election against a reform candidate in the following spring. All the elected officials would possibly earn political capital and public respect for attacking a wealthy New York landlord and developer and for championing the underdogs who were the artists of 111 1st Street. Even if New Gold Equities successfully blocked the ordinance in court, the politicians could claim that they fought the good fight for a constituency and embraced the cause of the artists as a campaign issue. The local politicians had much to gain from the vote and little to lose.

Soon thereafter, a dark, potentially deadly facet developed in the fight between the artists and the owner of 111 1st Street. A fire started in an empty studio on November 7, 2004, setting off the sprinkler system. In a repeat of the 2002 incident, the artists' studios suffered more damage from water than from fire.

An investigation by the Jersey City Fire Department discovered that the fire was caused by a disconnected gas pipe allowing "free-flowing gas to interact with lit piles of rags."[30] Candles in the studio set the rags aflame. Prior to the fire, the studio had been vacant with its doors locked and barred. An unknown individual had attempted to disable pipes in the basement that fed the sprinkler system; however, the sprinkler system remained strong enough to extinguish the fire. Afterward, the fire department shut off the gas and sprinkler systems in 111 1st Street and established a twenty-four-hour watch on the building until the sprinkler system could be repaired. Shortly thereafter the, the arson investigation unit declared the incident to be an act of arson, and two employees of New Gold Equities were arrested in December 2004.[31] When asked about the charges against the employees, a lawyer for New Gold Equities responded that as far as he knew "they were picked up for a parking ticket."[32]

Several suspicious details surrounded the fire at 111 1st Street. The fire broke out a day before a court hearing in which Goldman was to have sought a legal declaration that 111 1st Street was unsafe. This declaration would have rendered the recent historic designation moot and allowed Goldman to proceed with redevelopment. The event occurred in the same area of the building that had been damaged by fire in 2002. The incident of 2004 resulted in the fire department's shutting off the gas

to the building and forcing all the tenants to rely upon space heaters in November and December. This made an already uncomfortable working and living situation all the more difficult. Finally, it cannot be denied that employees of the owner of 111 1st Street were arrested.[33] Physical threats and arson are tactics historically embraced by more unscrupulous and less morally inclined property owners and their proxies in sites of displacement and gentrification.[34]

During the months of November and December 2004, the continual presence of off-duty police officers garnered further negative reaction from the tenants and from the local press. Although the off-duty officers were purportedly onsite to guarantee the safety and security of 111 1st Street and its tenants, they seemingly paid little attention to crimes committed against the artists or their property. In the weeks following the fire, the windows of two artists' cars were smashed, and one studio was burglarized.[35] More disturbingly, several artists and journalists reported that the police officers forced visiting journalists from the building and threatened them with trespassing charges. During one such incident, a resident artist, Shandor Hassan, invited a camera crew from New Jersey News into his studio for a scheduled interview concerning the recent fire. The off-duty officers entered the artist's studio and ordered the camera crew to vacate the premises immediately. Hassan commented on the action of the police and the owner: "They're trying to control the media. They have no shame. . . . [I]t's a news story."[36] The New Jersey News reporter, Adrienne Supino, escorted out of the building by the police, said, "We called the landlord to get permission to enter the building but it sounded like the landlord didn't want us there."[37]

The actions of the off-duty police lent evidence to the claims that the police served as hired muscle for Lloyd Goldman and New Gold Equities to control 111 1st Street and to harass the artists.

The constant presence of off-duty police also raises a disturbing question regarding the fire—later judged to be arson—of November 7, 2004. If the police were monitoring and controlling the entrance to 111 1st Street, was the arsonist known to them and, by extension, to the management or owner of the building? How was someone able to partially disable the water pipes in the basement and enter a mothballed studio without the knowledge of the officers supposedly patrolling the building?

Meanwhile, at the time of the fire and the running controversy over the off-duty police officers, the political landscape shifted in Jersey City. Acting Mayor Smith lost his bid for a full term. Jerramiah Healy, a former judge and councilman-at-large, ran on a law-and-order and neighborhood-

centric platform and won the special election for the mayoralty in November 2, 2004.

Healy entered City Hall just as the fight for 111 1st Street had entered its climactic stage, but arguably the fate of the building had already been determined, if unseen by many of the participants. A municipal employee elaborated upon this situation: "Healy gets all the blame, but he essentially inherited the mess. During his first week of office, forty tenants [were] screaming . . . outside of his office. He didn't know what to make of it. The machinery [against 111 1st Street was] already moving at that point."[38]

When confronted with the issue of 111 1st Street, the Healy administration established its own policy, fundamentally altering the city's relationship with the artists and the owner.

Previously, the city government under the Cunningham administration had supported—admittedly somewhat fitfully—the artists' desire to remain at 111 1st Street and attempted to broker a favorable agreement between the artists and New Gold Equities to achieve this goal. After Cunningham's death, Acting Mayor Smith embraced a more confrontational stance, launching a full-bore assault against the owner and threatening to take the property through eminent domain proceedings.

Instead of offering support for the artists after taking the mayor's office in November 2004, Healy stated that he viewed 111 1st Street as a tenant–landlord issue and a matter to be resolved through the professional staff of the city government and the court system; he did not see 111 1st Street as a platform for political interference or grandstanding. Healy explained his reasoning: "Eminent domain requires a commitment of taxpayer funds. I cannot resolve this longstanding feud between owner and artists by committing taxpayer money to bail them out."[39]

Healy, an attorney and a former judge, likely did not wish to spend city funds on an eminent domain lawsuit resting on a shaky foundation. Moreover, such a lawsuit would establish a precedent that the city government would likely be expected to follow in other high-profile cases, and the Healy administration did not want that to occur.

This policy shift by the city government followed the issuance of a demolition permit for several specific structures within 111 1st Street by a city employee. In December 2004, a building code official approved an emergency demolition permit for an elevator shaft, a plumbing shaft, and other portions of the southeast corner of 111 1st Street. Two weeks prior to the granting of the permit, a state Superior Court judge ordered Goldman and New Gold Equities to submit a plan to address the multitude

of building code violations lodged against the building. This prompted an outcry by the artists, who viewed this as another step by Goldman to force them from the warehouse. Lawyers representing the artists requested that a stay be placed on the permit, and the judge agreed to hear testimony by the city engineer explaining his decision.[40] Ultimately, the owner was allowed to proceed with the demolition as specified by the city official.

Instead of questioning the judgment of a member of the municipal professional staff, Mayor Healy supported the staff member's ruling but allowed that it could be challenged through courts; however, Healy would not overrule the building code official or take a side on the matter. A critic might argue that such action or inaction revealed a lack of support for the artists and a politician's submission to the pressures of a wealthy developer. However, by backing the decision of a bureaucratic professional, Healy demonstrated an admirable (and often lacking) managerial quality in politicians: He displayed confidence in and respect for an experienced city worker and wanted the process to wend its way through the proper channels. Healy publicly stood by the employee: "[The official] is a longtime employee with good standing in the city. I have to assume [he] did what he had to do."[41] Additionally, Healy deferred to the expertise and training of the staff member: "I'm not an engineer and I have to give some kind of credence to [the official]. Even if I could inject myself here, I would not. I would let it run its course through the courts."[42]

In a more humorous episode, a tenant of 111 1st Street filmed a sizable group of Jersey City police officers, some in uniform, some in plainclothes, but all with firearms and badges, drinking heavily just outside the building. One officer urinated on the wall of an adjacent building, and several officers staggered to their vehicles and subsequently drove away.[43] After a meeting with city officials and Mayor Healy, the tenants' association presented the video of the drunken police officers. Healy watched the video and stated that he personally knew several of the officers. Several years later, the video, entitled "Drunk Cops in Jersey City, NJ," went viral and was the subject of a New York City news story in 2008.[44]

As noted earlier, many of the artists of 111 1st Street expressed particular distaste toward Mayor Healy, but the machinery to push them from the studios and their home was churning long before his mayoralty. He assumed office well toward the end of the battle for 111 1st Street and was never heavily engaged in the matter. Finally, it should be emphasized that Healy was the only mayor and only prominent local politician who

did not make assurances and promises to the artists of 111 1st Street that he could not keep. Local, state, and federal elected officials made grand pledges of support toward the community housed at 111 1st Street. But what did they ultimately do? Nothing. To his credit, Healy never promised anything that he could not deliver.

Sadly enough, the greater fears of the artists proved to be justified. They rightly saw the gradual demolition of 111 1st Street as a method to accelerate the slow death of their community and a concerted effort by New Gold Equities. When questioned about the demolition occurring within 111 1st Street, a resident artist, Paul Williams, remarked, "They're willing to do anything to get rid of us. They just want us gone."[45] Another artist, Barbara Landes, astutely perceived the ownership's strategy: "It's a domino effect. You take down a little, then a little more and before you know it, it's down to the ground."[46]

On January 3, 2005, fifty-six of the tenants remaining at 111 1st Street appeared in State Superior Court to reach a settlement with Lloyd Goldman and New Gold Equities. The tenants had stopped paying their rents months earlier or placing their funds in an escrow account. (This is a usual mechanism for holding funds during any landlord–tenant dispute.) Why were the artists no longer paying rent? Three to six months earlier in 2004, their attorney advised them that they no longer needed to pay rent because of the fact that New Gold Equities had lodged eviction proceedings against them.[47] Because the artists were embroiled in the justice system and attempting to build political support in Jersey City, this strategy seems questionable at best.

The artists hoped they could prove that the owner knew that the artists had been living at 111 1st Street for many years and that such evidence would buy them more time in the building. For some reason, this line of argument never arose in the court proceedings. The respective lawyers for the artists and the ownership reached an agreement, largely disappointing to the artists: Goldman and New Gold Equities would forgive eight months of back rent, equal to $600,000, and provide a $35,000 collective settlement to cover the artists' legal fees, and the artists would vacate 111 1st Street by March 1, 2005.[48] One artist, Sandra DeSando, described the settlement as "just a matter of course."[49] Edward Fausty lamented, "It's amazing how much work you can put into something and get absolutely nothing from it."[50]

This settlement effectively killed the artistic community that lived, worked, and thrived at 111 1st Street. Following the court settlement of January 3, 2005, the artists began to disperse from the warehouse. Some

artists remained in Jersey City and others settled in New York City or elsewhere in the greater metropolitan area. Still others, feeling emotionally, physically, and spiritually crushed, fled the setting of their former home and dreams for distant parts of America and even foreign lands. Two days before the March 1, 2005, deadline, seventy-five tenants, friends, and supporters gathered in one artist's studio for a final farewell. Kelly Darr, who partook in the gathering, offered a vivid description: "[The] community [came] together in a joyous fashion. [We] held a Last Supper for [our] last event with bread and wine. Just like the real Last Supper."[51]

Many of the artists associated with 111 1st Street felt that the building and its community had marked a high point not only in their careers but also in their creative endeavors and in their personal lives. They all agreed that they had belonged to a special moment in a special place. Then, it was gone.

Several questions linger at the conclusion of the artists' tenure at 111 1st Street: What could have been done differently? What decisions and choices prevented a more favorable—to the artists—outcome? Looking back, the majority of the artists and the present arts community in Jersey City blame the sclerotic municipal government, specifically (and arguably unjustly) under Mayor Jerramiah Healy, and its unwillingness to force a well-heeled developer to adhere to the city's own urban planning and zoning. This widely accepted belief contains more than a grain of truth. The city held the most influence and the most power vis-à-vis Lloyd Goldman and New Gold Equities. Nonetheless, very few of the interviewed sources demonstrated any self-awareness or introspection concerning their own questionable strategies and movements during the fight for 111 1st Street. Maybe this was because of loyalty, embarrassment, or occasionally, self-righteousness. Maybe this was because the right questions were not directly asked.

Several sources, most of whom were former residents of 111 1st Street, did question the actions and even the motives of their fellow artists and their friends. In fact, one former resident, Tyrone Thomas, bluntly stated, "Artists are fuck-ups as well."[52] He then related how he had found a roughly 30,000-square-foot warehouse in a blighted riverside city in Connecticut. This city's government wanted to work with artists and was willing to sell the building to them for a bargain price of $33,000. Thomas relayed this information to the tenants' association and other artists and attempted to convince everyone to pool their resources to buy this building. He saw the Connecticut warehouse as an opportunity for the artists

to gain the stability of ownership but, even more important, the ability to save their community. Unfortunately, Thomas failed in his rallying efforts. Years later, he could not recall the name of the Connecticut city.[53]

Another past resident lamented that the artists had not followed a similar strategy. This artist had heard a rumor that the opportunity to secure the funds for purchasing a building existed at one time during the long fight: Goldman purportedly once presented the tenants' association—comprising only a handful of the residents of 111 1st Street—with an offer of a $20,000 payout per lease-holder if they would agree to vacate the building. Such a settlement would have left the artists with a large reservoir of funds to purchase a different building and make renovations, if they combined their money.[54] The source voiced his frustration: "The artists could have used the money to buy a building in Communipaw [a more impoverished section of Jersey City with not a few abandoned industrial structures at that time] or something."[55]

As the story goes, the tenants' association turned down Goldman's offer without even bothering to consult with the other residents. They did not want another building: They wanted 111 1st Street. This desire blinded them to the possibility of something better and of something very real—that is, another building, a building of their very own. This artist framed his story with the disclaimer that his anecdote was merely hearsay overheard during cocktails at a gallery opening for a fellow 111 1st Street alumnus. Later, he asked a colleague heavily engaged with the tenants' association about the rumor. This other artist denied it.[56] The real truth will likely never be known.

Another former resident, Elaine Hansen, who managed a yoga studio in the building, commented that the artists and specifically the tenants' association were incredibly unrealistic in their dealings with the city, the owner, and eventually the New Jersey legal system. Hansen added, "The artist-led meetings drove me a little crazy. . . . [The artists] weren't very willing to listen to professionals. It seemed like a power grab among certain people. To be blunt, as a woman I didn't have much voice—the guys ruled."[57]

The above quote contains several revealing statements and echoes sentiments of other sources. Several individuals offered the tenants' association sound advice on dealing with elected officials and with Lloyd Goldman. These consultants could not comprehend why the artists and their association seemed determined to follow their own flawed plans, such as becoming entangled in local politics and needlessly antagonizing Goldman.[58] The above source noted that the tenants' association "seemed like

a power grab." Another interviewee remarked that many of the artists leading the organization had been practicing art with modest or little success for some years. Through the increasingly public fight over 111 1st Street, they were finally receiving attention from their peers, from the press, and from the public.[59] Maybe they simply became caught up in the fleeting excitement and the passing glamour of the fight and lost the objectivity and detachment often needed to make complex decisions involving money, lawyers, and people. Finally, the charge of sexism within the group, if true, is a disappointing revelation. No other source and none of the press accounts mentions this dynamic of the tenants' association. However, galleries, collectors, museums, and artists have long been accused of sexism and have been targeted by feminist organizations. (Indeed, in the 1980s, an anonymous group, the Guerrilla Girls, formed to combat the perceived rampant sexism of museums and major art critics.) Although not corroborated, the source's claim of sexism cannot be peremptorily discounted.

Many newer Jersey City residents know nothing of the building, attesting to the fact that it has ceased to belong to the present. The building at 111 1st Street sits squarely in the past. It is history. What remains of 111 1st Street and what was its legacy upon the arts community in Jersey City and upon Jersey City as a whole? When asked this question, one city employee disparagingly remarked that newer, younger artists in the city—if they are even aware of it—thought that "111 was a bunch of dirty hippies that got free rent and didn't appreciate it" but then followed that thought with the comment that the death of 111 1st Street was a "devastating loss" and that the building had been an "immense benefit to the city."[60]

The majority of the sources agreed that the loss of 111 1st Street substantially altered the contours and the viability of the arts community. The property at 111 1st Street had provided the community and its regular events, such as the Artists Studio Tour, with a nucleus and a main staging ground. Although an impressive number of artists and creative types continue to work and to live in Jersey City, they are scattered throughout the city and its neighborhoods, no longer concentrated in a single site or a single area. Admittedly, many in the arts community see this as a positive development for the long-term health of the arts and a way to build and grow artistic clusters and neighborhoods throughout Jersey City.

In general, the loss of 111 1st Street diminished the image of Jersey City as a haven for artists. A Hudson County government official commented that the loss "[a]ffected the city and county economically—the potential for cultural tourism development, through the anchor of 111

First Street[,] is a great disappointment. Jersey City's branding and iden-
tity [were] not helped by the loss. . . ."[61]
Artist Henry Sanchez remarked:

Jersey City is now in the midst of "developer" and "speculator"
growth. There is very little of any arts community left. No more
111 1st Street. Galleries have closed. Nonprofits have left. The mu-
seum is now shuttered due [to] the City Hall budget cuts. I don't
know what will happen to Jersey City in the future, but there will
not be a renewed arts community coming back to Jersey City. I'm
not sure what the city has to offer artists and vice versa. . . . Jersey
City is a completely different place without 111. The population
that moved there to be part of that kind of spirit and community are
not happy and their lives have changed as well. Not for the better.[62]

Those involved in the arts community, as practitioners, organizers, or
supporters, believe the city government sees little use for the arts. One
source heavily involved with an art nonprofit bitterly observed, "There is
a prevailing message given to the arts scene . . . '[W]e don't want you, we
won't fight for you, we won't plan for your survival or provide permanent
spaces for you to thrive. You are on your own. Good luck.'"[63]
Although many individuals involved with 111 1st Street or the Jersey
City arts scene more generally depicted a grim picture, especially follow-
ing the building's demise, or what one former resident characterized as
"one big anthill, Tower of Babel—that was just crushed," others saw a
spirit of renewal born from the destruction of their beloved community.[64]
One former artist and resident, Bill Rybak, fondly recalled his role in or-
ganizing a massive arts exhibition and event in 2007 in the former Canco
factory (now known as the Canco Lofts), in an area of Jersey City edg-
ing toward the Pulaski Skyway, that "evoked the scale, drama, and funk-
iness of the old Art Center at 111."[65] The event offered food and drinks
to nearly 1,700 patrons and lovers of the arts and entertained them with
live music, a fashion show, and, of course, art. The following year, the
group launched another kick-off event, attracting close to 2,500 people.
For this alumnus of 111 1st Street, these successful arts events represented
". . . a way to demonstrate the kind of muscle the arts community could
still bring to bear on a cultural event in the city, and an affirmation of the
legacy of 111 1st Street and the community of artists that gave so much
to the city."[66]
The P. Lorillard Tobacco Company warehouse at 111 1st Street ush-
ered in a new era for Jersey City and nurtured an artistic community at

its most fragile, nascent moment. After nearly a decade of anger, frustration, and struggle alongside joy, friendship, and peace in a community of like-minded personalities and individuals, the artists of 111 1st Street bade farewell to their habitat and their home and moved onward. Although suffering a turbulent and treacherous economic and political environment, artists and the arts still survive in Jersey City. Art and artists are resilient and always seeking new spaces, buildings, neighborhoods, and communities wherein to work, create, and dream. One source offered this piece of optimistic commentary: "Whether or not a city makes plans for permanent arts venues or neighborhoods, art happens. Art happens because communities need it."[67]

6

One Last Fight
Historic Preservation and 111 1st Street

On March 1, 2005, an officer of the defeated tenants' association, William Rodwell, made a final round through the winding halls and cavernous rooms of 111 1st Street, much like any typical renter bidding farewell to a home, simultaneously recalling joyous moments and methodically noting any outstanding repairs lest the landlord dip into the security deposit. Employees of New Gold Equities accompanied Rodwell on this inspection. Rodwell noticed that the management personnel were in a buoyant, if not celebratory, mood. Why not? They had beaten back public support for the artists, cowed the city into withdrawing any assistance to them, and defeated them in New Jersey state court. New Gold Equities had won.[1]

After the humiliating final tour of 111 1st Street—the workshop for his art; his community with his fellow painters, sculptors, musicians, writers, and oddballs; his setting for grand ambitions and fantastical dreams; and his home for close to twenty years—Rodwell rested on the front steps and reflected on his years in the building. He never thought that his small, lovely world would end. Soon other artists and former residents joined him, reminiscing and saying goodbye to the old, labyrinthine tobacco warehouse and to their shared life. As the sun dimmed and as the chill of a dying winter nipped their hands and faces, the group dispersed, vowing to support one another's careers and promising to stay in touch and keep their memories alive. Then, they all were gone.[2]

While a guest at a relative's apartment on the following day, Rodwell received a telephone call from a reporter for the *Jersey Journal*. Another

former tenant had snuck into 111 1st Street and barricaded himself in his former studio. Because the individual refused to leave, the management eventually contacted law enforcement. The standoff ended with the police handcuffing the trespasser and dragging him out of the building. This unnamed person claimed that he would be "the last artist to leave 111."[3] This former tenant had long battled mental illness and had recently been released from a treatment facility before the general eviction. When the reporter questioned Rodwell on the latest news coming out of the suddenly empty and derelict 111 1st Street, he might have been amused or maybe just irked. Why was this reporter bothering him? This was no longer his problem. Several weeks later, the same unstable man was spotted slinking through the halls of the warehouse. The police were called again, but they failed to find and catch him. Rodwell never heard from this fellow tenant again.[4]

After their eviction and the death of their community, many of the artists divorced themselves from the Jersey City cultural scene, and some left the area altogether to seek a more welcoming environment for artists and creative types. (Whether such places provide any true permanence is a real question. The histories of various art communities suggest that they do not.) Still, a number of former residents remained in Jersey City, because it was their home and that of their acquaintances, friends, and family.

On May 23, 2005—not even a full three months after the defeat of the artists—a new battle for 111 1st Street began. The attorney and assorted representatives for New Gold Equities appeared before the Historic Preservation Commission of Jersey City and petitioned for the body's approval to demolish the P. Lorillard Tobacco Company warehouse. Any development, improvements, or outright destruction of buildings and structures located in historic districts or designated as historic landmarks in Jersey City must meet the approval of the historic preservation officer, a local civil servant, and the Historic Preservation Commission, a nine-member body of mayoral appointees. A party that wishes to dispute the ruling of the Historic Preservation Commission may file suit in state court. Additionally, the zoning for the neighborhood, the Powerhouse Arts District, required that all renovated or new buildings be a mix of artists' studios and artists' housing and market-rate apartments. This bureaucratic framework checked the company's ability to quickly tear down 111 1st Street, begin construction on a new building, and likely generate handsome returns on its original investment. Having emerged victorious from its fight against the artists and with a seemingly more amenable new

mayoral administration in office, New Gold Equities believed that the next steps toward its ultimate goal would be brief and involve little more than legal formalities.[5]

The attorney for New Gold Equities questioned several witnesses during a three-hour public presentation to the Historic Preservation Commission. A real estate development manager assessed the market value of the former tobacco warehouse and arts center at $7.5 million and estimated that the property would require a cash infusion of $26 million to bring it up to the municipal building code and then redevelop it along the PAD-specific zoning standards. Another real estate professional claimed that a substantial and expensive amount of work was needed to simply return the building to its being a functioning warehouse—its primary historical use. In a somewhat ironic twist, considering the nearly two decades of both benign and hostile neglect by the owner, a structural engineer stated that 111 1st Street displayed signs of imminent collapse because of its rotted wood foundations.[6] The attorney emphasized this line of testimony by adding that "We [New Gold Equities] have grave concerns that the building could collapse without warning. To continue to ignore this is something that New Gold can't continue to do. No one is going to save this building."[7]

A group of artists and former residents of 111 1st Street, notably several individuals active in the tenants' association during the protracted struggle with New Gold Equities, attended the Historic Preservation Commission meeting and found the owner's sudden interest in public safety and its self-appointed role as a public watchdog to be cynical and unintentionally humorous. William Rodwell, the erstwhile head of the tenants' association, snidely pointed out several obvious truths:

> Amazing, they say that the building has all these problems so that means it has to be demolished. That's because the owner never took care of it in the first place. I guess that we should give them credit for having such courage for risking their lives when they walked through the building after the tenants vacated. . . . [T]hey put on such a brave face.[8]

Rodwell underscored several glaring inconsistencies between the testimony of the witnesses for New Gold Equities and the reality of 111 1st Street. During the artists' tenure in the building, the owner and the management conducted very little maintenance and upgrades on the property and never concerned itself with the safety of its tenants or passers-by until the property value escalated and the battle with the artists reached a fever

pitch. Now, because the owner wanted to feed at the trough of the real estate bonanza, the physical integrity of 111 1st Street and the danger it presented to the average Jersey City citizen weighed heavily on the company's mind, not to mention its economic calculations.

In another line of possibly disingenuous testimony, the site manager showed a slide of the graffiti-marked walls of 111 1st Street and deplored the fact that the empty building had attracted vandals. The witness added that she had officially requested that the city provide security for the vacant building. The manager failed to add that 111 1st Street became an irresistible canvas for self-identified outsider artists only because of the eviction of the tenants and that the management had possessed the funds to hire full-time security during the last years of the building's operation. Now that the building sat empty and the owner aimed to demolish it, the security of the site should be presumably absorbed by the taxpayers.[9]

A historic architectural expert challenged the landmarking of 111 1st Street, citing the removal of the iconic smokestack as stripping the building of a unique and its most historic feature. Derisive laughter rippled through the audience, for the owner itself—not a civil servant or a city agency—had ordered the demolition of the smokestack in the courtyard in August 2004, claiming that it was on the verge of collapse.[10] A past resident attested to the durability and the quality of the smokestack's nineteenth-century craftsmanship by recounting that the contractors failed to destroy it with tools and resorted to painstakingly pulling it apart by hand, brick by brick.[11]

The smokestack was treasured by the artists and their supporters. (Former residents and local preservations still fondly remember it as the distinguishing feature of 111 1st Street.)[12] The smokestack's removal was permitted because of the fact that 111 1st Street had not been landmarked by the city at that time. The city council later passed an ordinance in October 2004 establishing 111 1st Street as a historic landmark. The circular logic of the argument against the historic significance of the building was not likely lost upon the commissioners or the public in attendance: 111 1st Street was historic, notably for its massive, skyline-puncturing smokestack. The owner destroyed the smokestack. Now 111 1st Street lacked its historic character. The owner argued that, therefore, he should be legally permitted to demolish 111 1st Street, because the smokestack had been torn down by him, thus denuding the building of its historic significance. Essentially, New Gold Equities, an owner of a historic property—111 1st Street—conducted demolition work in order to weaken the building's historic relevance.

During the public comments portion of the meeting, several artists and their allies offered spirited opinions on the cultural and aesthetic value of 111 1st Street and their reasons for wanting to preserve it and thought-fully redevelop it. Paul Sullivan, a former longtime tenant and art collec-tor, simultaneously presented a eulogy, a vision, and an insult:

> [111] was a magical place and the building still appears to be sal-vageable. I think with the right owner and the right atmosphere at City Hall that the building could be a great building again. . . . Just because some idiot can buy a Monet or a Rembrandt doesn't mean they have a right to destroy [it], although they think they do.[13]

Although they lost their community and their lives at 111 1st Street, the artists thought they still might be able to rescue the building itself. Then, 111 1st Street would remain a physical part of Jersey City and an artifact of its history, and others would be able to enjoy the building, al-beit in a different capacity. Their fight, their sacrifices, their losses would not be totally in vain.

At the end of the meeting, city officials scheduled a second meeting with the Historic Preservation Commission, citing the scope, complexity, and public interest in the case of 111 1st Street. City officials and their witnesses would argue against demolition and for the preservation of 111 1st Street at the meeting on June 27, 2005.

Meanwhile, during the debate over the future of the vacant P. Lorillard Tobacco warehouse, the Jersey City arts scene suffered another setback when a small, dingy bar named Uncle Joe's hung up an "out of business" sign in early May 2005. For several years, the bar had hosted a steady pa-rade of emerging and often local bands, cultivating a reputation as the center of the Jersey City music world, a parallel or complement to the arts complex at 111 1st Street. In fact, Uncle Joe's was located on 1st Street as well, creating a miniature arts district in the neighborhood. Longtime reg-ulars, occasional patrons, and first-time visitors gutted the interior of the club during its last night of business, hauling off the pool table, carrying out bar stools, and ripping sinks and urinals from the restroom walls.[14] The closing of Uncle Joe's was most likely due to poor income or to a busi-ness decision by the proprietor. Local musician and journalist Tris McCall complained about the loss to the community: "Well, that about wraps it up. Not just for Uncle Joe's, mind you, but also for the entire concept of a functional arts and entertainment district in downtown Jersey City."[15]

McCall voiced the collective frustration and disappointment of the arts community and art lovers throughout Jersey City. Within a span of

three months, they had lost both local nuclei of the visual arts and of live music. While competing with the national and global draw of Manhattan and the emergent Williamsburg and adjacent neighborhoods in northern Brooklyn, the Jersey City arts and cultural scene was hollowed out. In all likelihood, Williamsburg and other Brooklyn neighborhoods siphoned off scores of painters, sculptors, and musicians after the domino-like falls of 111 1st Street and Uncle Joe's.[16]

The downfall of the community at 111 1st Street and the subsequent closing of Uncle Joe's highlighted the precarious position of the arts in Jersey City and the city government's dedication to assisting artists in the Powerhouse Arts District. The city crafted the zoning legislation for the Powerhouse Arts District specifically to preserve the physical and architectural integrity of the underutilized industrial structures and to encourage and support the development of a vibrant arts and entertainment district; however, its commitment became questionable. Was the city government interested in partnering with local groups and individuals and building a viable and resilient cultural district and community in Jersey City, or was it more interested in accommodating wealthy real estate developers and promoting even more high-rise office and residential towers along the waterfront and bordering areas? Uncle Joe's and 111 1st Street together had provided the infrastructure for an arts district to attract new residents and visitors, but they were allowed to disintegrate. This fact called into question the wisdom and the will of property and business owners and local political leaders.

Nonetheless, the city appeared dedicated to maintaining and enforcing the Powerhouse Arts District ordinance in 2005. Immediately after the court settlement between the tenants of 111 1st Street and New Gold Equities, mayoral aide David Donnelly emphasized the city's commitment to the development plan for the district and to the preservation of its buildings, including the former tobacco warehouse: "[Lloyd Goldman] can't put up a tower and he can't tear the building [111 1st Street] down. The city is going to defend it to the end."[17]

Although the city government might have been unable to prevent the eviction of the artists from 111 1st Street, it seemed determined not to allow Goldman and New Gold Equities simply to ignore the zoning and raze the building. The request to demolish 111 1st Street was the first challenge to the historic designation of the Powerhouse Arts District, and the city likely realized that its acquiescence to New Gold Equities would result in similar lawsuits by other property owners following the same arguments and rationale.

The Jersey City government under Mayor Jerramiah Healy, himself a lawyer and a former municipal judge, may not have wanted to establish a legal or a policy precedent. The issue of 111 1st Street landed in Healy's lap when he was elected mayor in late 2004, an inheritance of previous mayoral administrations; nonetheless, much of the public and definitely the local arts community focused its ire upon Healy, because the artists were thrown out of 111 1st Street during the early days of his mayoralty. As a result, Healy did not likely wish to witness the destruction of the building itself and the evisceration of the Powerhouse Arts District in quick succession. If that happened, his administration would appear to be bowing to the whims of New York developers and doing little for the voting citizenry of Jersey City. At the very least, the city needed to put up a fight against New Gold Equities, even if it ultimately lost.

At a second Historic Preservation Commission hearing on June 27, 2005, the city presented its case for denying New Gold Equities a demolition permit for 111 1st Street. The attorney and witnesses for New Gold Equities claimed that the building was in a state of imminent collapse and thereby a danger to the public at the earlier meeting in May. The city contested that various engineering reports differently analyzed 111 1st Street. A municipal construction official stated that "inclusive engineering reports presented to [him] and experts" convinced him to deny a demolition permit.[18] The construction official also cited a report by a local architect which claimed that further investigation into 111 1st Street would be required to determine the actual physical state of the property.

In its rebuttal to the city, New Gold Equities' counsel presented a fresh round of arguments for demolition. When pressed by New Gold Equities' attorney to answer questions on the case of 111 1st Street, members of the Historic Preservation Commission demurred, saying they needed more time to study the conflicting engineering reports.[19] Members of the public unanimously clamored against the destruction of 111 1st Street and questioned the validity of New Gold Equities' testimony and the truthfulness of its witnesses. An artist who formerly practiced her craft at 111 1st Street accused the owner's representatives of "more lies" and contested that "[t]hey're just exaggerating information so that it works to their endgame, which is to demolish."[20]

At the June meeting, the Historic Preservation Commission acted guardedly, measuring every question and statement, likely because New Gold Equities had recently named its chairman in a court case. On June 10, 2005, New Gold Equities argued in State Superior Court that three public servants—the chairman of the commission, a city attorney,

and a city engineer—should be barred from any future hearings on 111 1st Street before the Historic Preservation Commission. The attorney for New Gold Equities presented evidence that the chairman had met with witnesses supportive of the preservation of 111 1st Street outside the formal atmosphere of an official commission meeting and that the two municipal employees had a conflict of interest by both representing the commission and by presenting a case to it. The State Superior Court judge ruled in favor of New Gold Equities. Immediately before the June 2005 meeting of the Historic Preservation Commission, the attorney for New Gold Equities revealed that a Commission member had worked at 111 1st Street as a cabinetmaker and asked that the said member recuse himself from the hearing. The member consented.[21] These moves by New Gold Equities' legal team might help to explain why the commission appeared to be less prosecutorial in the latest public hearing over the fate of 111 1st Street.

Unfortunately, the city legal team offered a tepid rationale for denying the demolition request. The entire body of their argument consisted of the need for more information and additional time in which to review it. An objective observer might interpret the city's testimony as a stalling tactic with little substance and guiding authority. Likewise, the city might have been exerting the absolute minimum of energy, funds, and manpower on 111 1st Street in order to save face. A new administration had taken office, and it might not have wanted to dwell on the problems created under its predecessors' watch. The will to combat New Gold Equities might not have extended beyond the Historic Preservation Commission, a volunteer body that the city government could override through other bureaucratic channels and that the landowner could challenge in court. Who knows in the end? One fact was certain: The June meeting ended as it began, with no clear decision on the future of 111 1st Street.

Although the future of 111 1st Street fell off the radar of the local media and the public during the next year, from the summer of 2005 to the summer of 2006, Lloyd Goldman and the Jersey City government simultaneously fought and quietly negotiated over the future of the tobacco warehouse. After the Historic Preservation Commission tabled the demolition permit for the building, Goldman filed a $100 million lawsuit against the municipal government, claiming that the city had infringed upon his rights as a property owner. The Jersey City government parried that attack by levying $75 million in fines for fire code violations, alledging that the owner had willfully allowed the property to become a public

hazard. As Goldman's and the city government's lawsuits wound through the New Jersey court system, a State Superior Court judge ordered both parties, the owner and the city, into mediation and nullified the historic designation of 111 1st Street. The judge's ruling on the building's historic designation significantly weakened—if not eliminated—the city's leverage in any dialogue with Goldman over plans for 111 1st Street.[22]

On June 23, 2006, Jersey City Council President Mariano Vega unexpectedly announced that a settlement between New Gold Equities and the city would be placed on the agenda of the city council meeting scheduled for the following week. Vega stated that the settlement would allow for three 40-story residential towers to be built in the Powerhouse Arts District. Two towers would be built at 110 1st Street, and one tower would be built at 111 1st Street, two parcels owned by Lloyd Goldman and his company New Gold Equities. Both Goldman and the city would drop their respective lawsuits. In exchange for the zoning changes, Goldman would donate $1 million to local arts institutions, set aside 117 units in the proposed residential towers for affordable housing, and build a gallery and a performance space in the complex. Such a grand project would require the complete demolition of the historic—in the eyes of activists and many residents, but now not according to the law—P. Lorillard Tobacco Company warehouse at 111 1st Street.

The building that first housed an engine of the past industrial economy and a company founded by a notable family in regional history and later held a peculiar community that helped usher in a new era for Jersey City—now a place of creative professionals, trendy bars, and an ambitious cultural scene—would be obliterated from the urban landscape. The P. Lorillard Tobacco Company warehouse at 111 1st Street would be no more. The elected representatives were fine with that outcome: They approved the settlement and the zoning changes to the Powerhouse Arts District ordinance on June 28, 2006.[23]

City Council President Vega explained the city's desire to move away from this issue:

> This has to come to [an] end sometime soon. There's too [much] money and too much time being spent on this issue. . . . At the end of the day, I know there will be displeasure especially from the residents who live in the Powerhouse Arts District, but I have to look out for all the residents[,] not just a narrow band of people.[24]

Vega's comments are revealing on a number of levels. The city government defined the fight over 111 1st Street purely along economic lines.

The struggle for the arts community and now the preservation of the building stood as a chance for Jersey City to define a vision for the Powerhouse Arts District and for the city. Yes, the real estate was valuable—remarkably so—in fact, the artists, the preservations, and the neighborhood residents were fighting to save the industrial aesthetic of the district and to form an alternative idea for a vibrant, livable neighborhood in a post-industrial city. The residents of the Powerhouse Arts District, those most directly affected by any action on 111 1st Street, were barely considered in the settlement between the city and Goldman. These residents—voters, taxpayers, and citizens—were described as "a narrow band of people," a group disconnected from the reality of governing the city and the lives of its everyday residents.

This phase in the fight for 111 1st Street, now a struggle to define not only the aesthetics of the Powerhouse neighborhood but also its physical contours and space, unveiled the much larger and nuanced political, social, and economic vectors at play in Jersey City. The elected officials viewed the residents of the Powerhouse Arts District and their supporters, most likely transplants from New York City or elsewhere and not natives of Jersey City, as somehow illegitimate political actors or as interlopers in city affairs. These new citizens had no right to participate in the debate. They had no right to the city. The city officials did not view themselves as beholden to or representing these more recent arrivals. These same politicians resorted to this "old-timer" versus "new-comer" dynamic to secure their political base and influence, arguing that the new, engaged, and often more affluent residents should not influence the political trajectory of the city. This strategy has been seen in cities across the country, not simply Jersey City. Adjacent to part of Jersey City, Hoboken only recently settled this political and demographic shift. Ironically, these "old-timer" leaders typically agreed to the more questionable bargains with developers and other interests, raising the question as to how effectively they safeguarded the long-term interests of their ethnic, racial, and socioeconomic bases.

This side discussion also raises another question: What makes an authentic resident? When does an individual become a *de facto* citizen of a locality? Once people change their mailing addresses, file income taxes, or register to vote, they belong to a locality in a legal sense; however, that does not mean they belong to a larger community or to the local political culture. In the case of Jersey City, does one need to have been born there in order to be a true resident? Does one need to possess a certain ethnic, national, or racial pedigree? When does one cease to be a "newcomer"? When does one simply belong?

The settlement did not go over well with this "narrow band of people." Charles Kessler, an activist and an instrumental figure in the Powerhouse Arts District, was disgusted by the city's unwillingness to stand by its very own ordinances: "The city should be defending its zoning. The thing that bothers me is that the Powerhouse Arts District will be thrown out the window. . . ."[25]

One couple who had recently moved into an apartment in the neighborhood, specifically for its historic texture of warehouses and cobblestone streets, felt hoodwinked and were considering leaving the area. The proposed high-rises would block their view of the Powerhouse and strip the district of its character and its fundamental reason for existence.[26] In an interview, the wife of the couple presciently suggested that the newly minted agreement between the city and Goldman would "cause a domino effect with all the plans being overturned."[27]

In April 2006, the Powerhouse Arts District Neighborhood Association (PADNA) formed in part to lobby for preserving the historic industrial fabric of the area. A neighborhood activist believed that galvanized residents joined the newly minted neighborhood organization "to hold the city accountable to [its] plan" and cited the city's willingness "to grant extreme variances from the [Powerhouse Arts District] plan" as a major point of contention between PADNA and the city.[28]

In an open letter to the public, Daniel Levin, a local community organizer, expressed a much more caustic interpretation of the settlement and the associated zoning changes: "It's now official. If you are a developer in Jersey City and can afford to tie up the City with litigation, you will eventually get what you want, the public be damned."[29]

By approving the settlement with Lloyd Goldman and making the desired zoning changes, the city council effectively gutted "what was to become the cultural heart of Jersey City" and cast doubt upon its own credibility regarding development issues.[30] This move by the city council revealed that the Jersey City government had no strong planning vision, no understanding of architectural history, and no will to fight the demands of deep-pocketed developers and investors.[31] The elected officials of Jersey City just did not "get it."

A near-perfect parallel example of the preservation envisioned by the masterminds of the original Powerhouse Arts District legislation could be found in the DUMBO (Down Under the Manhattan Bridge Overpass) area of Brooklyn, where industrial structures were repurposed for studios, shops, eateries, and apartments. Although now extremely expensive as a commercial area and a residential neighborhood, DUMBO maintained its

traditional industrial architecture. New York City and developers—specifically David Walentas and his Two Trees Management Company—saw the wisdom in preserving the built environment and its structures and correctly predicted the long-term massive economic returns in that strategy. In 2007, the New York City Landmarks Preservation Commission designated DUMBO as a historic district, spurring further redevelopment and adaptive reuse of the neighborhood's buildings. Today, DUMBO contains some of the more desirable and expensive real estate in Brooklyn and is an emerging technology and economic hub. Twenty-five percent of New York's technology firms and approximately 10,000 employees are based in the neighborhood.[32] DUMBO provided Jersey City with a successful model and development blueprint to emulate and even improve upon. Its leadership needed only to look outward.

A nagging question throughout the fights for the arts community at 111 1st Street and later for the physical presentation of the building itself was why did the elected officials not "get it." Why did they not understand that the dynamic had fundamentally shifted in Jersey City? The Jersey City of the first decade of the twenty-first century was not the Jersey City of the 1960s, 1970s, and 1980s, the nadir not only of Jersey City but of urban centers across the United States. By the early 2000s, the Jersey City waterfront was booming with some of the more valuable real estate in the Garden State and some of the more expensive properties along the east coast. An abandoned mess of rotted wharves and rusted knots of railroad tracks had been replaced by the gleaming office towers of Goldman Sachs, Chase Manhattan, and other corporations and businesses in the financial and banking industries. Luxury high-rise apartments attracted renters and buyers from Manhattan, other parts of New Jersey, and even as far away as Asia. Tenements and coldwater flats in downtown Jersey City, once the cramped homes of immigrants from Puerto Rico and first-generation and second-generation Irish Americans and Polish Americans, now commanded sale prices in the high six figures. The restored downtown brownstone blocks called to mind the picturesque setting of *Sesame Street*. The parks of downtown Jersey City were restored to their original Victorian splendor with paths, benches, gazebos, and flower beds. More and more people priced out of New York looked to Jersey City to buy a home and to start a family. By any objective measure, Jersey City was becoming a very decent place to live. Yet the governing class appeared to give away the store by kowtowing to developers' whims and demanding few extractions from them in order to improve the infrastructure or quality of life. The politicians saw any project as a way to

increase the tax rolls and to stage a ribbon cutting, barely considering the particulars of a development or its impact on the long-term health of a given neighborhood or the city. Again, why?

The general nature of democratic politics partially answers the question. A tension between short-term and long-term calculations exists within the system as a result of the frequency of elections. Politicians are always cognizant of the next election and gearing their actions and votes to win that one. Politicians often avoid delving into the deep complexities of a given issue and thanklessly toiling at it year after year: They want to form a plan of action, vote on it, and then move on to the next problem. Any thorny policy issue will likely outlive the career of any single politician, so the default solution is not to deal with it and kick the proverbial can down the road. This tension can be seen at every level of government. However, the answer to the inability or the unwillingness of Jersey City politicians to tackle a sophisticated development plan for the Powerhouse Arts District or to gain concessions from real estate professionals lies in the specific characteristics of the local political system and political class.

Historically, the political leadership of Jersey City has been parochial and insular. Until recently, many of the elected officials were older, first- or second-generation Americans or migrants from the Caribbean or the American South. As a group, they were not overly educated or cosmopolitan. They did not look to other cities for policy ideas, examples, and successes. They even failed to observe the nearby remaking of parts of Manhattan and Brooklyn and to transfer those models to Jersey City. Longtime civic activist and good-government advocate Daniel Levin described the political class of Jersey City as such:

> Our city government doesn't look east. . . . [U]p until recently, everybody involved with the government [was] pretty much home-grown or had come here for the jobs. . . . They all went to, whether they may have gone to college, but they all went to local schools. Going to Rutgers [University] is a big reach. So they're all locally looking inwards at Jersey City, not outward, which is surprising [given] what's happening.[33]

One local artist highlighted the rather limited imagination of the political leadership and (by extension many voters) during his time in Jersey City: "People bragged about never having left Jersey City. One candidate lived in Florida for six months. This disqualified him [in the eyes of the voters] for office."[34]

An acknowledgment of this mentality begins to unpack the stance of the Jersey City political class vis-à-vis Lloyd Goldman and 111 1st Street and other developers. It helps to explain the alarming inability to fully capitalize upon the natural benefits of the city, namely its mass transportation infrastructure, varied housing stock, underutilized industrial buildings, and—finally and most important—its proximity to Manhattan.

Meanwhile, an example of an emerging art, music, bar, and restaurant district or scene existed in Williamsburg, Brooklyn. Only a combined PATH train and a subway ride (with an easy transfer at 14th Street in Manhattan) was required to find a model worth studying. At the same time, the concept of the creative class (e.g., artists, educators, and graphic designers) and the need for municipalities to draw upon and retain the members of the creative class were widely circulated among academics, intellectuals, the media, and policymakers.[35] The creative class strategy presented localities with a relatively cheap investment and potentially great returns of an expanding tax base, a population needing few social services, and a sunny public image. Mayors and local boosters of cities both great (Philadelphia, Pennsylvania) and small (Albany, New York) seemed intrigued by the creative class theory and saw little to lose in following its formula. Strangely enough, the leadership of Jersey City appeared to be unaware or ignorant of this trendy urban policy program and, even worse, dead-set on doing exactly the opposite—that is, discouraging an inward movement of artists and creative professionals or, at the very least, doing little to welcome them.

However, in an uncharacteristic display of foresight and sound urban planning, the city inserted a condition into its deal with Goldman: A world-class architect needed to design the future building on the site of 111 1st Street. When speaking about 111 1st Street, Council President Vega remarked that the city "wanted something that will help define the [Powerhouse Arts District] zone and certainly allow [the building] to be distinguished from any other high rise."[36] The city attorney, who oversaw the legal agreement for the city, presented New Gold Equities with a list of seven renowned architects as candidates for the project.[37] (One may only speculate on how the list was drawn up.)

In September 2006, the firm of Rem Koolhaas, a Dutch architect, won a commission for the project. Koolhaas himself unveiled the grandiose and potentially transformative plans for 111 1st Street at the (now-defunct) Jersey City Museum in February 2007. At the press conference detailing the new 111 1st Street, Koolhaas boldly and garrulously declared that "the time has come to do a building that is less than typical."[38]

The design called for a fifty-two-story skyscraper constructed of a cube and two rectangular blocks stacked atop one another in a perpendicular pattern with terraces and open spaces at each structural joint. The $400 million Koolhaas plan for 111 1st Street would create a vertical city or an almost independently functional neighborhood—a mini-city—with twenty-five floors of apartments; a seven-story hotel; forty loft apartments; one hundred and twenty artists' live/work spaces; six floors of parking; street-level stores; an art gallery; and a theater. The base block would hold the retail, gallery, theater, and artists' spaces; the middle block would hold the lofts and the hotel; and the upper block would hold the apartment complex. A meditation pool and a sculpture garden would greet residents and visitors at the street level.[39] Koolhaas concluded his presentation with an odd attempt at artistic mysticism by noting that "this building was born under a lucky star."[40]

City officials effusively approved of the Koolhaas design. Jersey City planning director Robert Cotter raved, "This is the most cutting-edge piece of architecture I have seen in my career. I would hope that this type of project would lead other developers to come into the city with unique plans."[41]

Mayor Jerramiah Healy could barely contain his excitement for the project: "This structure is going to be different from anything that we have seen here [in Jersey City] . . . or in the state of New Jersey."[42]

Healy saw the Koolhaas design as presaging a new Jersey City in both form and image. He noted, "[The proposed development] is another step in the ongoing transformation and revitalization of Jersey City. It's time New Jersey, New York, and the world see Jersey City as an international metropolis."[43]

Old enough to remember the waning years of Jersey City's industrial heyday, the mayor then lapsed into a momentary reminiscence: "This area [the Powerhouse Arts District] used to be full of two-family frame houses, factory buildings and hole-in-the-wall bars."[44]

Was Healy, a politician with a blue-collar pedigree, the son of Irish immigrants, nostalgic for his city of yore with its smokestacks, rowdy taverns, and strong Catholic parishes? As Jersey City sped toward the emerging model of a twenty-first-century American city tooled for professional and creative industries and attentive to global trends, politicians from the old-time stock grew less secure, less relevant. A backslapping, outgoing politician like Healy could have thrived in the Jersey City of coldwater flats and factories. Did Healy miss those places and those times, or did he marvel at the progress and changes undergone by Jersey City? A city of

Koolhaas buildings would have little need of or love for him. An astute retail politician, Healy may have even foreseen his future. Regardless, he continued with his gleeful pronouncements of the new 111 1st Street and his predictions for Jersey City: "We're not just seeing a renaissance. We're building a new city."[45]

The enthusiasm for the Koolhaas plan even infected past supporters of the 111 1st Street artists and vocal critics of the building's owner and city officials. John Gomez, the founder of the Jersey City Landmarks Conservancy, an organization that advocated for the Powerhouse Arts District, echoed the statements of the municipal boosters: "I think it's an exciting, brilliant design. Rem Koolhaas is one of the world's great architects. It's different, but I think Jersey City needs something different like this. It's a bold statement."[46]

Jersey City leaders were clearly hoping for a Bilbao effect upon the Powerhouse Arts District and the entire city. The "Bilbao effect" refers to the purported ability of a single and distinctive work of architecture to elevate a city to a must-see place in the opinions of travel writers, wealthy globetrotters, and fine-art lovers. The term itself originated from the Frank Gehry–designed Guggenheim Museum in Bilbao, Spain. The Guggenheim Museum opened in 1997 and transformed the Basque city from an aging center of shipping and industry into a busy tourist destination. Millions of tourists and tax revenues flowed into Bilbao; transportation and infrastructure improvements followed in the years after the ribbon cutting of the Guggenheim Museum. Other cities, such as Denver, Colorado, and Bellevue, Washington, attempted to copy the Bilbao formula: They commissioned groundbreaking museums or cultural centers by famous architects, thinking that the new buildings would spur rapid economic success. Unfortunately, these and other cities did not experience economic advancement or physical investment at any level near that of Bilbao.[47]

Nonetheless, the proponents of the 111 1st Street plan hoped that the building would place Jersey City on the architectural map and would position it as a global city. Jersey City—like the entire Garden State—had long suffered and still suffers from an insecurity complex and ridicule from the national media. The towering Koolhaas building would allow the city to stand on its own and proclaim itself to be an independent, burgeoning metropolis. All the boasting surrounding the Koolhaas design spoke of optimism and an overwhelming sense of progress. Jersey City was moving forward, thanks to a big plan—a bold plan.

The insatiable, propulsive force of creative destruction required that

the old 111 1st Street make way for the new, sleek, and modern one. The warehouse represented the old, dirty, industrial Jersey City of the past; the Koolhaas plan stood for the efficient and service-oriented Jersey City of the future. Soon after the unveiling of Koolhaas's vision, the P. Lorillard Tobacco Company warehouse—the past center of an American industrial giant and later the nucleus of a community of painters, poets, and craftsmen—was demolished. Artist and former resident of 111 1st Street William Rodwell photographed the entire process, as if meticulously documenting a crime scene.[48] The groundbreaking and construction of the Koolhaas building were slated to begin in 2008.

The fate of 111 1st Street and the city's perceived weakness in confronting Lloyd Goldman and New Gold Equities had the predicted impact of emboldening other developers and further weakening the restrictions and guidelines for the Powerhouse Arts District A longtime figure in the fight for 111 1st Street offered a pithy characterization of the situation, stating that 111 1st Street "was the first domino."[49]

In October 2007, only several months after the demolition of 111 1st Street, Toll Brothers, a Horsham, Pennsylvania–based real estate developer, petitioned the city government for variances in the Powerhouse Arts District. Specifically, the company wished to build three thirty-plus-story residential towers in the footprint of the former Manischewitz factory on Bay Street. Scores of residents spoke against the Toll Brothers plan at a city council meeting in April 2008, and the Powerhouse Neighborhood Association threatened to file a lawsuit to halt the project. The city council approved the zoning changes requested by Toll Brothers.

Steven Fulop, the councilman representing the Powerhouse Arts District, voted against the amendments and stated that they would simply lead to more high-rises and the ultimate evisceration of the district.[50] Fulop blasted the actions of his colleagues and the mayoral administration: "If the city isn't going to respect its own zoning, why should [developers]?"[51]

With the demolition of 111 1st Street and next with the variances granted to Toll Brothers, the Jersey City government shredded its own redevelopment plan, viewing it as an inconvenience to developers and as an impediment to increasing tax revenues. The dense eleven blocks of the Powerhouse Arts District contained a preserve of the city's industrial past, almost like a ship in a bottle. However, this architectural public treasure held no attraction for the majority of elected officials. Instead, the government opted for more bland high-rise development, something already prevalent along the waterfront and needing few, if any financial incentives.[52]

Charles Kessler, an individual deeply involved in the original Power-house preservation and redevelopment movement, expressed his disappointment with the body blow to a comprehensive and an enforceable plan:

> We have a plenty of high rises, we have an entire waterfront that's suitable for high rises. I expect a developer to try to make as much profit as he can. But here we had an incredible resource that speaks to Jersey City's history like nothing else—railway history, industrial history—and rather than fight to save it, the city just folded.[53]

With the figurative death of the plan, Jersey City sadly would lose an important physical reminder of its own history.

City officials counter-argued that the original Powerhouse Arts District plan was impractical from its conception and that it had been drafted in 2004 as a knee-jerk response to the public battle over 111 1st Street. According to the defenders of the changes to the Powerhouse Arts District ordinance, the original policy could not generate a critical mass of residents to support retail, spur renovation of the iconic Powerhouse, and generate further investment for the district. The executive director for the Jersey City Redevelopment Agency supported such reasoning: "The idea of keeping density extremely low on a PATH stop is a luxury the city can't afford. It's not consistent with smart growth, and it's not best for the whole city."[54]

The statements coming from municipal agencies and from City Hall merit closer analysis. Admittedly, the original Powerhouse Arts District plan was drawn up during the interregnum following the unexpected death of Mayor Glenn Cunningham in 2004. The then acting mayor, L. Harvey Smith, spearheaded the Powerhouse Arts District legislation and shepherded it through the city council in late October 2004. The special mayoral election occurred a week later in November. Politics and the desire for an electoral victory (Smith lost the election; Healy won it) likely played no small part in the drafting of the plan and the rush to pass it, thereby providing an element of credibility to the criticisms of the original ordinance by the Healy administration.

The Healy administration embraced the talking point that the Power-house Arts District presented a distinct choice between historic preservation and smart growth. They argued that strictly maintaining the guidelines spelled out by the Powerhouse Arts District redevelopment plan jeopardized the infill of vacant parcels and the development of underutilized or empty structures; that is, investors and builders would avoid the

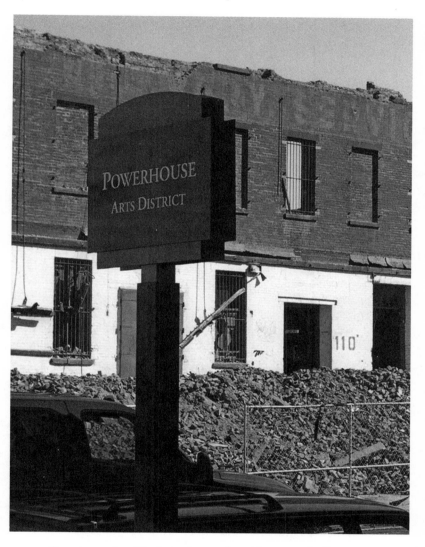

Powerhouse Arts District, unknown date. (Courtesy of Bill Rybak)

Powerhouse District and possibly Jersey City altogether and place their funds and resources in more malleable municipalities. At best, this was a simple-minded view of the attraction of historic districts for investment and as a bulwark of high property values. Historic districts always contain some of the more, if not the most, desired and pricey property in a city. At worst, it was a dishonest excuse, barely hiding an instinct to placate real estate interests.

The Powerhouse Arts District sat within easy walking distance of both the Grove Street PATH station and the Hudson-Bergen Light Rail, thereby minimizing automobile dependency and connecting workers and residents to the robust mass transportation network of the metropolitan region. High-rise office and residential towers largely hemmed in the district, providing any potential business with an enviably large pool of customers and clients. If the district had developed as first planned, hundreds of apartments, mostly rented or owned by affluent individuals and families, would have been built in refurbished industrial spaces and in new buildings following the heights and densities of the historic structures. Such a population would have no difficulty drawing retail and restaurant entrepreneurs. The Powerhouse Arts District plan was an attempt at both smart growth and preservation.

Finally, any claim of devotion to smart growth by a city official during the Healy administration merits healthy skepticism. As demonstrated by the Powerhouse Arts District debate following the demise of 111 1st Street, a pattern was emerging. The Healy administration would chase after any investment regardless of its potential impact on the larger fabric of the city. Meanwhile, the administration possessed little understanding of the increasingly nuanced demands and aspirations of the city's more civically active residents. For example, parking figured prominently into any large real estate development plan. With a tight, walkable grid of streets and a public transportation system tying together the waterfront and offering round-the-clock access to Manhattan and the New York City subway system, why cater to the automobile and the suburban way of life? During the early years of the Healy administration, construction continued at a feverish pace along the waterfront and within the downtown neighborhoods, yet no new parks, schools, or libraries were built. Sewage and water lines were never upgraded, resulting in flooding after every large rainstorm. Smart growth involves amenities, infrastructure, and urbanization (or reurbanization) of the physical landscape. At best, Jersey City embraced the smart growth philosophy with a lukewarm passion.

During the debates over the preservation of 111 1st Street and the variances granted to Toll Brothers, supporters of the Powerhouse Arts District and residents of the neighborhood repeatedly worried that the city was establishing a habit of caving to the demands of real estate interests and betraying the vision for the area as both a living monument to the city's industrial past and as an incubator for the arts. The Powerhouse Arts District Neighborhood Association (PADNA) continued to advocate for the original zoning as a model for sound urban planning. In the view of the neighborhood organization—comprising residents and many property owners invested in the long-term health and quality of life of the neighborhood—the Powerhouse Arts District plan was working and would nurture a unique community, if given time.

Still, a number of new residential projects did honor the historic standards and the allotments for artists' studios and housing. The renovation of the former J. Leo Cooke Warehouse at 140 Bay Street was the first project completed in the neighborhood. Today the building houses a successful array of creative businesses, including an architectural firm and a popular café (a framing shop closed in July 2016 after twenty years of business in Jersey City).[55] The former Atlantic & Pacific (A&P) Warehouse at 150 Bay Street was rehabbed, and a lottery was held for artists for twenty-four affordable units (10 percent of the total number of units) in the new apartment building. An artist benefiting from the affordable housing testified to its value as a social policy instrument: "It's changed everybody's life. It's allowed us to focus on art."[56] Currently, several businesses operate on the ground floor of the A&P warehouse, including a craft brewery, a bar and nightclub, and a gelato store with space for cooking demonstrations and classes.

The right developers and the right investors might have jumped at the opportunity to create a unique mixture of housing and retail in a quirky setting and nurtured projects similar to the J. Leo Cooke Warehouse and the Atlantic & Pacific Warehouse. Perhaps, such individuals and business entities needed to be courted by city agencies and elected officials. Similarly targeted development has met with resounding success in DUMBO in Brooklyn, New York; Old City in Philadelphia, Pennsylvania; in downtown Durham, North Carolina (in old tobacco warehouses, in fact); and other urban areas throughout the United States. Such an admirable goal would require patience, vision, and imagination, qualities sometimes lacking in local government officials.

Regardless of the motivations of City Hall or of developers, construction work in the Powerhouse Arts District largely ground to a halt in

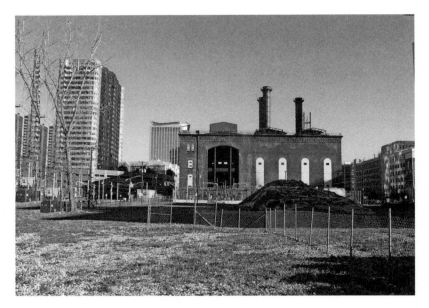

The property at 111 1st Street, Jersey City, New Jersey, November 2011. The smokestacks of the Hudson & Manhattan Railroad Powerhouse were removed in 2013. (Courtesy of Jessica Murphy)

2008. By the end of the year, the American housing market imploded, credit and liquid cash dried up, and the global economy went into free-fall. Rem Koolhaas's grand plans for 111 1st Street disappeared with the real estate bubble, leaving a gaping hole where the artistic utopia once thrived and the historic warehouse once stood. The developers' machinations met the seemingly unmovable object of a worldwide economic recession. The defeated, embittered artists of 111 1st Street and the frustrated activists who vainly fought to save the building and the Powerhouse Arts District must have grimly enjoyed that new reality. They were no longer the only losers.

The battles for 111 1st Street and later the Powerhouse Arts District occurred during the frenzied housing bubble of the 2000s, a phenomenon intensified in the lucrative metropolitan New York real estate market. Too much money could be made by developers and investors through challenging or circumventing the Powerhouse Arts District rules, and the city government appeared to be a willing accomplice in such efforts. Government officials claimed that the regulations threatened the profit margins of

potential investors. The Jersey City planning director explained: "Every time someone looked at a project there, even if they were a friend of the arts, they couldn't bank it."[57]

The fact that banks underwrote and developers broke ground on projects in neighborhoods and districts with equally stringent guidelines in other American cities and in the Powerhouse Arts District itself calls these arguments into question. In all likelihood, the politicians simply wished to cut the ribbons on new projects, appease the demands of the powerful real estate lobby and local construction unions, and increase tax revenues with minimal efforts. Professional staff simply followed the policy established by elected officials (for that is the defined responsibility of a permanent bureaucracy).

Articles in the local press, comments on local message boards, and residents at public meetings often bemoaned the lack of support for artists in the city's proclaimed arts district. In fact, several interviewed sources noted this glaring discrepancy between the stated policy of the city government, the promotion of realtors, and the reality of the neighborhood itself. Speaking as the then-president of Pro Arts, Kay Kenny bitterly remarked: "So called Powerhouse Arts District that we worked so hard to create is just another luxury high-rise condo development whose spaces are not user-friendly to artists."[58] Kelly Darr offered a more savage remark: "[The] only artists [in the neighborhood] were exterminated. . . ."[59]

In contrast to the gloomy, defeatist opinions of the former residents of 111 1st Street, government officials still argued that the arts were integral to the city's cultural, social, and economic future and they described the city as a partner and an advocate for the arts.[60] As late as February 2011, the city voted to landmark the remaining warehouses in the area surrounding (the now-former) 111 1st Street, reflecting a desire to preserve the industrial architectural heritage and carve out a space for artists and creative industries—at least, on paper.[61]

As the local, national, and global economy sputtered along, the Jersey City government faced fiscal difficulties for the foreseeable future (a reality shared by many American municipalities). Meanwhile, Lloyd Goldman, the arch-nemesis of the stalwarts of 111 1st Street, returned to the public eye, and the Healy administration reignited the ire of proponents of the Powerhouse Arts District in 2012.

A glance at the relationship between Lloyd Goldman and the city government seemed to verify the worst suspicions of activists and concerned citizens. One month prior to the historic designation of the Powerhouse Arts District in 2004, Goldman and his company New Gold Equities tore

down 110 1st Street, another property owned by him. Later, the city government under Mayor Healy granted New Gold Equities a variance on the property to build a 35-story high-rise in exchange for setting aside 25 units for affordable housing out of a total of 452 apartments in 2006.

Although the recession halted the planned construction on 110 1st Street, New Gold Equities aimed to break ground on the site in 2013; however, the company approached the city and claimed that the affordable housing requirement prevented it from arranging the financing for the project. The mayoral administration agreed to waive the affordable housing requirement and presented the change to the city council in May 2012.[62] The pattern of the government succumbing to the demands of real estate magnates and ignoring the complaints of residents and community organizations appeared to be firmly set. As Councilman Fulop summarized it: "The developers know that the city doesn't have a backbone. They know that once you change this, you change the next one, and the next one and the next one."[63]

A representative from PADNA saw affordable housing as essential for retaining artists in the area and for maintaining its core identity: "The PAD is supposed to be an artist community and without affordable housing it's difficult for artists to live in the community, and then we are nothing but an artist neighborhood by name and name only."[64]

The city attorney presented a new agreement between the city and New Gold Equities that stripped away the affordable housing mandate at 110 1st Street. A majority of the city council balked at the contract. A reform faction led by Fulop now controlled the chamber and positioned itself as a counterweight to the mayor's office. Once the vote counting began, the city attorney realized that the agreement would be defeated and quickly withdrew the measure. Throughout the council session, the corporation counsel failed to acknowledge the irony of his arguing for changing a settlement that he had personally negotiated.

Discussions among New Gold Equities, the mayor's office, and the city council members continued throughout the summer of 2012. Eventually, New Gold Equities struck a deal in which it would set aside ten units for affordable housing at 110 1st Street—roughly 2.2 percent of the total units, far less than the 10 percent mandated in the Powerhouse Arts District plan—and contribute $1.1 million to the city's affordable housing trust. In July 2012, the city council approved this new agreement with New Gold Equities. Councilman Fulop still voted against the bargain, calling it "flawed" and a "bad deal."[65]

New Gold Equities broke ground on 110 1st Street in March 2013,

two months before city council and mayoral elections in Jersey City. Because construction had already begun on the site, the ceremony was held across the street at 111 1st Street.[66] Mayor Healy touted the city as "business friendly" and reminded onlookers that the survival of the city was "dependent on private development."[67] During the press conference, no one mentioned the deceased artist community of 111 1st Street, the empty grave upon which they were all standing and celebrating the newest addition to the skyline. The artists and their dreams for their home, for their neighborhood, and for Jersey City no longer existed even as a memory.

During this latest squabble over the future of the Powerhouse Arts District in 2012, a board member for the neighborhood association predicted that "someone will build there [110 1st Street and the Powerhouse Arts District] without being given the key to the city."[68] In May 2013, Councilman Fulop defeated Jerramiah Healy for mayor, and Fulop's council slate carried a majority of the city council seats. A prominent component of Fulop's campaign platform was a commitment to smart development throughout Jersey City. Fulop promised to broker deals with the developers that would better benefit the city and its residents. Additionally, his administration would uphold and enforce current ordinances and agreements.

Without a doubt, such a policy shift might ensure that a fragment of the Powerhouse Arts District survives in the image and form as envisioned by its original advocates and, even more important, that artists might still eke out a living, build a home, and make Jersey City a much more interesting and memorable place. Until that moment arrives—possibly a fantasy spun by dreamers and idealists—what lessons can be drawn from the tangled tale of 111 1st Street? What does its story tell us about the past and the possible future of Jersey City? These are the questions facing artists, activists, and citizens in Jersey City and in many cities throughout America. If this story can spur a community to save its uniquely local structures, features, and even people from the forces of development and gentrification and make their neighborhoods places worth caring about and living in, that would be a fine legacy for 111 1st Street.

7
What Might Be Learned?

The destruction of 111 1st Street was a terrible loss for local artists, preservationists, and neighborhood activists, and it impoverished the urban fabric and the architectural landscape of Jersey City. The P. Lorillard Tobacco Company warehouse at 111 1st Street represented both individual and collective dreams of what the city could have been—a hive of creativity, a sanctuary for both veteran and aspiring artists, an anchor for a bustling neighborhood of renovated warehouses, and a cornerstone for a new Jersey City. In the end, these visions came to nothing. The building at 111 1st Street was emptied and ripped apart.

The story of the P. Lorillard Tobacco Company warehouse at 111 1st Street exemplifies a failure of government policy and imagination and provides a cautionary tale for artists and other marginal communities in areas experiencing rapid investment and gentrification. The story reveals the values (or lack thereof) of the Jersey City political and leadership classes. An optimistic observer of city life could say that the fate of 111 1st Street might present residents of Jersey City and those of other neighborhoods and cities with a rallying cry. A pessimist critic might remark that the tale is all too familiar and that nothing might happen except more of the same.

The story of 111 1st Street figures into the contemporary history of Jersey City and serves as a window into the changes experienced by the city over the past thirty years. Political maneuvers, economic restructuring, and demographic shifts can all be seen in 111 1st Street. From a

purely practical perspective, what might artists and their supporters take away from the story of 111 1st Street? How can they learn from the missteps and mistakes in dealing with the building's owner and the Jersey City government? How might artists and their supporters secure a place for the arts in their communities? How might they prevent artists from being pushed out of neighborhoods as they economically improve? From an idealistic perspective, what was lost with the razing of 111 1st Street? Why is it different from any other hard-luck story or any other "old" building? Essentially, why does it matter to Jersey City and to people who care about creativity, arts, and cities?

The history of Jersey City reveals that the city is constantly in flux. The landscape is changing. The built environment is changing. The economy is changing. The population and social composition are changing. This fact is not a negative phenomenon: A dynamic city is a desirable and successful city, yet certain artifacts of the past ideally remain, offering residents a physical connection to the past. These remnants might be parks, gardens, monuments, or buildings. Jersey City preservationist and former councilperson John Hallanan III articulated the value of such spaces:

> . . . [Y]ou can walk through a city, or even a geographic region, and see different eras and different styles of architecture in the built form. You're able to appreciate a wide range of designs and the diversity of a place. That's what gives great cities a sense of permanence.[1]

The building at 111 1st Street (and its surrounding neighborhood) provided a booming section of the city undergoing breathtaking redevelopment and construction with such an experience. The warehouse also provided a visual and physical segue between the modern Jersey City waterfront and the historic downtown brownstones. It allowed one to seamlessly glide from the present into the past. Built in 1866, a mere year after the Civil War, 111 1st Street connected residents to an era deep in American history. As a former work space, 111 1st Street linked the city to the early years of the American industrial age, an era when manufacturing dominated the economy and the cultural imagination. For these reasons, 111 1st Street deserved to be saved, preserved, and redeveloped in a sensitive, intelligent manner.

The question of history—its value and its presence in everyday life—is revealed in the story of the P. Lorillard Tobacco Company. The story of 111 1st Street demonstrated how one city can place so much emphasis

on its past and its history, while another cares so little for it. Only a river and a handful of miles separate these two cities. They are New York City and Jersey City.

The Lorillard family and the company that it built in both New York City and Jersey City witnessed and participated in the currents and movements of local, regional, and national history. Pierre Lorillard, the founder of the firm, died during the British occupation of Manhattan during the American Revolution, sparking a family myth that he fell at the hands of blood-crazed Hessians for his unapologetic patriotism for his adopted country. The Lorillard Company ushered in both an early and a later phase of the industrial revolution in America, transforming tobacco manufacturing from an artisanal trade into a highly mechanized and routinized production. The family's sense of conservation allowed a swath of the Bronx—otherwise a very dense, very loud, and very urban landscape—to remain wild. The company provided thousands of immigrants with a livelihood and a degree of security in Jersey City during the Gilded Age, a time in America infamous for an excess of wealth and a rather brutal way of work and life. Later, the disused factory stood as a reminder or a ruin of a different manner of work, a different time, and, in some ways, a different world.

Today, the former Lorillard snuff mill along the Bronx River belongs to the New York Botanical Garden. This national landmark was carefully restored and renovated in the past decade, and the Garden itself exists in no small part thanks to the former Lorillard estate. Tourists, suburbanites, and New Yorkers all enjoy the retreat offered by the Garden and the chance to stroll through the paths of an old-growth forest and picture when the Bronx was a leafy idyll of farms, forests, wildlife, rivers, and streams. Who knows? A visitor might spy a deer or the shadow of a Lenape warrior on the hunt in those old, dark woods.

The reach across history of the Lorillard family extends beyond the Bronx. Next door to the storied Algonquin Hotel on 44th Street in Manhattan, a historic plaque commemorates the stables formerly at the address that housed the horses for the Lorillard family—both George Lyndes Lorillard and Pierre Lorillard IV were thoroughbred racing enthusiasts—and the Astor family. Physical landmarks of the Lorillard Company also exist elsewhere in the United States. Two former Lorillard warehouses in Lancaster, Pennsylvania, the David H. Miller Tobacco Warehouse and the B. F. Good & Company Leaf Tobacco Warehouse, are listed on the National Register of Historic Places.

In stark contrast, Jersey City has no memorial, sign, or plaque for the

P. Lorillard Tobacco Company. When occupied by the artists, 111 1st Street stood as a living monument to the company and Jersey City's industrial past. The artists spoke proudly of living in a building that once operated as a site of production and carried a genuine whiff of history. Activists argued that the role of the Lorillard family in regional history and the role of the Lorillard Company and especially its longtime employee Dr. Leonard Gordon in Jersey City history imbued the physical building with a value beyond the scope of economics and money.

The building carried an aura.[2] Walter Benjamin, the cultural critic and theorist, speculated on how to define an aura: "What, then, is the aura? A strange tissue of space and time: the unique apparition of a distance, however near it may be."[3] The P. Lorillard Tobacco Company warehouse at 111 1st Street certainly consisted of this "strange tissue of space and time." Sites and places originally built for manufacturing goods and materials—factories, lofts, and industrial spaces—are now auratic environments: They offer unique sensations and experiences amid an increasingly homogeneous and easily reproduced landscape, and their origins remain in the past and at a historical distance from their contemporary inhabitants. The building at 111 1st Street belonged to the fabric of Jersey City and its history—indeed, it provided a visual language and vocabulary essential for telling the story of the Powerhouse Arts District and Jersey City. Regardless, 111 1st Street was destroyed. As a matter of public history, 111 1st Street never existed.

Cultural critics have long lambasted New York City for selling its soul for commercialism and wallowing in a deplorable state of constant construction and reinvention. For instance, upon returning to New York City, his birthplace, in 1904, after living in Europe for twenty years, the novelist Henry James was disgusted by the perceived money-chasing and ahistorical character of the city.[4] A (then-) contemporary architectural marvel, the skyscraper, symbolized all that was wrong with Manhattan for James:

> Crowned not only with no history, but with no credible possibility of time for history, and consecrated by no uses save the commercial at any cost, [skyscrapers] are simply the most piercing notes in the concert of the expensively provisional into which your supreme sense of New York resolves itself.[5]

Every generation laments the "lost" New York that it once knew and treasured. For all its faults, New York City values its historic, cultural, and artistic contributions. Buildings with architectural pedigree, beautiful

places of worship, artfully designed parks, and storied restaurants, shops, and taverns can be found in every borough and in almost every neighborhood. The leadership of New York City and a subpopulation of vocal citizens appreciate and recognize the importance of history to their city and view it as a key ingredient to economic development, civic engagement, and local pride. New York City understands that culture and history make a place worth caring about, living in, and fighting for. Many other cities do as well.

Why has Jersey City failed in this regard? Jersey City's history parallels that of its larger sibling on the Hudson River. Both were founded as Anglo-Dutch settlements in the early 1600s and first gained importance as parts of maritime and mercantile empires. Similar waves of immigrants arrived in the nineteenth and twentieth centuries, changing the demographic and political landscapes of both cities. Today, both New York City and Jersey City rely upon finance and banking to an arguably unhealthy degree to drive their respective economies. Yet, art, culture, and history shape and influence the identity of New York City, while they seem to have had little lasting impact on Jersey City. While New York City—and many other cities—embraces its history and profits quite handsomely from it, Jersey City rejects its history and loses an invaluable, irreplaceable resource. What makes the two cities so different?

The reason may be one of social, economic, and cultural position. New York City is the home to the headquarters of major publicly traded and private-owned corporations, media organizations with national and global influence, renowned colleges and universities, leading hospitals and medical research facilities, and some of the premier—if not the best—arts and cultural institutions in the world. Old families, even a handful descended from Dutch patroons, and *nouveau riche* make their homes there. New York City has a powerful population of elites interested in promoting the arts and culture and preserving the city's landmarks. For example, Jacqueline Kennedy Onassis led the successful effort to save Grand Central Terminal from demolition, and former Mayor Michael R. Bloomberg donates heavily to local museums. Unfortunately, Jersey City never developed a rich network of educational or cultural institutions to compete with New York City or even smaller, similar-sized urban centers elsewhere in America. Quirky scions of Dutch landholders do not wander the streets of Jersey City, and captains of industry do not reside in its tony neighborhoods. Local nonprofits do not launch campaigns to combat social ills, and socialites do not vigorously organize fundraisers for the acquisition of great art and cultural artifacts. Simply put, Jersey City lacks a

social or cultural elite. The reason for this may be surprisingly straightforward and apparent: Jersey City is too closely situated to New York City.

For example, this problem manifests itself in the newly built waterfront housing and neighborhoods. Although typically educated and working in well-paying professions, the new citizens living near the waterfront largely view themselves as temporary residents, simply stopping in Jersey City until picking up and moving elsewhere. These individuals rarely engage themselves in civic or political matters and campaigns. More than anything, they simply enjoy living near New York City at a more affordable price.

In some ways, Jersey City was a victim of globalization before the concept was even diagnosed or adequately described. When the P. Lorillard Tobacco Company moved its industrial operations from the Bronx to Jersey City, it did not relocate the administrative and managerial arm of the company. The Lorillard Company remained headquartered in New York City; thus, the majority of its officers likely resided there and invested their volunteer and philanthropic energies in the churches, societies, charities, and institutions in their hometown—not in the sooty, scrappy city across the Hudson River.

This unfortunate pattern continues today. When speaking about the local arts scene, musician and writer Tris McCall observed that figures and personalities organizing arts events during the demise of 111 1st Street in 2005 are still doing so in present-day Jersey City.[6] This deserves admiration and praise; however, it suggests a lack of vitality and new people and ideas. Interestingly enough, 111 1st Street might have combated this civic malaise. Local activist Daniel Levin stated: "Many . . . involved in 111 1st remain a part of our community . . . as teachers in our schools, craftsmen who operate small businesses and as protectors of our history and parks."[7] If 111 1st Street had survived, what might the Jersey City arts scene and larger civic culture look like today?

The history of the arts community at 111 1st Street—its birth, its life, and its death—is the larger subject of this narrative. The 111 1st Street community anchored the Jersey City art scene, acting as a centerpiece for regular cultural events and studio tours. It helped attract artists and like-minded individuals to Jersey City, who collectively contributed to the "rebirth" of Jersey City as a commercial nexus and a desirable home. This community also helped Jersey City shed its image as a dirty, impoverished, and dying city. (Admittedly, sections of the city remain afflicted by deep-rooted poverty and crime.) The building at 111 1st Street could have continued to serve as the nucleus of the local arts and culture scene

and matured into a jewel of the now-affluent downtown area. The building itself was massive, and the knowledge base of its residents was deep and varied. Imagination alone limited the possibilities. This, too, is gone.

The final loss was the most abstract but possibly the greatest. The building at 111 1st Street and its collection of artists and craftsman presented Jersey City with a model for a different future. Instead of chasing after developers and the latest lucrative industry, Jersey City might have positioned itself as a place welcoming artists, musicians, and other creative individuals. It might have fashioned policy that laid the foundation for such groups to not just survive but also thrive. The city government might have determined to preserve the physical artifacts of its industrial past, testifying to their importance in the life and the history of the city and positioning them to play a role in its future. Jersey City would be a much different city from the one it is today. If 111 1st Street had survived, a slice of the city would have lived for the pursuit of culture, art, and the mind. In the end, this is ultimately speculation, so who knows? Recognizing this loss, what lessons might be drawn from the story of 111 1st Street?

Artists are often the earlier initiators (and often victims) of gentrification. They are both celebrated and criticized in the debates surrounding the topic and they are the proverbial canary in the coal mine twice over. Property owners, real estate interests, and aspiring politicians often gain from gentrification, while longtime businesses and residents (presuming that they rent and do not own) and earlier newcomers to a changing neighborhood—artists, educators, and other individuals lacking deep financial resources and access to capital—lose from those changes.

The residents of 111 1st Street were renters, technically commercial tenants, leaving them with scant legal protection or leverage with the building's owner, New Gold Equities. However, New Gold Equities reportedly offered to buy out the artists' leases on several occasions. If this rumor was true, the artists could have accepted the buyout, pooled their resources, and purchased a similar industrial space elsewhere in Jersey City, in Hudson County, or in another region or state. If the artists had realistically approached the situation and not allowed themselves to become enamored with the drama and the media fanfare, they might have been able to save their community by transplanting it. Although they would no longer work and live at 111 1st Street, their relationships and dreams might have survived. They just would have been different. Idealism and intransigence needed to give way to flexibility and realism.

For example, when Lloyd Goldman showed his initial building plans to the tenants' association, he was tacitly offering them a place at the table in serious discussions over the future of the building. He solicited their support and help in lobbying the city to approve his plans. The association could have worked with Goldman and tried to secure more influence and maybe a better deal. Instead, they completely rebuffed his overtures.

The artists of 111 1st Street tried repeatedly with successive mayoral administrations to rally elected officials to their cause. Various politicians at the local, state, and even federal levels pledged support and aid to the artists, but not one leader followed through on any of the promises. When the artists were evicted from 111 1st Street in January 2005, no politician consoled them on the cold winter morning when they exchanged good-byes in front of the locked doors of their former home. The artists of 111 1st Street counted on government officials to keep their word. That was a major error. Local politicians are concerned with bread-and-butter issues: schools, property taxes, law enforcement, and public services. Arts and culture are too niche and nuanced for most politicians, especially ambitious ones. Politicians respond to interest groups commanding resources, organization, or votes. The artists of 111 1st Street lacked all three. The artists might have looked for a common cause or overlapping issues shared by other civic organizations, nonprofits, and interest groups and collectively pressured the politicians to take a stand and act on their behalf. However, the artists did not seem to build social capital with any organizations beyond those focused on the arts. Partially because of these reasons, the political class of Jersey City listened to the developers and the real estate interests—arguably their contemporary default position.

If the artists had successfully spurred the Jersey City government into action, what might have the government done? First and foremost, the Jersey City government could have enforced and championed its own zoning ordinances and development plan for the Powerhouse Arts District. Such a strategy might not have kept the artists in 111 1st Street, but it would have allowed the neighborhood to grow along the aesthetic and social parameters as spelled out in the original Powerhouse Arts District plan. Any new development would have contained dedicated space for artist studios and affordable housing.[8] Artists, if not those of 111 1st Street, would have benefited and called the neighborhood home. The Powerhouse Arts District plan would have preserved the exterior of the historic warehouses and industrial spaces and maintained the architectural integrity and heritage of the neighborhood.

Could the government have kept the artists at 111 1st Street? Probably not. New Gold Equities was determined to evict the artists and redevelop the property at 111 1st Street. At best, the city might have slowed the process down by standing as a mediator between the two parties or by threatening eminent domain or other legal action. The city might have saved the building from demolition, but it calculated that fighting New Gold Equities in court would be too difficult and too expensive.

Taking this into account, what might artists and their supporters do in other neighborhoods and cities? They need to recognize gentrification as a very brutal and a very real threat. If a neighborhood shows signs of economic improvement, gentrification is almost inevitable. Recognizing gentrification and marshaling resources to counter it or define its terms before it gains a critical mass might be the key to survival. This will likely involve collective action, such as detailed planning, coalition building, community engagement, and fundraising. None of these actions is glamorous, sexy, or immediately rewarding. All of this will distract artists from their work and demand a sizable amount of their time and their energy. Even then, artists and their supporters might still fail to control or halt gentrification.

Since the fall of 111 1st Street, the political and social landscape has further shifted. In the past several years, various news outlets have profiled Jersey City as an affordable alternative to Brooklyn. The city government itself launched a regional marketing campaign named "Jersey City: Make It Yours" to lure young, educated individuals and families. Thousands of housing units are being constructed not only in the traditional economic centers of the waterfront and downtown but increasingly in other neighborhoods. Councilman Steven Fulop defeated Mayor Jerramiah Healy in 2013, ushering in a generational and arguably philosophical change in the political leadership and governance of the city. Urban areas throughout New Jersey (and America)—both small and large—are working to shed a decades-old stagnation and attract and retain young people. Jersey City leads the state in this demographic and social transformation and is projected to become the largest city in the Garden State by the end of the current decade.

Do these changes augur well for the arts and other artistic organizations and communities in Jersey City? Although the mayoral administration of Steven Fulop looks beyond the borders of Jersey City for policy and urban programming—in stark contrast to its immediate predecessor—it embraces top-down management and a corporate mentality in

relation to the arts and culture. Recently, the administration attempted to revoke a longstanding lease with the Friends of the Loew's for the historic 1929 Loew's Wonder Theatre. This nonprofit group painstakingly restored this movie theater in the Journal Square neighborhood of the city and the group operated it with little to no resources from the city. The administration announced its plans to contract with AEG, a national concert promoter, to manage the theater, offering it generous tax subsidies and unceremoniously pushing aside the Friends of the Loew's. In May 2015, a county judge ruled in favor of the Friends of the Loew's, ordering the city to honor its lease with the organization.[9] In retaliation, Fulop pressured the county government to revoke a grant earlier awarded to the Friends of the Loew's for repairs and maintenance.

The Jersey City Mural Arts Program might be viewed as another example of such questionable arts policy. Since its inception in 2013, the program has contracted with local, national, and international artists, most notably Shepard Fairey, to create and paint murals on the sides of buildings, overpasses, and structures in neighborhoods throughout the city. However, the program has faced repeated critiques concerning its application process and management and accusations of censorship and political inference. Established mural programs, such as Mural Arts Philadelphia, rely upon professional artists, art historians, and curators to vet applications, and the process begins with an open application. In Jersey City, the mural program is managed by a single Department of Public Works employee and operates with no publicized or clear application process.[10] Several individuals associated or familiar with 111 1st Street see the mural program as little more than a cynical attempt to project the image of an arts-friendly government and to boost the political profile of Mayor Steven Fulop. Kay Kenny, artist and past president of Pro Arts, suggested that the mural program "superficially gives the impression of promoting the arts but is largely created by non-local artists and functions more as a decorative element rather than a grassroots support. . . ."[11] Daniel Levin offered a more scathing analysis: "[The city] uses the arts and skims off it, like with the mayor-directed mural program that has not been fully developed into a real and sustainable mural program."[12]

If 111 1st Street has proven one fact, it is this: The survival of artists' communities is precarious in the best of circumstances. However, hope does exist in Jersey City and elsewhere for such communities. As traditional downtowns and urban centers appear to be waking up after decades of somnolence, new visitors and residents express a concern for quality of

life and an interest in cultural experiences. These people want restaurants, music, theaters, parks, and galleries. Artists can play an integral role in this contemporary urban renaissance. The question now becomes: How do artists retain their position once a town or a city neighborhood becomes desirable? How do they avoid the sad fate of those sculptors, painters, filmmakers, and writers of 111 1st Street, who in the end, lost everything?

Conclusion
Some Years Later

More than a decade has passed since the artists of 111 1st Street lost their studios, their homes, and their close-knit community. Jersey City recovered from the recession better than much of New Jersey and much of the United States, mainly because it rests next door to Manhattan. Construction has restarted along the Jersey City waterfront and within the affluent downtown neighborhoods and shows signs of spreading to other parts of the city. A massive project in the Journal Square section will completely redefine that area. Smaller entrepreneurs bet on less established neighborhoods in the city, opening a café here or a restaurant there. Individuals priced out of Manhattan and Brooklyn and unswayed by the chronic anti–New Jersey prejudice voiced in the media take a chance in these same neighborhoods, seeing the allure of owning a modest home with a tiny backyard and embracing a more humanly scaled urban life. Downtown Councilman Steven Fulop was swept into the mayor's office in 2013, initially evoking a real sense of optimism and bringing needed reform and modernization to the municipal bureaucracy and policy. Unfortunately, enthusiasm for Mayor Fulop has waned among many of his supporters.

The Powerhouse Arts District carries few visible traces of the nearly twenty-year romance between the artists and the now-disappeared P. Lorillard Tobacco Company warehouse. Despite the housing dedicated to artists in new and renovated buildings (admittedly, a paltry percentage of the total number of units) and the sympathetic advocacy of the dominant neighborhood organization, artists and other creative personages are

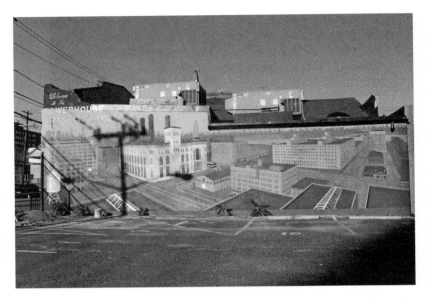

Mural of the Powerhouse Arts District neighborhood, November 2011. The mural
has been whitewashed, effectively erased from public memory. (Courtesy of Jessica
Murphy)

merely a vestigial presence amid the warehouses, scaffolding, and building
cranes. A walk through the Powerhouse Arts District reveals a neighbor-
hood undergoing radical change and an erasure of memory.

Just across Marin Boulevard, the boundary separating the Powerhouse
Arts District from the downtown proper, a mural on the exterior wall of
a squat building once greeted visitors and residents alike with the slogan
"Welcome to the Powerhouse Arts District, Jersey City, NJ." The mural
depicted a quaint, idealized vision of the neighborhood with water towers
standing on the roofs of sepia-colored warehouses, rail cars coursing
through the wide brick-lain streets, and the area's namesake—the Hud-
son & Manhattan Railroad Powerhouse—with its smokestack looming
over the entire landscape. The Hudson River and the Manhattan skyline
layered the scene's horizon. This mural captured the neighborhood in a
moment before the wrecking ball and the plans of developers reshaped
the area into a another collection of apartment towers for moneyed émi-
grés, disenchanted Manhattanites, and couples pausing before abandoning
city life for the suburbs, but the mural also communicated the hopes of

the neighborhood's residents and its remaining artists for a community preserving a physical landscape once fashioned for industry and production. Such spaces might serve as redoubts against corporate consumerism and global images. The mural offered a testament to something different. Sadly enough, this mural has been painted over. Scrubbed from the public memory. Is the neighborhood far behind?

Along adjacent blocks, scaffolding embraces the majority of the remaining warehouses, signaling the return of monetary value to the properties and their imminent redevelopment or, at the minimum, revealing their owners' motivation to halt any further decay and deterioration of their investments. Construction is ongoing in the vacant lots, promising more residents and more changes to the already fragile balance between the old and the new, the eclectic and the stale, in this relatively small slice of the city. The city currently defines the Powerhouse Arts District as eleven blocks. Because the city landmarked the standing warehouses in 2011, developers can no longer tear down the existing nineteenth-century buildings.[1] However, the city has blinked almost every time when confronted with a lawsuit or an indelicate squabble with a property owner in the Powerhouse Arts District, so the preservation of the warehouses appears to be far from an anchored reality. At best, it is a goal; at worst, it is a passing delusion.

Several new luxury buildings utilize the (largely disappeared) industrial heritage of the neighborhood and its recent past as an arts haven to spin a colorful narrative for themselves and as a marketing device directed at wealthy customers. Empty electric car filling stations sit outside the Art House, a forgettable boxy structure well beyond the budgets of artists. Next door, the Oakman, another high-end apartment building, is named after John Oakman, the architect of the Hudson & Manhattan Railroad Powerhouse, the neighborhood's namesake.

A denuded Powerhouse still manages to dominate the area. In 2013, citing decades of neglect and outright abandonment, structural engineers labeled the smokestacks of the iconic Powerhouse to be unsound and a public safety threat. The city removed the tall, rusted metal stacks, effectively deadheading the iconic centerpiece of the entire neighborhood, further weakening the argument for its preservation and the experiment of fashioning a unique urban landscape within these blocks and, possibly even more important, denying residents and visitors a strange visual delight.[2] This is an incalculable loss to the cultural imagination and confidence of the city. Longtime residents view the Powerhouse as a building integral to the collective identity of Jersey City. The Powerhouse stands

as another physical and cultural bridge between Jersey City's past and present. For example, the Jersey City Landmarks Conservancy, an organization advocating for preservation and re-adaptive development, uses the Powerhouse as its logo, illustrating the building's place in the city's identity. Vegetation grows on the roof of the Powerhouse, attesting to its *de facto* abandonment by the city government.

After a nearly ten-year delay, an uninspired building named "The One" now stands at 110 1st Street, the sister site of the fallen 111 1st Street. The project created controversy within the community and Jersey City at large. Lloyd Goldman, the owner of both properties and the central villain in the artists' saga at 111 1st Street, continued to push the boundaries with the city government, almost seeming to relish antagonizing the neighborhood's residents and exposing the relative powerlessness of municipal officials. During the construction of 110 1st Street, Goldman's company, now named BLDG, destroyed a tiny pocket park of brick paths and greenery adjacent to the property. BLDG claimed that it planned to improve the park. Goldman did not present such a plan to the appropriate city officials and he did not seek approval for the demolition work.[3] The neighborhood's councilperson and the city's spokesperson both expressed outrage, but Goldman and his company appeared to have felt few, if any repercussions. The park has not been rebuilt.

The P. Lorillard Tobacco Company warehouse at 111 1st Street, and the nearby buildings must have offered quite the sight during their industrial heyday. Black, heavy soot choked the air and stained workers' clothes. Wagons and carriages loaded with goods for markets and docked ships packed the streets. The gutters overflowed with manure, rubbish, and rotting food. Men, women, and, yes, children, largely German and Irish immigrants with a sprinkle of Italians and Poles, tromped through the streets to their workshops or to a nearby saloon for a drink "with all the trimmins."[4] Whistles blew, commanding laborers to their posts or releasing them from their daily dose of drudgery. People shouted greetings, curses, jokes, and farewells. These people worked hard in an unforgiving landscape of machines, grime, and noise, but this world seemingly offered more hope and lucre than the impoverished, hardscrabble villages and farms left behind in the Old World. Over the years, the horses and carts gave way to trucks and railcars. The work was a little better, a little less dangerous, thanks to the organizing of the workers and the emergent power of unions. The accents and complexions changed. Children no longer worked and now only attended school, sparing them an introduction to the hardships of the adult world for a little while longer. Women

left the factory for the grueling routine of domesticity, returned during the Second World War, and then begrudgingly surrendered their spots on the production line to former soldiers and sailors coming home after the excitement and the danger of the European and the Pacific theaters. Men lingered a little less at the bar, enticed by the passive entertainment of radio and television and the suddenly spacious quarters of their new, larger homes. The factories still hummed, and the warehouses still bustled.

In the postwar decades, the once-stable jobs disappeared as industry fled to the wide, open land of the growing suburbs and the cheaper wages and less regulation of the western and southern states (and ultimately foreign nations). Managers and owners wanted to build new, modern plants and staff them with employees unblemished by pesky ideals of fair work and fair pay. The railroad tracks rusted and buckled; the warehouses echoed with emptiness and silence; and the once hectic wharves rotted and collapsed against the steady tide of the Hudson River.

Eventually, a new breed of pioneers landed in Jersey City. Resembling the first Pilgrims landing on the rocky coast of Massachusetts, staring at the cold, threatening forests, yet somehow imagining a new life in a strange world, a handful of artists discovered this decayed landscape. The artists built their colony in the gargantuan tobacco warehouse, painting in freezing, unheated lofts and taking momentary breaks to glance out the window at the dark streets below and the dazzling Manhattan skyline in the near distance. To the artists, this building and the forgotten industrial neighborhood formed a beautiful place to dream, to create, and to live. Word of this fertile, welcoming setting made its way to Manhattan and beyond. More artists accepted the invitations of the founders of 111 1st Street, believing that Jersey City could erupt into a frenzied artistic scene, a modern incarnation of Athens, Paris, or Greenwich Village. The last creative outposts teetered in Manhattan, and their fall against the forces of gentrification and rising levels of wealth was nothing but inevitable. This patch of Jersey City contained all the raw ingredients to become the next SoHo and to challenge the creative village being built along the Brooklyn waterfront in Williamsburg as the next hub of art, literature, and music. They, the first artists, saw the potential and settled here. This was their most cherished dream.

The narrative of 111 1st Street and other artists' communities reveals colorful and creative periods in urban locales and in urban history. The lives and habits of artists and writers draw an audience and elicit comment and controversy, and people who enjoy and appreciate the arts always yearn to know more about art's creation and context. Some people envy

the lives of artists as depicted in popular media with their perceived freedom from the responsibilities of an ordinary, mundane life, their license for debauchery, and their devotion to the semi-mystical force of creativity.

Why are newspapers, magazines, journals, and websites publishing features on artists forming new communities among decaying neighborhoods, followed by stories of artists expelled from similar neighborhoods by far wealthier and influential individuals and corporations?[5] These stories and the places and the people which they detail might speak to the American *zeitgeist*. They communicate an essence craved by the reading public. People want and possibly need the vibrant communities formed and forged by the artists of 111 1st Street and their brotherhood in neighborhood after neighborhood, in city after city. Americans want to live in communities of interconnected, engaged, and affable citizens, yet the shared social dynamic continues to deteriorate by almost every metric. For decades, authors and commentators have bemoaned the decline of trust and community in our country, and we as a people largely agree with these observations.[6]

The artists in Jersey City choose a different manner of life, rejecting the consumerist, materialist culture of the modern day. They founded their own unique community at 111 1st Street in Jersey City. They built it over nearly two decades and fought for its survival until the bitter end in 2005. This might be what people find so compelling about bohemian landscapes. People want to belong to authentic, living communities. They realize that something is lacking in the contemporary way of American life, but they do not possess a vocabulary to describe their desire. The current way of life blinds them to any possible alternatives. They do not understand that another world is possible. During their years at 111 1st Street, the artists built a new model, an example of a community and a denial of the world enraptured by "getting and spending," as William Wordsworth declared in his poem "The World Is Too Much with Us."[7] A local writer, Tris McCall, neatly summed up this notion:

> [The artists] offered Jersey City transformative possibilities, and politely challenged people in town to reimagine public space. They offered the rest of us a self-sufficient model of urban living—one based on creativity, affection, and imagination in action. . . .[8]

Sadly enough, 111 1st Street did not survive. Nothing remains of the artists and their time in Jersey City. People moved on with their lives. Individual memories grew dull and less vivid with years and age. An ever-changing and faster world defeated their gambit to sidestep the capitalist

game and create a utopia among industrial ruin. The denizens of 111 1st Street were a certain group of people during a specific period of time, in a unique place. Their story has concluded, yet a new 111 1st Street might exist today in Detroit, Scranton, Buffalo, or maybe even somewhere still in Jersey City. Maybe one or two of them can win against developers and indifferent politicians. Maybe they can show us a way back to a country of community.

Epilogue
The 111 1st Street Exodus: Where Are They Now?

Hundreds of artists and craftspeople worked at 111 1st Street during its life as a creative community. Many local activists and organizers fought to save this community and later the building and the Powerhouse Arts District. Tracking down each of these individuals and documenting their lives following their collective exodus from 111 1st Street would prove to be a massive, if not impossible task. Below is a small sample of the 111 1st Street family and friends.

Werner Bargsten (wernerbargsten.com) retired from television production. He sculpts in a studio in South Orange, New Jersey. Jersey City remains his home.

Kelly Darr worked as an artist and arts educator in Jersey City for two decades. Several years ago she relocated to Montauk on Long Island, New York. She paints in a studio near the historic Montauk Point Lighthouse. Her art has been shown in galleries and events in the Hamptons and elsewhere on Long Island.

Edward Fausty (edwardfausty.com) spent four years, from 2001 to 2005, photographically documenting 111 1st Street. A professional photographer and printmaker, Fausty currently lives and maintains a studio in Boonton, New Jersey. He is presently developing his own book on 111 1st Street.

Elaine Hansen founded Yoga Shunya (yogashunya.com) in Jersey City, and she manages the studio and teaches there. In 2002, she purchased a former ironworks in Jersey City with a long-term plan of converting the building into artist housing and studios. This project remains

ongoing. Hansen still lives in Jersey City and shows her paintings, drawings, and photographs in local art exhibits.

Kay Kenny (kaykenny.com) lives in South Orange, New Jersey, and Saugerties, New York. After serving as president of Pro Arts and frustrated with the failure to preserve the Powerhouse Arts District, Kenny stepped away from Jersey City. A painter and a photographer, Kenny teaches at New York University and recently received her fourth New Jersey State Council on the Arts grant.

Tris McCall (trismccall.net) writes about art, culture, politics, and New Jersey. He remains a voice for creating a welcoming environment for artists in Jersey City. After publishing a novel and working as a music critic for the *Newark Star-Ledger*, McCall returned to the stage as musician with a show in New York City in 2016. He still calls Jersey City home.

Margo Pelletier (thinedgefilms.com) relocated to Catskill, New York. Her documentary films were screened at regional and international film festivals and won several awards. In 2016, Pelletier completed production on her first feature film, *Thirsty*, a musical based on the life of Scott Townsend, a Provincetown, Massachusetts, drag performer. Pelletier passed away on November 27, 2016.

William Rodwell moved to New Mexico following the destruction of 111 1st Street to work as a scenic artist in television and film production. A sculptor and photographer, he is happy and healthy somewhere in the United States.

Bill Rybak (billrybak.net) lives and works outside New Paltz, New York, in the Hudson Valley. An accomplished artist across multiple media, including sculpture, printmaking, and photography, Rybak has shown his art in galleries and exhibits throughout the Hudson Valley, New Jersey, and the New York metropolitan region. He also works as a commercial artist and graphic designer.

Henry Sanchez taught at the School of Visual Arts from 2009 to 2016. An artist and activist, Sanchez founded the English Kills Project (englishkillsproject.squarespace.com), an initiative harnessing art and science to press for the environmental remediation of the Newtown Creek in Brooklyn, New York. He relocated to Houston, Texas in 2016.

Appendix
The Artists of 111 1st Street, Jersey City, New Jersey

The exhibit *Working Here: Art at 111* was held at 111 1st Street between October 13, 2001, and November 11, 2001. The catalog accompanying the exhibit listed the artists working at 111 1st Street and named those artists awarded grants by agencies and foundations. Although likely uncomprehensive, this is the only authoritative list of the artists of 111 1st Street known to me. The list has not been altered, updated, or verified.

Past and Present 111 Artists

Rashid Akmanov
Marnie Andrews
Bill Arning
Kari Auerbach

Jose Badosa
Jeff Baker
Rance Barela (deceased)
Werner Bargsten
Bill Barrell
Jane Beck
Julia Belomlinsky
Betty Bodian
Dusty Boynton

Aaron Burdick
Caroline Burton

Rafael Canela
Robert Casey
Charles Chamot
Wei Jane Chir
Ted Ciezelski
Nancy Cohen
Don Cornett
Francisco Cortes
Orlando Cuevas
Midori Curtis

Kelly Darr
Michael Daube
Sandra DeSando
James Doberman
Richard Dorian
Spelman Evans Downer
John Doyle

Elizabeth Eder
Ron English
Maggie Ens
B. J. Ervick
Gloria Escobar
Michael Evans

Pat Falconer
Ed Fausty
Larry Feldman
Gary Finkel
Ann Folger
Julie Forgione
Michelle Forsyth
William Franks
Kathe Frantz
David Freeman
Simon Fulford

Alex Garvin
Misha Gervits
Mireia Gibert
Judy Glantzman
Dan Gluibizzi
Nancy Golden
Sergei Goloshapov
Nick Grew
Kelly Griffin
Joseph Grigely
Gatis Gudet
Keith Gunderson

Elaine Hansen
Randy Harris

Shandor Hassan
Patter Hellstrom
Rob Hendrickson

Jeff Jacobson
Nancy Jo Johnson
David Jones

Kay Kenny
Boris Kheyman
Alexey Khvostenko
Beom Kim
Hyun Gun Kim
Erika Knerr
Arkady Kotler
Jenny Krasner
Tina Krause
Karrie Kruskopf

Jim Lambert
Gianfranco Langatta
Jessica Lenard
Alex Leonard
Antal Lesko
Chris Lesnewski
Jennifer Li
Robert Lobe
Jeanette Louie
Eric Lowenstein
Kathy Luker
Jeff Lundenberger
Karin Luner
Brian Lytle

Allen Maertz
Nancy Mahl
Sandra Malak
Franca Marini
Bella Marsky
Marsha Massih
Luis Mendez
Jay Milder

Tyrone Mitchell
Whalen Moe
Gordon Moore
Bruce Morozko
Sana Musasama

Elvira Nungesser

Nick Oberling
Jim Olsen
Elizabeth Onorato

Zoe Pasternak
Albert Pedulla
Margo Pelletier
Bryan Perrin
Lee Perry
Jim Pershing
Robert Pfitzenmeir
Lisa Portnoff
Katalin Pota
James Prater
Al Preciado
Lily Prince
James Pustorino
Baiba Putnina

Harry Reynosa
Teri Richardson
Marcella Robinson
Mark Roden
Gloria Rodriguez
William Rodwell
Mark Rudolph
Cheryl Russo

Henry Sanchez
Mayumi Sarai
Steve Sarocky
Francesca Schiffrin
Matt Schwede
Jill Scipione

Susan Shaftan
Stephan Shedrowitz
Sara Simboli
Sandy Skoglund
James St. Clair
Kurt Steele
Elizabeth Stephens
Vicki Stewart
Dylan Stone
Joe Stone
Barbara Stork
Alex Sundukov

Josh Tedeschi
Julie Terestmann
Lisa Thomas
Tyrone Thomas
Brett Thompson

Loura Van Der Meule
John Variano
Kurt Von Ellers
Arturs Virtmanis

Eric Whitney
Chris Whittey
Robert Williams
Craig Winkelman
Ralph Wolf
Greg Wood
Bruce Winn

Fred Yee
Gleb Yentus

Thelma Zunz

Grants Recipients

Adolph and Esther Gottleib Foundation

Robert Lobe, 1994
Gordon Moore, 2000
William Rodwell, 1995

Geraldine R. Dodge Foundation Fellowships

Wei Jane Chir, 2001
Barbara Stork, 2000

Guggenheim Foundation

Robert Lobe, 1985
 (Chesterwood Residency)
Tyrone Mitchell, 1984

Joan Mitchell Foundation

Christopher Lesnewski, 1997
Tyrone Mitchell, 1994

National Endowment for the Arts

Robert Lobe, 1979, 1984
Gordon Moore, 1982
Sandy Skoglund, 1980

New Jersey State Council on the Arts

Bill Barrell, 1983
Wei Jane Chir, 1998
Nancy Cohen, 1986, 1989, 1993
Kay Kenny, 1985, 1987, 1993
William Rodwell, 2001

New York Foundation for the Arts

Tyrone Mitchell, 1990
Sandy Skoglund, 1988

Pollock-Krasner Foundation

Bill Barrell, 1995
Nancy Cohen, 1989
Elaine Hansen, 1998
Robert Lobe, 1992

Tiffany Foundation

Gordon Moore, 1991

Acknowledgments

A first book is the product of not just a few years but of a lifetime. This work began well before I knew anything about the histories of 111 1st Street and Jersey City. An author does not write his or her own book. I would like to thank those who helped me in known and unknown ways.

Dr. Rosemary Wakeman first encouraged me to explore the subject of 111 1st Street and its artists. Without her support and guidance, I doubt I would have attempted to pen this book. I hope the finished product testifies to her influence as a scholar, writer, and teacher.

James T. Fisher offered his own insights into the culture, history, and politics of Jersey City and Hudson County, New Jersey.

Michael C. Gabrielle, John Gomez, and Helen-Chantal Pike shared their love of and reverence for local New Jersey history at book and historic preservation events (and even at the Asbury Park boardwalk).

John Beekman, Cynthia Harris, and Daniel Klein of the New Jersey Room of the Jersey City Free Public Library demonstrated an uncanny knowledge of Jersey City and provided me with invaluable research assistance. They are the keepers of Jersey City's history. On a more personal note, they endorsed my research with an invitation to present my work at the library, giving me my first real audience.

Aleta Valleau Mangual hosted me at Tachair Bookshoppe (an establishment gone too soon and fondly remembered) to test my material against another Jersey City crowd.

Juan Fernandez and Herbert Mayner helped me locate obscure mate-

rial, long after I ignored their plaintive requests to return overdue library books.

My students and staff indulged my bouncing ideas off them during their tenure at the Maloney Library.

Todd Melnick, my mentor and friend, deserves my gratitude for fostering a work environment valuing scholarship and intellectual pursuits at the Maloney Library.

My fellow author Patrick Verel strengthened this book with his support and insights.

Mark Bunbury Jr. clarified the finer points of New Jersey law.

Robert Farren and Cindy Howle, two copy-editing veterans and friends, prepared me for navigating the publishing process.

Kirk Howle lent his artistic talents and technical capabilities by ensuring that all my book's images met the highest publishing standards.

Jolan Falk of Creative Force designed a wonderful map to introduce readers to the geography of Jersey City.

Edward Fausty, William Rodwell, and Bill Rybak offered their photographs for inclusion in this book, completing this recounting of 111 1st Street.

DW Gibson penned the Foreword, burnishing my book with his name and reputation.

Kevin Joel Berland of Starfish House Editorial Services compiled the useful, exhaustive index.

Jennifer Richards of Over the River PR planned the events and publicity for my book.

To the energetic staff of Fordham University Press, thank you for transforming my random pages into a beautiful, wonderful book. You made my oldest dream come true. William Cerbone and Eric Newman worked tirelessly to whip my manuscript into shape. Katie Sweeney and Kate O'Brien-Nicholson introduced my book to a reading public. Ann-Christine Racette escorted my book (and me) through its production. Fredric Nachbaur picked my manuscript from the slush pile and gave it a read. Fred, thank you for believing in my words and my book, even when my hope waned.

My thanks to Fr. Timothy Tighe, CSP, and Fr. John Shea, SJ, for listening.

Matt Smith introduced me to the joys and mysteries of city life. He and I have spent nearly two decades discussing and debating the ideas unpacked in this book.

During the course of my writing this book, several loved ones passed

away, including both of my grandmothers, Vesta Goodwin and Phyllis Snyder. To all those lost, may I make you proud.

To my family, including my siblings, Timothy Goodwin, John Goodwin, Cara Goodwin, and Susan Goodwin; my mother, Karen Goodwin; my mother-in-law, Lucia Murphy, and her husband, Nicholas Pinto; and my father, James Goodwin, for taking his son to the public library on Saturday mornings.

To my wife of ten years, Jessica Murphy: This project spanned many episodes and eras of our shared life. May it reflect a glimmer of the joy, pride, and love you give me.

A hearty thank you to all the business owners, municipal officials, activists, and citizens of Jersey City who agreed to my interview requests. Your words and thoughts shaped this book.

Finally, to the artists of 111 1st Street, this is your story. Enjoy.

Notes

Introduction: Why Does 111 1st Street Matter?

1. Charles Kessler, "Why I Quit Painting," *Left Bank Art Blog*, May 26, 2015 (http://leftbankartblog.blogspot.com/2015_05_01_archive.html).

2. Carmela Karnoutsos, "P. Lorillard Tobacco Company," *Jersey City Past and Present* (http://www.njcu.edu/programs/jchistory/pages/L_Pages/Lorillard_Tobacco.htm).

3. "Lorillard Company Over 180 Years Old," *Jersey City Observer*, May 18, 1940.

4. Ibid.

5. *111 First Street: From Paris to Jersey City, They Showed No Love*, directed by Branko (2013).

6. As an employee of a Jesuit university and as a practicing Catholic, I felt especially uncomfortable during the alleged slander directed at Cardinal Dulles, a former professor and a respected figure at Fordham University.

7. Interview with William Rodwell, September 8, 2012.

8. Interview with Tris McCall, September 12, 2013.

1. The Lorillard Legacy

1. Charles Morrill (1828–97) notably worked on the Academy of Music and Union Dime Savings Bank, both in New York City. Morrill may have contributed to the design and construction of both projects. Later, Morrill was a hardware manufacturer and merchant. He also served as agent for the U.S. Treasury Department. Obituary of Charles Morrill, *New York Tribune*, April 4, 1897.

2. Rick James, *Warehouse Historic District, Jersey City, NJ: State & National Registers of Historic Places Nomination* (http://jclandmarks.org/nomination -warehousedistrict.shtml); Carmela Karnoutsos, "P. Lorillard Tobacco Company," *Jersey City Past and Present* (http://www.njcu.edu/programs/jchistory/ Pages/L_Pages/Lorillard_Tobacco.htm); William Rodwell, *Timeline: 111 First Street, Jersey City, NJ: 1866–2005 (unpublished document)*.

3. Edward Robb Ellis, *The Epic of New York City* (New York: Old Town Books, 1966): 92–93.

4. This sense of religious tolerance and freedom of worship in the New York region arguably sprung from the philosophy and sensibilities of its Dutch founders. This is an intriguing facet and period of American colonial history long overlooked, if not forgotten, by historians, commentators, and civic-minded citizens. Russell Shorto, *The Island at the Center of the World: The Epic Story of Dutch Manhattan and the Forgotten Colony That Shaped America* (New York: Doubleday, 2004). Shorto's work opened a new vein of popular colonial history and, perhaps, will serve as a springboard for future research and writing on New Amsterdam and its legacy. Historian Dr. Roger Panetta edited a lavishly illustrated collection of essays on the Dutch colonial experience in New York and its cultural influence on the region. Roger Panetta, ed. *Dutch New York: The Roots of Hudson Valley Culture* (New York: Fordham University Press, 2009).

5. Harry Dunkak, "The Lorillard Family of Westchester County: Tobacco, Property and Nature," *The Westchester Historian* 71, no. 3 (summer 1995): 51–53; A. Wayne Cahilly, *Historical Sketch of Stone Mill and Surrounding Land* (Bronx, N.Y.: New York Botanical Garden, 2010): 2; Joan H. Geismar, *Lorillard Snuff Mill, New York Botanical Garden, Bronx County, New York: Memo Report/Archaeological Assessment* (Bronx, N.Y.: New York Botanical Garden, 2008): 26–27; *Lorillard and Tobacco: 200th Anniversary: P. Lorillard Company: 1760–1960* (Greensboro, N.C.: P. Lorillard Company, 1960): 17.

6. Dunkak, "The Lorillard Family of Westchester County": 53–54; Geismar, *Lorillard Snuff Mill*: 26–27.

7. Dunkak, "The Lorillard Family of Westchester County": 54; Cahilly, *Historical Sketch of Stone Mill and Surrounding Land*: 2; A. Wayne Cahilly, *Lorillard Operations* (Bronx, N.Y.: New York Botanical Garden, 2010): 2–4; Geismar, *Lorillard Snuff Mill*: 27–29.

8. Dunkak, "The Lorillard Family of Westchester County": 54.

9. Ibid.: 57.

10. Ibid.; Cahilly, *Lorillard Operations*: 4–6.

11. Cahilly, *Historical Sketch of Stone Mill and Surrounding Land*: 5–6.

12. Charles Siedler (1839–1921) emigrated from Germany to New York City as a young boy. In 1868, he became a partner at the P. Lorillard Tobacco Company and retired in 1894. He later became president of the Bergen Savings Bank in Jersey City. He served a single term as a Republican mayor of Jersey City (1876–78), but he did not appear to find a calling in politics and public

service. He died in 1921 and is buried in the Bayview–New York Bay Cemetery in Jersey City.

13. James, *Warehouse Historic District*; Karnoutsos, "P. Lorillard Tobacco Company; Rodwell, *Timeline*.

14. Moses Foster Sweetser, *King's Handbook of the United States* (Buffalo: Moses King Corp., 1892): 564.

15. Hamilton S. Wicks, "American Industries—No. 1," *Scientific American* 40, no. 2 (January 11, 1879).

16. *Industries of New Jersey: Hudson, Passaic, and Bergen Counties* (New York: Historical Publishing Co., 1883): 886; James, *Warehouse Historic District*.

17. "A Free Library for Employes [*sic*]," *Frank Leslie's Illustrated Newspaper* (February 21, 1885): 11–12.

18. James, *Warehouse Historic District*; Karnoutsos, "P. Lorillard Tobacco Company."

19. "A Free Library for Employes [*sic*]": 11–12.

20. This statue is referred to as both the *Soldiers, Sailors, and Marines Monument* and the *Soldiers, Sailors, and Marines Memorial*. Philip Martiny (1858–1927) was born in France and arrived in America in 1878. He maintained a sculpture studio near Washington Square in Manhattan and worked on public and private projects, including the New York City Hall of Records, the Jefferson Building of the Library of Congress, and St. Bartholomew's Episcopal Church in New York City.

21. James, *Warehouse Historic District*; Carmela Karnoutsos, "Leonard J. Gordon Park," *Jersey City Past and Present* (http://www.njcu.edu/programs/jchistory/pages/L_Pages/Leonard_Gordon_Park.htm).

22. Powers, *Faces Along the Bar*: 11–15, 227.

23. "A Free Library for Employes [*sic*]": 11–12.

24. "The Lorillard Tobacco Works," *Documents of the 109th Legislature of the State of New Jersey*, v. 1, no. 12 (1895): 259.

25. This might have been Dr. Gordon at some time. However, this has not been verified.

26. "The Lorillard Tobacco Works": 259–60.

27. *Lorillard and Tobacco: 200th Anniversary*: 5, 42.

28. James, *Warehouse Historic District*; "P. Lorillard Halts Local Production," *Jersey Journal*, July 6, 1956.

29. "P. Lorillard Halts Local Production."

30. Karnoutsos, "P. Lorillard Tobacco Company."

31. *Hudson County South Directory*.

2. Crossing the Hudson

1. Sharon Zukin, *Loft Living: Cultural Capital and Urban Change* (Baltimore: Johns Hopkins University Press, 1982); Richard Kostelanetz, *Artists' SoHo: 49 Episodes of Intimate History* (New York: Fordham University Press, 2015).

2. Christopher Mele, *Selling the Lower East Side: Culture, Real Estate, and Resistance in New York City* (Minneapolis: University of Minnesota Press, 2000).

3. Robert Anasi, *The Last Bohemia: Scenes from the Life of Williamsburg, Brooklyn* (New York: FSG Originals, 2012).

4. David B. Cole, "Artists and Urban Development," *Geographical Review* 77, no. 4 (October 1987): 392.

5. This nostalgic place-naming was noted in the gentrification of Brooklyn as well. Certain names were cherry-picked from the local history and attached to certain neighborhoods to give them character or the echoes of a rich history. For example, Boerum Hill in Brooklyn is named after the estate of a colonial farming family. Interestingly enough, the landscape is flat; that is, there is no hill in Boerum Hill. Suleiman Osman, *The Invention of Brownstone Brooklyn: Gentrification and the Search for Authenticity in Postwar New York* (New York: Oxford University Press, 2013): 25.

6. Rodwell, *Timeline*.

7. Interview with William Rodwell, June 26, 2011.

8. I believe that this "Gennaro" is Gennaro Tedesco, one of several artists featured in an early news article on 111 1st Street. Beth Kissinger, "Arts Movement: Goodbye SoHo, Lightin' Out for New Territory," *Jersey Journal*, August 6, 1990.

9. Interview with Henry Sanchez, July 11, 2011.

10. Interview, July 15, 2011.

11. "[A]rtists are also [the middle class's] advancing or colonizing arm. . . . The urban artist is commonly the expeditionary force for inner-city gentrifiers, pacifying new frontiers ahead of the settlement of more mainstream residents. As a successful inner-city realtor declared, if in doubt when marketing to the new middle class, 'follow the hippies.'" David Ley, *The New Middle Class and the Remaking of the Central City* (Oxford: Oxford University Press, 1996): 192; Mele, *Selling the Lower East Side*: 233–36; Neil Smith, *The New Frontier: Gentrification and the Revanchist City* (New York: Routledge, 1996): 18–20, 198–200; *Urban Affairs Quarterly* 25, no. 4 (June 1990): 621: ". . . [T]he models to explain the differentiation among the in-movers during the different stages is the in-movers' attitudes toward risk. Those moving in earliest are the *risk-oblivious*, willing to chance their financial investment and, perhaps their personal safety"; Robert Kerstein, "Stage Models of Gentrification: An Examination." Also see Phillip L. Clay's (1979) "Stage Model of Gentrification" in Loretta Lees, Tom Slater, and Elvin Wyly, *Gentrification* (New York: Routledge, 2008): 31–33: "[A] small group of risk-oblivious people move in and renovate properties for their own use."

12. Sharon Zukin first and best described this model in her landmark study of SoHo in Manhattan, and Winifred Curran further developed Zukin's model in her research on Williamsburg, Brooklyn. Zukin, *Loft Living*; Lees, Slater, and Wyly, *Gentrification*: 118–21. Winifred Curran, "From the Frying Pan to the Oven: Gentrification and the Experience of Industrial Displacement in

Williamsburg, Brooklyn," *Urban Studies* 44, no. 8 (July 2007): 1427–40; Winifred Curran, "In Defense of Old Industrial Spaces: Manufacturing, Creativity and Innovation in Williamsburg, Brooklyn," *International Journal of Urban and Regional Research* 34, no. 4 (December 2010): 871–85. Richard Kostelanetz wrote a personal history-*cum*-memoir of the peak of SoHo as an outsider and artists' community. Kostelanetz captures the energy and magic of the SoHo community and neighborhood at a transitional and now lost time. Kostelanetz, *Artists' SoHo.*

13. "Ennis seems to be set on the "artists [*sic*] concept, though. . . . Ennis envisions a 'real arts' center—more artists, several galleries—in the future. 'The potential is great,' he says.'" Doug Ennis quoted in Kissinger, "Arts Movement."

14. "The building is also home to the businesses of some non-artists, including a dress manufacturer, a screen printing company and a carpentry shop." Ibid.

15. William Rodwell quoted in Ibid.

16. Property tax records are public documents; however, they list the property owner, not the tenants. Unless reported in a news article or publication, the usage of the property is more difficult to pin down. Business directories and reverse telephone directories appear to be unavailable for the period discussed.

17. Interview with Kelly Darr, June 18, 2011.

18. Interview with William Rodwell, June 26, 2011.

19. Interview, July 15, 2011.

20. Interview with Margo Pelletier, August 28, 2013.

21. David Ley, "Artists, Aestheticisation and the Field of Gentrification," *Urban Studies* 40, no. 12 (November 2003): 2533.

22. Alison L. Bain, "Constructing Contemporary Artistic Identities in Toronto Neighborhoods," *The Canadian Geographer* 47, no. 3 (2003): 310.

23. "The Arts Are on First," press release.

24. Ibid.

25. The discovery of this press packet and the accompanying advertisement is important in the history and the comprehension of 111 1st Street. This fact cannot be understated. I became fascinated by 111 1st Street after reading a brief article on the subject in a local magazine. Kate Rounds, "The Fate of 111 First Street: Artists, Development, and the Destiny of a City," *Jersey City Magazine* 6, no. 2 (fall/winter 2009/2010): 52–57. The article noted that the lofts and studio space at 111 1st Street had been purportedly advertised in various publications, including *The Village Voice.* None of the interviewed subjects attested to this statement. However, the existence of this press packet lends credence to the statement. Any individual or group hoping to attract artists in the late 1980s and early 1990s would have likely purchased advertising space in *The Village Voice.* A copy of this crucial document is kept in the collection of the New Jersey Room Collection of the Jersey City Free Public Library. This discovery underscores the importance of public libraries in the preservation and promotion of local history and largely forgotten moments.

26. "The Arts Are on First"; George M. Point, "An Arts Community Steps into a Spotlight," *New York Times*, February 17, 1991.

27. Gerald McCann ranks as one of the more notorious, colorful, memorable, and ultimately shameless characters in Jersey City and Hudson County politics—no easy task. In his second and nonconsecutive term as mayor, he was charged and convicted on federal charges in a savings-and-loan scam in 1992. This was unrelated to his political and government work. McCann remained involved in local politics as a behind-the-scenes player. He won a seat on the Jersey City Board of Education in 2007 and subsequently lost his seat in 2011 to a reform ticket. Most recently, McCann was accused of harassing the son of a city council candidate, Michael Yun. Yun was running against a longtime McCann protégé, the now–former New Jersey Assemblyman Sean Conners. In an irony possible only in the byzantine and often internecine world of Hudson County politics, Sean Conners ran as a candidate associated with the same reform movement which railed against McCann in the past and engineered the loss of McCann's Board of Education seat. Previously, Conners affiliated himself with the local political machine. Yun ultimately defeated Conners in the council race.

28. Rodwell, *Timeline*; "The Arts Are on First"; Point, "An Arts Community Steps into a Spotlight."

29. Richard McAllister quoted in Point, "An Arts Community Steps into a Spotlight."

30. Ibid.

31. Anthony M. DeStefano, "The Strange Case of Steven Romer," *New Jersey Monthly* (February 1992): 40–44.

32. Ibid.: 42.

33. Ibid.: 40–44.

34. Interview with Kelly Darr, June 18, 2011; interview with William Rodwell, June 26, 2011.

35. Interview with William Rodwell, June 26, 2011.

36. Point, "An Arts Community Steps into a Spotlight."

37. Rodwell, *Timeline*.

38. Alex Frangos and Peter Grant, "Meet the Other World Trade Center Builder," *Wall Street Journal*, September 11, 2008, Real Estate.

39. Robert Cotter quoted in "Warehouse Work Studio Approved," *Jersey Journal*, June 26, 1993.

40. For an informative and colorful snapshot of this period, see James T. Fisher, *On the Irish Waterfront: The Crusader, the Movie, and the Soul of the Port of New York* (Ithaca, N.Y.: Cornell University Press, 2009). Steven Hart, *The Last Three Miles: Politics, Murder, and the Construction of America's First Superhighway* (New York: New Press, 2007) crystallizes the reign of Frank Hague and Jersey City at its peak in his study of the Pulaski Skyway. A recent biography attempts to rehabilitate the reputation and biography of Frank Hague. Leonard F. Vernon, *The Life & Times of Jersey City Mayor Frank Hague: I Am the Law*

(Charleston, S.C.: History Press, 2011). Helene Stapinksi presents a vivid yet more subjective account of this era in her memoir-*cum*-history of Jersey City. Stapinski, *Five-Finger Discount: A Crooked Family History* (New York: Random House, 2001).

41. Bret Schundler styled himself as a mayor in the mold of Rudolph Giuliani (a positive political model in the 1990s), and Schundler is remembered favorably by many voters and citizens. Following his two terms as mayor of Jersey City, Bret Schundler launched two failed attempts at New Jersey's governor's office, tacking far to the right on social issues such as abortion, gays, and guns. This hardline stance provided him with little traction in a largely middle-class, educated, and arguably moderate-to-liberal state. (In contrast, the current Republican governor, Chris Christie, avoided such debates in his campaigns for governor and management of public affairs and policy prior to his quixotic presidential bid in 2016.) Schundler announced a third mayoral bid in 2009 but left the race likely because of the massive financial advantage of the incumbent mayor, Jerramiah Healy. Schundler joined the Christie administration as the New Jersey Commissioner of Education in 2010, but he was dismissed from this appointed position by August 2010 after a clerical omission resulted in the state's losing several hundred million dollars in federal Race to the Top grant funding. In an ignominious end to a once-promising public service career, Schundler requested termination in order to collect unemployment insurance.

42. Interview with Kay Kenny, July 31, 2011.

43. Pro Arts eventually initiated contact with a real estate investor about purchasing a building in the vicinity of 111 1st Street and repurposing it as artist housing. Although the investor and the group contracted an architect to draw up plans and secured financing, the deal ultimately collapsed. The timeframe and the full details of this prospective project remain hazy. Nonetheless, if such an arts-oriented project had succeeded, the story of 111 1st Street and its artists might have ended much differently. Jersey City itself would be much different today. Interview with Kay Kenny, July 31, 2012. Interview with William Rodwell, September 8, 2012; [Daniel Levin], *Timeline of 111 First Street & Jersey City's Arts District.*

44. David W. Chen, "Among the Loading Docks, Dreams of a Lively Art District," *New York Times*, July 7, 1996.

45. However, the legislation sternly disallowed rock or music clubs. This cabaret ordinance was only recently altered, softening the language forbidding live music. This partially explains the dearth of live music venues compared with those in Williamsburg, Asbury Park, or, sadly enough, even Hoboken. Historically, this bias against music may very well be traced back to the long mayoralty of Frank Hague, who viewed and promoted himself as a moralizing crusader, zealously closing down dance halls and brothels. "He allowed no nightclubs or houses of prostitution in the city, kept the streets clean of litter and vagrants, and banned the presence of women in bars. . . ." Carmela Karnoutsos, "Frank Hague, 1876–1956, Mayor of Jersey City 1917–1947 (Retired),"

Jersey City: Past and Present (http://www.njcu.edu/programs/jchistory/pages/h_pages/hague_frank.htm).

46. Jersey City Ordinance, 96-069 (June 26, 1996); Chen, "Among the Loading Docks."

47. Robert Cotter quoted in Chen, "Among the Loading Docks."

48. Jane Jacobs, *The Death and Life of Great American Cities* (New York: Vintage, 1992): 152–77.

49. Interview with Kelly Darr, June 18, 2011; interview with Henry Sanchez, June 29, 2011.

50. Brian Donohue, "Artists Paint Rosy Picture of Mayor," *Jersey Journal*, June 20, 1997; Dan Bischoff, "Hizzoner on the Hudson: Jersey City Mayor Bret Schundler Is a Policy Wonk with an Eye for Art," *Newark Star-Ledger*, August 30, 1998.

51. Jerramiah Healy quoted in Donohue, "Artists Paint Rosy Picture of Mayor."

52. Jerramiah Healy quoted in Ibid. This is a humorous comment for any student of Jersey City politics or anyone familiar with Healy's colorful and occasionally embarrassing antics. He was photographed passed out drunk and naked in front of his home in 2004. He was arrested for engaging in a brawl with police officers at the Jersey Shore in 2006 and convicted on those charges in 2007. He released a Christmas album, sang on the local New York City morning news show, and frequently enjoyed the wares of local bars and taverns.

53. Bret Schundler quoted in Ibid.

54. Interview, June 22, 2011; interview, July 15, 2011.

55. NJN News, "Solid State Opening at 111 First St.," November 24, 1995 (http://www.youtube.com/user/underdevelopmentTV#p/u/38/nPdI_c0QDUk).

56. Channel 11 News, "The New SoHo," November 11, 1996 (http://www.youtube.com/watch?v=SWLldtUUsv4&feature=related).

57. State of the Arts, "Studio Tour 2000," NJN [autumn 2000] (http://www.youtube.com/user/underdevelopmentTV#p/u/20/1VzzmhCq3oo).

58. Interview, July 15, 2011.

59. Interview with Tyrone Thomas, July 21, 2011.

60. Interview with Edward Fausty, June 5, 2011.

61. Interview with Bill Rybak, June 29, 2011.

62. Interview with Henry Sanchez, June 29, 2011.

63. Interview with Tris McCall, September 12, 2013.

64. Interview with Elaine Hansen, August 8, 2013.

65. Interview with Bill Rybak, June 29, 2011.

66. Interview with Kelly Darr, June 18, 2011.

3. The Spaces in Between

1. Sharon Zukin, *Naked City: The Death and Life of Authentic Urban Spaces* (New York: Oxford University Press, 2011): 35–61.

2. This could be cynically attributed to the media's standing in the urban growth coalition. John R. Logan and Harvey L. Molotch, *Urban Fortunes: The Political Economy of Place* (Berkeley: University of California Press, 1987): 70–73.

3. Stephan Shedrowitz quoted in Alberto Canal, "Artist Flees 'Hell,'" *Jersey Journal*, October 11, 2001.

4. Patti Smith chronicles Robert Mapplethorpe's development as an artist and his steadfast and obsessive dedication to the constant improvement of his work and his skills in her recent memoir. Incidentally, Smith's memoir captures the essence and texture of New York's bohemia in the late 1960s and early 1970s. This is a must-read for any scholar, thinker, or reader interested in the New York arts scene or the life of an artist. Patti Smith, *Just Kids* (New York: Ecco, 2010). The pseudonymous street artist Banksy also commented on the gradual and difficult growth of the artist in the 2010 documentary *Exit Through the Gift Shop*. These are only two contemporary statements of the sheer *work* required to become and succeed as an artist.

5. Prescott Tolk, "Where's WALDO: Artists Told They Can Only Access Their Lofts at Certain Times," *Jersey City Reporter*, December 2, 2001. Interview with Edward Fausty, June 5, 2011; interview with author, July 15, 2011.

6. Robert Rapuano quoted in Canal, "Artist Flees 'Hell.'"

7. Interview with Kelly Darrr, June 18, 2011.

8. Interview, July 15, 2011.

9. William Rodwell, *Timeline: 111 First Street, Jersey City, NJ: 1866–2005* (unpublished document).

10. Tolk, "Where's WALDO."

11. N.J.S.A. 46:8–10; Legal Services of New Jersey, *Tenants' Rights in New Jersey: a Legal Manual for Tenants in New Jersey* (Edison: Legal Services of New Jersey: 2007): 32–33; 51–52.

12. Thanks to Mark Bunbury Jr., Esq., for clarification on this legal matter.

13. Tolk, "Where's WALDO"; Rodwell, *Timeline*; Canal, "Artist Flees 'Hell,'" *Jersey Journal*, October 11, 2001; David Danzig, "Creative Curfew?" *Jersey Journal*, December 10, 2001.

14. Danzig, "Creative Curfew?" Indeed, this mandate was not written into the original municipal ordinance. This change appears to have been legislated in early 2001. However, I cannot find a specific date or the exact details regarding this substantial expansion of the original WALDO ordinance.

15. Interview, June 22, 2011.

16. Rodwell, *Timeline*. Unfortunately, I have yet to locate another source to corroborate these facts. Nonetheless, their inclusion is integral to examining the motivations of the building's owner.

17. Paul Lawless, "Power and Conflict in Pro-growth Regimes: Tensions in Economic Development in Jersey City and Detroit," *Urban Studies* 39, no. 8 (2002): 1329–46; James T. Prior, "Jersey City: America's Golden Door," *New Jersey Business* 45, no. 1 (January 1999): 30–46; Logan and Molotch, *Urban Fortunes*: 60–62.

18. Interview, June 22, 2011. Glenn Cunningham briefly served as mayor from 2001 to 2004. His death of a massive heart attack in 2004 triggered a special election won by Jerramiah Healy.

19. Alison L. Bain, "Constructing Contemporary Artistic Identities in Toronto Neighbourhoods," *The Canadian Geographer* 47, no. 3 (2003): 310–12; Richard E. Ocejo, "The Early Gentrifier: Weaving a Nostalgia Narrative on the Lower East Side," *City & Community* 10, no. 3 (September 2011): 293–97.

20. Interview with William Rodwell, November 19, 2016.

21. Interview, July 15, 2011.

22. Rodwell, *Timeline*.

23. Kathryn Kimball, "Man Held in Attack on TV Actress," *Jersey Journal*, July 24, 2001; Nancie L. Katz, "'Soprano' Singing the Blues," *Daily News*, September 3, 2007.

24. Interview, July 15, 2011; Katz, "'Soprano' Singing the Blues."

25. Katz, "'Soprano' Singing the Blues."

26. Danzig, "Creative Curfew?"

27. Rodwell, *Timeline*.

28. Interview, July 15, 2011.

29. Danzig, "Creative Curfew?"

30. Interview with Margo Pelletier, August 28, 2013.

31. Interview with Kelly Darr, June 18, 2011; interview with William Rodwell, June 26, 2011.

4. Who Owns a Space?

1. William Rodwell, *Timeline: 111 First Street, Jersey City, NJ: 1866–2005 (unpublished document)*. The actual date of the formation of the tenants' association appears as both 2000 and 2001 in documents and interviews.

2. Interview with William Rodwell, June 26, 2011.

3. Prescott Tolk, "Artists Told They Can Only Access Their Lofts at Certain Times," *Jersey City Reporter*, December 2, 2001; David Danzig, "Creative Curfew?" *Jersey Journal*, December 10, 2001.

4. Tolk, "Artists Told They Can Only Access Their Lofts at Certain Times."

5. Danzig, "Creative Curfew?"

6. Alex Booth quoted in Tolk, "Artists Told They Can Only Access Their Lofts at Certain Times."

7. Viki Stewart quoted in Danzig, "Creative Curfew?"

8. Rodwell, *Timeline*.

9. Harold Seide quoted in David Danzig, "Indications Show Some Artists Live In. . . ," *Jersey Journal*, December 29, 2001. Full title cut off of photocopied article.

10. The gentrification of downtown Jersey City is worth noting. The downtown neighborhoods merit a study of their own and will not be further

discussed. Loretta Lees, "Super-Gentrification: The Case of Brooklyn Heights, New York City," *Urban Studies* 40, no. 12 (November 2003): 2487–509.

11. The fascination produced by industrial structures and industrial decay deserves an exhaustive study and scholarly exploration. Specifically, the link between such physical spaces and their associated "aura" and their relationship with artists and creative individuals deserves further research. Additionally, the placement of industry and manufacturing in the public imagination merits genuine study. The 2012 presidential candidates from both political parties—specifically President Barack Obama and ex-Senator Rick Santorum—argued that a restored and reinvigorating manufacturing base promises a steady and healthy economy and middle class for America. A cursory glance at such statements does seem to hold some truth. The economy of Germany rests upon a vibrant export-driven industry, and Germany emerged from economic recession much better than other developed economies. Even longtime creative class proponent Richard Florida now admits the importance of manufacturing. Hazel Borys, "Richard Florida on Technology, Talent, and Tolerance," *Placemakers*, November 18, 2013 (http://www.placemakers.com/2013/11/18/richard-florida-on-tech-talent-and-tolerance/). This theme reappeared during the 2016 presidential primaries and general election, clearly speaking to the cultural identity of a sizable percentage of Americans from various backgrounds and political persuasions. The form, size, and scope of a reinvigorated manufacturing base constitute another question.

12. Greg Wood quoted in Danzig, "Creative Curfew?"

13. Neil Smith, *The New Urban Frontier: Gentrification and the Revanchist City* (London: Routledge, 1996): 13–18.

14. Interview, June 8, 2011; interview with William Rodwell, June 26, 2011; interview with Henry Sanchez, June 29, 2011; interview, July 15, 2011.

15. Interview with Kelly Darr, June 8, 2011.

16. Interestingly, this statement parallels the belief that gentrification is both a universal and specific phenomenon. Loretta Lees, "A Reappraisal of Gentrification: Towards a 'Geography of Gentrification,'" *Progress in Human Geography* 24, no. 3 (2000): 405; Tom Slater, "Looking at the 'North American City' Through the Lens of Gentrification Discourse," *Urban Geography* 23, no. 2 (2002): 131–53. Slater expands upon this theoretical concept, arguing that the political, social, and even academic context shapes the gentrification debate, research, and writing. Tom Slater, "North American Gentrification? Revanchist and Emancipatory Perspectives Explored," *Environment and Planning A* 36 (2004): 1210; Robert A. Beauregard, "Trajectories of Neighborhood Change: The Case of Gentrification," *Environment and Planning A* 22 (1990): 855–74. Beauregard demonstrates how the political, economic, and social framework of an area or a locality shapes the nature of gentrification.

17. Lance Freeman, *There Goes the 'Hood: Views of Gentrification from the Ground Up* (Philadelphia: Temple University Press, 2006). Freeman challenges the perception that minorities lose and lose big in gentrified neighborhoods. He argues that gentrification presents some tangible benefits—better safety,

cleaner streets, more shopping choices—to the original inhabitants of neighborhoods. His study largely centers on Harlem in Manhattan and Fort Green in Brooklyn. Lucas Peterson, "Brooklyn's Frugal Soul," *New York Times*, November 6, 2016: "[A young native Brooklyn female resident was] overwhelmingly positive about the changes to the borough that had come about since she was a child. . . . [She] was unabashed: 'I love gentrification.'"

18. This was also the case with the redevelopment of the Jersey City waterfront, now called the Gold Coast or Wall Street West. Aside from probable vagrants and criminals, the waterfront housed no residents.

19. The Bureau of Labor lists the 2015 median income for an independent artist, writer, or performer as $45,080. Bureau of Labor Statistics, "Occupational Employment and Wages," December 2015 (http://www.bls.gov/ooh/arts-and-design/craft-and-fine-artists.htm). The median income is a decent but by no measure wealthy income. The statistic must be read in the context that most artists are independent contractors or freelancers; therefore, they receive no health care, life insurance, pension or investment benefits. Ancillary benefits or income associated with most solid middle-class jobs are essential for building personal or family economic stability and wealth. The median household income in the United States was $55,575 in 2015, around 15 percent more than that of artists. Kirby G. Posey, *Household Income: 2015* ([Washington, D.C.]: U.S. Census Bureau, 2015): 1 (https://www.census.gov/content/dam/Census/library/publications/2016/demo/acsbr15–02.pdf).

20. Ann Markusen, "Urban Development and the Politics of a Creative Class: Evidence from a Study of Artists," *Environment and Planning A* 38 (2006): 1921–40.

21. Rodwell, *Timeline.*

22. Interview with William Rodwell, June 26, 2011; interview, July 15, 2011.

23. Rodwell, *Timeline.*

24. Prescott Tolk, "City Tries to Get 'WALDO' Artists' District Right, Again," *Jersey Journal*, March 3, 2002; Jason Fink, "Focus on Future of WALDO," *Jersey Journal*, March 6, 2002.

25. Urban Land Institute, "Learn about ULI," Urban Land Institute (http://www.uli.org/LearnAboutULI.aspx); Urban Land Institute, "The Mission and Priorities of ULI," Urban Land Institute (http://www.uli.org/LearnAboutULI/WhatWeDo/MissionandPrinciples.aspx).

26. Glenn Cunningham quoted in Tolk, "City Tries to Get 'WALDO' Artists' District Right, Again."

27. Gerald McCann quoted in Fink, "Focus on Future of WALDO." As noted earlier, McCann is a notorious and longtime local political actor.

28. Ibid.

29. Helene Stapinksi, *Five-Finger Discount: A Crooked Family History* (New York: Random House, 2001): 202–3.

30. John Petrick, "Study Boosts District for Arts, Housing," *Jersey Journal*, March 11, 2002. Whether an arts community can be planned is an entirely dif-

ferent question. A recent study of Omaha, Nebraska, suggests that such a community cannot. Michael Seman, "How a Music Scene Functioned as a Tool for Urban Redevelopment: A Case Study of Omaha's Slowdown Project," *City, Culture, & Society* 1, no.4 (December 2010): 207–15. Not surprisingly, the Chinese government has attempted an opposite strategy with a state-sponsored model of an arts neighborhood in Beijing to promote the Chinese capital as a global center of culture and creativity. Jennifer Currier, "Art and Power in the New China: An Exploration of Beijing's 798 District and Its Implications for Contemporary Urbanism," *The Town Planning Review* 79, no. 2/3 (2008): 237–65.

31. Interview with William Rodwell, June 26, 2011.

32. Petrick, "Study Boosts District for Arts, Housing."

33. In fact, I could locate no articles published about 111 1st Street for the remainder of the year. One could argue that this does not prove the absence of important events and happenings, just a lack of attention and public discourse.

34. Rodwell, *Timeline*.

35. Interview, June 22, 2011.

36. John Petrick, "Urban Still Life: Jersey City Artists Struggle to Keep the Vision Alive," *The Record*, January 7, 2003.

37. Ron English quoted in Petrick, "Urban Still Life."

38. William Rodwell quoted in Petrick, "Urban Still Life."

39. I remember first visiting Williamsburg, Brooklyn, from Philadelphia, Pennsylvania, in early 2003. My hosts, friends of my now wife, touted all the great music clubs, bookstores, cafés, and art exhibition spaces in Williamsburg. I was skeptical. Time has humbled me. The gentrification or even financification of Williamsburg deserves its own serious study. For a personal account of Williamsburg, see Robert Anasi, *The Last Bohemia: Scenes from the Life of Williamsburg, Brooklyn* (New York: FSG Originals, 2012).

40. Rodwell, *Timeline*; Martin Espinoza, "Art-Felt Plea to Stay Put: Group Says Rent Hikes at 111 First St. Will Force Artists Out of the Arts District," *Jersey Journal*, February 10, 2004.

41. Interview, June 22, 2011.

42. Louis Manzo quoted in Espinoza, "Art-Felt Plea."

43. New Jersey is a strong tenant state. Unfortunately, the tenants could take only limited advantage of the state policy and laws concerning tenant–landlord issues.

44. Ted Sherman and Josh Margolin, *The Jersey Sting: Chris Christie and the Most Brazen Case of Jersey-Style Corruption—Ever* (New York: St. Martin's Griffin, 2012).

45. Louis Manzo, *Ruthless Ambition: The Rise and Fall of Chris Christie* (Walterville, Ore.: Trine Day, 2014).

46. Greg Brickey quoted in Espinoza, "Art-Felt Plea."

47. Interview, June 22, 2011. More research would be required to fully grasp and detail the relationship between Matthew Burns and Glenn Cunningham.

48. Rodwell, *Timeline*.

5. When a Dream Dies

1. William Rodwell, *Timeline: 111 First Street, Jersey City, NJ: 1866–2005* (unpublished document).

2. Interview, September 7, 2011.

3. Interview with Bill Rybak, June 29, 2011.

4. Interview with Kelly Darr, June 18, 2011.

5. Bill Rybak provided me with images of these blueprints. The gift is much appreciated. Such projects have met with considerable success through the United States. A nonprofit based in Minneapolis, Minnesota, Artspace, advocates for artists' spaces and housing, consults in such projects, and develops property for artists and arts uses. This is just one such organization.

6. Rodwell, *Timeline*; interview with William Rodwell, July 31, 2012.

7. Rodwell, *Timeline*.

8. Interview, June 22, 2011.

9. Ibid.

10. Glenn Cunningham quoted in Peggy McGlone, "First in Their Hearts," *Newark Star-Ledger*, April 25, 2004.

11. Marion Grzesiak quoted in McGlone, "First in Their Hearts."

12. McGlone, "First in Their Hearts."

13. The concept of a "straddler" is best articulated by Alfred Lubrano in his account of the children of working-class households, who gain an education and find themselves elevated beyond the class of their birth. This is an under-studied and largely unspoken phenomenon in American culture and social life. Lubrano discusses the difficulties and dislocation experiences of such straddlers. Alfred Lubrano, *Limbo: Blue-Collar Roots, White-Collar Dreams* (Hoboken, N.J.: Wiley, 2005).

14. Interview, June 22, 2011.

15. Interview with Kelly Darr, June 18, 2011; Rodwell, *Timeline*.

16. Rodwell, *Timeline*.

17. L. Harvey Smith quoted in William Wichert, "Fest Raises Funds at 111 First: Arts District Gains Political Attention," *Jersey Journal*, August 16, 2004.

18. Wichert, "Fest Raises Funds at 111 First"; Rodwell, *Timeline*.

19. Interview, June 22, 2011.

20. Ibid.

21. Terrence McDonald, "New Hudson Freeholder E. Junior Maldonado to Be Sworn in Next Week," *Jersey Journal*, July 12, 2013.

22. This emphasis on security and safety at the expense of individuals is a common theme in gentrification studies. Neil Smith documented this effect in his in-depth research on the East Village. (This neighborhood was no more than a portion of the Lower East Side, but it was rechristened the East Village to link it to the storied cachet of the West Village and decouple it from the then–gritty and dangerous streets of the larger neighborhood. Now, more college students, foreign tourists, and the global rich meander through the

neighborhood streets than aspiring poets, punk rockers, and greying radicals.) Several scholars have noted this problem in their respective studies of Toronto neighborhoods. Last, the concept of the state—in this case, the Jersey City police department—abetting or working in concert with developers or private interests to chide or force out undesirable elements and populations is an emerging process associated with the neo-liberal state as defined by its critics. Neil Smith, *New Urban Frontier* (London: Routledge, 1996): 210–32; John Paul Catungal, Deborah Leslie, and Yvonne Hii, "Geographies of Displacement in the Creative City: The Case of Liberty Village, Toronto," *Urban Studies* 46, no. 5/6 (May 2009): 1095–114; John Paul Catungal and Deborah Leslie, "Placing Power in the Creative City: Governmentalities and Subjectivities in Liberty Village, Toronto," *Environment and Planning A* 41 (2009): 2576–94.

23. Interview, July 15, 2011.

24. Interview with Kelly Darr, June 18, 2011.

25. Rodwell, *Timeline*.

26. This reasoning is a tested tactic in peeling away labor for any coalition attempting to rival the urban growth model. Walmart successfully exploited this tactic in South Chicago and attempted to use it to gain a foothold in New York City. In New Jersey, casino operators attempted this strategy when a statewide ballot question was scheduled for the 2016 general election. The ballot initiative would have permitted the construction of casinos in northern New Jersey, one of which would have been built near Liberty State Park in Jersey City. Voters rejected the building of new casinos.

27. New Gold Equities Corp., "The Future of 111 1st Street," *Jersey City Reporter*, August 22, 2004.

28. Ricardo Kaulessar, "City Council Approves Arts District: Plan Will Go into Effect in 20 Days," *Jersey City Reporter*, October 31, 2004.

29. Ibid.

30. Ricardo Kaulessar, "Bricks in the Wall: Tenants of 111 1st St. Fight for Building Against Bleak Odds," *Jersey City Reporter*, December 5, 2004.

31. Alexander Lane, "Color These Artists Fighting Mad: Jersey City Colony Says Landlord is Forcing Them Out," *Newark Star-Ledger*, November 25, 2004; Kaulessar, "Bricks in the Wall"; Michaelangelo Conte, "Arson Unit Presses 111 First Fire Probe," *Jersey Journal*, December 15, 2004; Michaelangelo Conte, "Two Arrests at 111 First: Building Workers Picked Up by Arson Unit; Police Aren't Releasing Details," *Jersey Journal*, December 15, 2004 .

32. Daniel Horgan quoted in Conte, "Two Arrests at 111 First."

33. Acknowledging a gap in my research, I cannot determine if the two employees were ever convicted on any charges.

34. A 1987 Steven Spielberg–produced film, *batteries not included*, presents a family-friendly version of this unsettling practice involving the tenants of a walk-up apartment building in the East Village in New York and small robotic alien lifeforms.

35. Lane, "Color These Artists Fighting Mad."

36. Shandor Hassan quoted in Kaulessar, "Bricks in the Wall."

37. Adrienne Supino quoted in Kaulessar, "Bricks in the Wall."

38. Interview, June 22, 2011.

39. Jerramiah Healy quoted in Damien Cave, "An Artists' Colony on Thin Ice; in Jersey City, Tenants' Cause Loses Momentum," *New York Times*, December 15, 2004.

40. Bonnie Friedman, "Owner Gets a Permit, Preps for Demolition," *Jersey Journal*, December 14, 2004; Cave, "An Artists' Colony on Thin Ice"; Bonnie Friedman, "Healy: Demolition Work Up to Judge," *Jersey Journal*, December 15, 2004.

41. Jerramiah Healy quoted in Friedman, "Healy: Demolition Work Up to Judge."

42. Jerramiah Healy quoted in Cave, "An Artists' Colony on Thin Ice."

43. Interview with Kelly Darr, June 18, 2011; interview with Tyrone Thomas, July 21, 2011; Rodwell, *Timeline*.

44. "Drunk Cops in Jersey City, NJ" (http://www.s6k.com/page.cfm?id _news=72964048&type=1&xid=59765667); CW11: s6k: I's "Drunk Cops" Story Goes to Primetime News (http://www.youtube.com/watch?v=58GJd LOEvXY).

45. Paul Williams quoted in Cave, "An Artists' Colony on Thin Ice."

46. Barbara Landes quoted in Cave, "An Artists' Colony on Thin Ice."

47. Interview with William Rodwell, November 19, 2016.

48. Rodwell, *Timeline*; Tina Kelly, "Artists Make Deal to Vacate Jersey City Site," *New York Times*, January 5, 2005; Bonnie Friedman, "Moving Day for 111 First St. Artists: Grim Picture," *Jersey Journal*, March 1, 2005; interview with William Rodwell, June 26, 2011.

49. Sandra DeSando quoted in Kelly, "Artists Make Deal to Vacate Jersey City Site."

50. Edward Fausty quoted in Jonathan Miller, "Being a Starving Artist Has Its Drawbacks," *New York Times*, January 9, 2005.

51. Interview with Kelly Darr, June 18, 2011

52. Interview with Tyrone Thomas, July 21, 2011.

53. Ibid.

54. Interview, July 15, 2011.

55. Ibid.

56. Ibid.

57. Interview with Elaine Hansen, August 7, 2013.

58. Interview with Kelly Darr, June 22, 2011; interview with Daniel Levin, September 13, 2013.

59. Interview, July 15, 2011.

60. Interview with Kelly Darr, June 22, 2011.

61. Interview, September 7, 2011.

62. Interview with Henry Sanchez, June 29, 2011.

63. Interview, September 8, 2011.

64. Interview with Tyrone Thomas, July 21, 2011.
65. Interview with Bill Rybak, June 29, 2011.
66. Ibid.
67. Interview, September 8, 2011.

6. One Last Fight: Historic Preservation and 111 1st Street

1. William Rodwell, *Timeline: 111 1st Street, Jersey City, NJ: 1886–2005* (unpublished document).
2. Ibid.
3. Ibid.
4. Ibid.
5. Bonnie Friedman, "Permission Sought to Demolish 111 First St.," *Jersey Journal*, May 27, 2005; Ricardo Kaulessar, "111 First St.: Historic Preservation Commission Considers Demolition Application from Owner of Former Arts Center Site," *Jersey City Reporter*, May 29, 2005.
6. Friedman, "Permission Sought to Demolish 111 First St."; Kaulessar, "111 First St."
7. Daniel Horgan quoted in Friedman, "Permission Sought to Demolish 111 First St."
8. William Rodwell quoted in Kaulessar, "111 First St."
9. Friedman, "Permission Sought to Demolish 111 First St."; Kaulessar, "111 First St."
10. Friedman, "Permission Sought to Demolish 111 First St."; Kaulessar, "111 First St."
11. Interview with Kelly Darr, June 18, 2011.
12. Rodwell, *Timeline*; interview with Kelly Darr, June 18, 2011.
13. Paul Sullivan quoted in Friedman, "Permission Sought to Demolish 111 First St."; Paul Sullivan quoted in Kaulessar, "111 First St."
14. Jonathan Miller, "In Jersey City, the Day the Music Died," *New York Times*, May 8, 2005.
15. Tris McCall quoted in Miller, "In Jersey City, the Day the Music Died."
16. The memory of Uncle Joe's still looms large in the imagination and memory of the Jersey City arts scene. For the past several years, a local music promoter has organized a musical festival near Halloween in the Jersey City and Harsimus Cemetery, memorializing the departed bar and club. A music venue has yet to fill the void generated by the demise of Uncle Joe's. In fact, Jersey City still lacks a vibrant music scene.
17. David Donnelly quoted in Tina Kelley, "Artists Make Deal to Vacate Jersey City Site," *New York Times*, January 5, 2005.
18. Ray Mayer quoted in Ricardo Kaulessar, "To Demolish or Not: Fate of 111 First St. Still Undecided at Historic Preservation Meeting," *Jersey City Reporter*, July 3, 2005.
19. Kaulessar, "To Demolish or Not."

20. Elizabeth Onorato quoted in Kaulessar, "To Demolish or Not."

21. Kaulessar, "To Demolish or Not."

22. Steve Chambers, "From a Warehouse to a Skyscraper," *Newark Star-Ledger*, June 25, 2006; "110 and 111 First St.—Towers?," *Jersey City Reporter*, June 25, 2006.

23. Chambers, "From a Warehouse to a Skyscraper"; "110 and 111 First St.—Towers?"

24. Mariano Vega quoted in "110 and 111 First St.—Towers?"

25. Charles Kessler quoted in "110 and 111 First St.—Towers?"

26. Chambers, "From a Warehouse to a Skyscraper."

27. Ibid.

28. Interview, September 26, 2011.

29. Daniel Levin, "Power House District," July 28, 2006 (letter to editor).

30. Ibid.

31. Ibid.

32. Jefferson Graham, "It's Hip to Be Tech in Brooklyn's DUMBO," *USA Today*, May 7, 2013; Nadine Brozan, "Artists Canvassing for Space," *New York Times*, October 13, 2002.

33. Interview with Daniel Levin, September 13, 2013.

34. Interview, July 15, 2011.

35. Richard Florida, *The Rise of the Creative Class* (New York: Basic Books, 2002); Richard Florida, *Cities and the Creative Class* (New York: Routledge, 2005).

36. Mariano Vega quoted in Chambers, "From a Warehouse to a Skyscraper."

37. Antoinette Martin, "The Hanging Tower of Jersey City," *New York Times*, March 4, 2007.

38. Rem Koolhuas quoted in Jarrett Renshaw, "111 First: 1 of-a-Kind Idea," *Jersey Journal*, February 27, 2007.

39. Martin, "The Hanging Tower of Jersey City"; Renshaw, "111 First"; Russell Ben-Ali, "These 3 City Blocks Go Straight Up," *Newark Star-Ledger*, February 27, 2007.

40. Rem Koolhaas quoted in Martin, "The Hanging Tower of Jersey City."

41. Robert Cotter quoted in Renshaw, "111 First."

42. Jerramiah Healy quoted in Ben-Ali, "These 3 City Blocks."

43. Jerramiah Healy quoted in Renshaw, "111 First."

44. Jerramiah Healy quoted in Martin, "The Hanging Tower of Jersey City."

45. Ibid.

46. John Gomez quoted in Ben-Ali, "These 3 City Blocks."

47. Witold Rybczynski, *Makeshift Metropolis: Ideas about Cities* (New York: Scribner, 2010): 132–40. Rybczynski presents a good examination of the purported Bilbao effect.

48. Interview with William Rodwell, June 26, 2011.

49. Charles Kessler quoted in Peter Applebome, "Adjusting Vision of Waterfront Arts District to Include High Rises," *New York Times*, May 15, 2008.

50. Applebome, "Adjusting Vision of Waterfront Arts District"; Joshua Brustein, "High Rises at Center of Arts District Debate," *New York Times*, May 18, 2008; interview, September 26, 2011.

51. Steven Fulop quoted in Brustein, "High Rises at Center of Arts District Debate."

52. Applebome, "Adjusting Vision of Waterfront Arts District"; Brustein, "High Rises at Center of Arts District Debate."

53. Charles Kessler quoted in Applebome, "Adjusting Vision of Waterfront Arts District."

54. Robert Antonicello quoted in in Applebome, "Adjusting Vision of Waterfront Arts District."

55. [Daniel Levin], *History of the Powerhouse Arts District (unpublished document)*.

56. Robert Koch quoted in Laura Kusisto, "Tower Ruffles an Arts Disrict," *Wall Street Journal*, June 24, 2012.

57. Robert Cotter quoted in Jon Whiten, "Neighborhood Spotlight: The Powerhouse Arts District," *New Magazine* (winter 2011): 8.

58. Interview with Kay Kenny, July 27, 2011.

59. Interview with Kelly Darr, June 18, 2011.

60. Interview, June 8, 2011; interview, September 7, 2011.

61. Terrence McDonald, "Jersey City's Historic Preservation Commission Votes to Nominate 5 Downtown Warehouses for Local Landmark Status," *Jersey Journal*, February 12, 2011. In the spirit of full disclosure, I voted for this landmark status in my position as a historic preservation commissioner for Jersey City. This vote occurred several years after the demolition of 111 1st Street. In my interviews and exchanges with sources, I never disclosed my volunteer position with the city, so as to avoid any possible conflicts of interest or to suggest that I represented the city in any way.

62. Terrence McDonald, "Jersey City Withdraws Request to Abolish Affordable-Housing Requirement in First Street Tower," *Jersey Journal*, May 9, 2012; Terrence McDonald, "Powerhouse Arts District Group Objects to Jersey City's Affordable-Housing Plan for 110 First St.," *Jersey Journal*, May 10, 2012; E. Assata Wright, "Affordable Housing vs. Financing," *Jersey City Reporter*, May 20, 2012; Kusisto, "Tower Ruffles an Arts District."

63. Steven Fulop quoted in McDonald, "Jersey City Withdraws Request."

64. Kevin Pollock quoted in McDonald, "Powerhouse Arts District Group Objects."

65. Steven Fulop quoted in Terrence McDonald, "110 First St. Developer Proposes Building 10 On-Site Affordable Housing Units, Instead of 25," *Jersey Journal*, July 16, 2012.

66. Terrence McDonald, "Jersey City Lauds Long-Awaited Construction of $180 million Residential Tower," *Jersey Journal*, March 13, 2013; Terrence McDonald, "Jersey City Groundbreaking for 110 First Street Tower That Will Have 350 Rental Units," *Jersey Journal*, March 14, 2013.

67. Jerramiah Healy quoted in McDonald, "Jersey City Lauds Long-Awaited Construction."

68. Kevin Pollock quoted in McDonald, "Powerhouse Arts District Group Objects."

7. What Might Be Learned?

1. John Hallanan III quoted in Michael C. Gabrielle, *The History of Diners in New Jersey* (Charleston, S.C.: American Palate, 2013): 120–21. Interestingly enough, Hallanan was discussing diners as important fixtures in Jersey City and New Jersey history.

2. Walter Benjamin, "The Work of Art in the Age of Its Technological Reporducibility," in *The Work of Art in the Age of Its Technological Reproducibility, and Other Writings on Media*, ed. Michael W. Jennings, Brigid Doherty, and Thomas Y. Levin, trans. Edmund Jephcott and others (Cambridge, Mass.: Belknap Press of Harvard University Press: 2008): 19–55.

3. Ibid.: 23.

4. Sam Roberts, "The Old Neighborhood," *New York Times*, May 28, 2006.

5. Henry James, *The American Scene* (New York: Horizon Press, 1967): 77.

6. Interview with Tris McCall, November 3, 2016.

7. Interview with Daniel Levin, November 5, 2016.

8. Affordable housing—for the middle class, not just the impoverished—is increasingly becoming a public policy issue for urban areas with rapidly rising housing values. If cities such as Jersey City, Washington, and others hope to maintain a mix of incomes, professions, and classes in their cities, addressing and alleviating the *affordable* housing crisis is essential.

9. Terrence McDonald, "Jersey City Loses Bid to Boot Non-Profit Group from Loew's," *Jersey Journal*, May 29, 2015.

10. Claire Voon, "Jersey City Censors a Public Artwork It Commissioned," *Hyperallergic*, July 26, 2016 (http://hyperallergic.com/313744/jersey-city-censors-a-public-artwork-it-commissioned/); Cindy Rodriguez, "A Jersey City Mural Gets Painted Over After a Variety of Complaints," *WNYC*, July 29, 2016 (http://www.wnyc.org/story/jersey-city-mural-gets-painted-over-after-variety-complaints/); Terrence McDonald, "Questions Linger After Jersey City Paints Over Controversial Monopoly Mural," *Jersey Journal*, July 26, 2016.

11. Interview with Kay Kenny, November 3, 2016.

12. Interview with Daniel Levin, November 5, 2016.

Conclusion: Some Years Later

1. Terrence T. McDonald, "Jersey City's Historic Preservation Commission Votes to Nominate 5 Downtown Warehouses for Local Landmark Status," *Jersey Journal*, February 12, 2011.

2. Terrence T. McDonald, "Powerhouse Being Redeveloped in Downtown Jersey City Must Lose Its Old Smokestacks," *Jersey Journal*, March 27, 2013.

3. Terrence McDonald, "Jersey City 'Disgusted' with Developer Who Demolished City Park," *Jersey Journal*, March 13, 2015.

4. Madelon Powers, *Faces Along the Bar: Lore and Order in the Workingman's Saloon, 1870–1920* (Chicago: University of Chicago Press, 1998): 211; 207–26. Powers's book provides a great, colorful portrait of a lost pre-Prohibition and urban world and a neighborhood and working-class institution—the local tavern.

5. A cursory search of the *New York Times Index* using the search terms "artists" and "gentrification" found fifty-five stories published just between January 1, 2016, and December 31, 2016.

6. Robert Putnam is the most well-known critic of this social deterioration. His work *Bowling Alone* is a convincing and eloquent account of the steep and threatening decline of American sociability and of the commonweal. This book was written well before the advent of smartphones, high-speed Internet, Netflix, and iTunes. One might wonder how Putnam's criteria would measure our culture today, a mere decade and some years after its initial publication. Robert Putnam, *Bowling Alone: The Collapse and Revival of American Community* (New York: Simon & Schuster, 2000).

7. William Wordsworth, "The World Is Too Much with Us," in *The Norton Anthology of English Literature*, ed. M. H. Abrams, 6th ed. (New York: Norton, 1996): 1394.

8. Interview, September 12, 2013.

Bibliography

Anasi, Robert. *The Last Bohemia: Scenes from the Life of Williamsburg, Brooklyn.* New York: FSG Originals, 2012.

Bain, Alison L. "Constructing Contemporary Artistic Identities in Toronto Neighbourhoods." *The Canadian Geographer* 47, no. 3 (2003): 303–17.

———. "Resisting the Creation of Forgotten Places: Artistic Production in Toronto Neighbourhoods." *The Canadian Geographer* 50, no. 4 (2006): 417–31.

Barth, Gunther. *City People: The Rise of Modern City Culture in Nineteenth-Century America.* New York: Oxford University Press, 1982.

Beauregard, Robert A. "Trajectories of Neighborhood Change: The Case of Gentrification." *Environment and Planning A* 22 (1990): 855–74.

———. *When America Became Suburban.* Minneapolis: University of Minnesota Press, 2006.

Bell, Daniel. *The Coming of Postindustrial Society: A Venture in Social Forecasting.* New York: Basic Books, 1973.

Benjamin, Walter. "Paris, Capital of the Nineteenth Century." In *The Arcades Project*, trans. Howard Eiland and Kevin McLaughlin. Cambridge, Mass.: Belknap Press of Harvard University Press, 1999.

———. "The Work of Art in the Age of Its Technological Reproducibility, and Other Writings on Media." In *The Work of Art in the Age of Its Technological Reproducibility, and Other Writings on Media*, ed. Michael W. Jennings, Brigid Doherty, and Thomas Y. Levin; trans. Edmund Jephcott, Rodney Livingstone, Howard Eiland, and Others. Cambridge, Mass.: Belknap Press of Harvard University Press, 2008.

Bernt, Matthias. "The 'Double Movements' of Neighborhood Change: Gentrification and Public Policy in Harlem and Prenzlauer Berg." *Urban Studies* 49, no. 14 (November 2012): 3045–62.

Borys, Hazel. "Richard Florida on Technology, Talent, and Tolerance." *Place-makers*, November 18, 2013. http://www.placemakers.com/2013/11/18/richard-florida-on-tech-talent-and-tolerance/.

Brenner, Neil, and Nik Theodore, eds. *Spaces of Neoliberalism: Urban Restructuring in North America and Western Europe*. Malden, Mass.: Blackwell, 2002.

Broderick, James F. *Paging New Jersey: A Literary Guide to the Garden State*. New Brunswick, N.J.: Rutgers University Press, 2003.

Bromley, Rosemary D.F., Andrew R. Tallon, and Colin J. Thomas. "City Centre Regeneration through Residential Development: Contributing to Sustainability." *Urban Studies* 42, no. 13 (December 2005): 2407–29.

Brown-Saracino, Japonica. *A Neighborhood That Never Changes: Gentrification, Social Preservation, and the Search for Authenticity*. Chicago: University of Chicago Press, 2009.

Brueckner, Jan K., and Stuart S. Rosenthal. "Gentrification and Neighborhood Housing Cycles: Will America's Future Downtowns Be Rich?" *The Review of Economics and Statistics* 91, no. 4 (November 2009): 725–43.

Bureau of Labor Statistics. "Occupational Outlook Handbook: Craft and Fine Artists." December 17, 2015. http://www.bls.gov/ooh/arts-and-design/craft-and-fine-artists.htm.

Butler, Tim. "For Gentrification?" *Environment and Planning A* 39, no. 1 (January 2007): 162–81.

————. "Re-urbanizing London Docklands: Gentrification, Suburbanization or New Urbanism?" *International Journal of Urban and Regional Research* 31, no. 4 (December 2007): 759–81.

Cahill, A. Wayne. *Historical Sketch of Stone Mill and Surrounding Land*. [Bronx, NY: New York Botanical Garden], 2010.

————. *Lorillard Operations*. [Bronx, NY: New York Botanical Garden], 2010.

Cameron, Stuart, and Jon Coaffee. "Art, Gentrification and Regeneration—From Artist as Pioneer to Public Arts." *European Journal of Housing Policy* 5, no. 1 (April 2005): 39–58.

Casellas, Antònia, Esteve Dot-Jutgla, and Montserrat Pallares-Barbera. "Artists, Cultural Gentrification and Public Policy." *Urbani Izziv* 23, suppl. 1 (2012): 104–14.

Catungal, John Paul, and Deborah Leslie. "Placing Power in the Creative City: Governmentalities and Subjectivities in Liberty Village, Toronto." *Environment and Planning A* 41 (2009): 2576–94.

Catungal, John Paul, Deborah Leslie, and Yvonne Hii. "Geographies of Displacement in the Creative City: The Case of Liberty Village, Toronto." *Urban Studies* 46, no. 5/6 (May 2009): 1095–114.

Chapple, Karen, and Shannon Jackson. "Commentary: Arts, Neighborhoods, and Social Practice: Towards an Integrated Epistemology of Community Arts." *Journal of Planning Education and Research* 29, no. 4 (2010): 478–90.

Chidester, Robert C., and David A. Gadsby. "One Neighborhood, Two Communities: The Public Archaeology of Class in a Gentrifying Urban

Neighborhood." *International Labor and Working-Class History* 76 (Fall 2009): 127–46.

Cizler, Jasna. "Urban Regeneration Effects on Industrial Heritage and Local Community—Case Study: Leeds, UK." *Sociologija i Prostor* 50, no. 2 (2012): 223–36.

Clark, Terry, Richard Lloyd, Kenneth K. Wong, and Pushpam Jain. "Amenities Drive Urban Growth." *Journal of Urban Affairs* 24, no. 5 (2002): 493–515.

Cohendet, Patrick, David Grandadam, and Laurent Simon. "The Anatomy of the Creative City." *Industry and Innovation* 17, no. 1 (February 2010): 91–111.

Cole, David B. "Artists and Urban Development." *Geographical Review* 77, no. 4 (October 1987): 391–407.

Curran, Winifred. "From the Frying Pan to the Oven: Gentrification and the Experience of Industrial Displacement in Williamsburg, Brooklyn." *Urban Studies* 44, no. 8 (July 2007): 1427–40.

———. "In Defense of Old Industrial Spaces: Manufacturing, Creativity and Innovation in Williamsburg, Brooklyn." *International Journal of Urban and Regional Research* 34, no. 4 (December 2010): 871–85.

Curran, Winifred, and Trina Hamilton. "Just Green Enough: Contesting Environmental Gentrification in Greenpoint, Brooklyn." *Local Environment* 17, no. 9 (October 2012): 1027–42.

Currid, Elizabeth. "Bohemia as Subculture:'Bohemia' as Industry: Art, Culture, and Economic Development." *Journal of Planning Literature* 23, no. 4 (May 2009): 368–82.

———. *The Warhol Economy.* Princeton, N.J.: Princeton University Press, 2009.

Currier, Jennifer. "Art and Power in the New China: An Exploration of Beijing's 798 District and Its Implications for Contemporary Urbanism." *Town Planning Review* 79, no. 2–3 (2008): 237–65.

Davidson, Justin. "Is Gentrification All Bad?" *New York* (February 10, 2014): 36–75.

Davidson, Mark. "Spoiled Mixture: Where Does State-led 'Positive' Gentrification End?" *Urban Studies* 45, no. 12 (November 2008): 2385–405.

Davidson, Mark, and Loretta Lees. "New-Build Gentrification: Its Histories, Trajectories, and Critical Geographies." *Population, Space and Place* 16 (2010): 395–411.

Dunkak, Harry. "The Lorillard Family of Westchester County: Tobacco, Property and Nature." *The Westchester Historian* 71, no. 3 (summer 1995): 51–58.

Eckerd, Adam. "Cleaning Up without Cleaning Out? A Spatial Assessment of Environmental Gentrification." *Urban Affairs Review* 47, no. 1 (2011): 31–59.

Edensor, Tim. *Industrial Ruins: Spaces, Aesthetics, and Materiality.* New York: Berg, 2005.

Ellis, Edward Robb. *The Epic of New York City: A Narrative History.* New York: Old Town Books, 1966.

Falconer, Bruce. "Eviction Noticed: Gentrification in Berlin Shutters a

Bombed-Out Building Where Artists Had Squatted Since the Wall Came Down." *American Scholar* 82, no. 1 (winter 2013): 100–4.

Feagin, Joe R., and Robert Parker. *Building American Cities: The Urban Real Estate Game.* Englewood Cliffs, N.J.: Prentice-Hall, 1990.

Filicko, Therese, and Sue Anne Lafferty. "Defining the Arts and Cultural Universe: Lessons from the Profiles Project." *Journal of Arts Management, Law & Society* 32, no. 3 (2002): 185–205.

Fisher, James T. *On the Irish Waterfront: The Crusader, the Movie, and the Soul of the Port of New York.* Ithaca, N.Y.: Cornell University Press, 2009.

Florida, Richard. *Cities and the Creative Class.* New York: Routledge, 2005.

———. "More Losers Than Winners in America's New Economic Geography." *Atlantic Cities,* January 13, 2013. http://www.theatlanticcities.com/jobs-and-economy/2013/01/more-losers-winners-americas-new-economic-geography/4465/.

———. *The Rise of the Creative Class.* New York: Basic Books, 2002.

Fox, Maxwell. *The Lorillard Story.* Researched by Carl W. Drepperd. [New York: P. Lorillard Company], 1947.

Frank, Thomas. "Getting to Eureka." *Harper's Magazine* (June 2013): 7–9.

Freeman, Lance. *There Goes the 'Hood: Views of Gentrification from the Ground Up.* Philadelphia: Temple University Press, 2006.

Gabrielle, Michael C. *The History of Diners in New Jersey.* Charleston, S.C.: American Palate, 2013.

Geismar, Joan H. *Lorillard Snuff Mill, New York Botanical Garden, Bronx County, New York: Memo Report/Archaeological Assessment.* [Bronx, NY: New York Botanical Garden, Lionel Goldfrank III Institutional Mapping Dept.], 2008.

Gibson, DW. *The Edge Becomes the Center: An Oral History of Gentrification in the Twenty-First Century.* New York: Overlook Press, 2015.

Hackworth, Jason. *The Neoliberal City: Governance, Ideology, and Development in American Urbanism.* Ithaca, N.Y.: Cornell University Press, 2007.

Hackworth, Jason, and Neil Smith. "The Changing State of Gentrification." *Tijdschrift voor Economische en Sociale Geografie* 92, no. 4 (2001): 464–77.

Hamnett, Chris, and Drew Whitelegg. "Loft Conversion and Gentrification in London: From Industrial to Postindustrial Land Use." *Environment and Planning A* 39 (2007): 106–24.

Harris, Andrew. "Art and Gentrification: Pursuing the Urban Pastoral in Hoxton, London." *Transactions of the Institute of British Geographers* (2011): 1–16.

Hart, Steven. *The Last Three Miles: Politics, Murder, and the Construction of America's First Superhighway.* New York: New Press, 2007.

Harvey, David. *The Limits to Capital.* Chicago: University of Chicago Press, 1982.

———. *Rebel Cities: From the Right to the City to the Urban Revolution.* New York: Verso, 2012.

———. "The Right to the City." *New Left Review* 53 (September/October 2008): 23–40.

Hughes, Evan. "Consider the Gentrifier." *Tin House* 14, no. 1 (autumn 2012): 35–40.

Indergaard, Michael. "What to Make of New York's New Economy? The Politics of the Creative Field." *Urban Studies* 45, no. 5/6 (May 2009): 1063–93.

Industries of New Jersey: Hudson, Passaic and Bergen Counties. New York: Historical Publishing Co., 1883.

Jackson, Jeffrey H. "Artistic Community and Urban Development in 1920s Montmartre." *French Politics, Culture & Society* 24, no. 2 (summer 2006): 1–25.

Jacobs, Jane. *The Death and Life of Great American Cities.* New York: Vintage, 1992.

James, Henry. *The American Scene.* New York: Horizon Press, 1967.

James, Rick. *Warehouse Historic District, Jersey City, NJ: State & National Registers of Historic Places Nomination.* http://jclandmarks.org/nomination-warehouse district.shtml.

Jersey City: Past and Present. http://www.njcu.edu/programs/jchistory/entries.htm.

Jersey City Ordinance. 96–069 (June 26, 1996).

Jonas, Andrew E.G., and David Wilson, eds. *The Urban Growth Machine: Critical Perspectives, Two Decades Later.* Albany: State University of New York Press, 1999.

Karnoutsos, Carmela. "Frank Hague, 1876–1956, Mayor of Jersey City, 1917–1947 (Retired)." *Jersey City: Past and Present.* http://www.njcu.edu/programs/jchistory/Pages/H_Pages/Hague_Frank.htm.

———. "Leonard J. Gordon Park." *Jersey City: Past and Present.* http://www.njcu.edu/programs/jchistory/pages/L_Pages/Leonard_Gordon_Park.htm.

———. "P. Lorillard Tobacco Company." *Jersey City Past and Present.* http://www.njcu.edu/programs/jchistory/pages/L_Pages/Lorillard_Tobacco.htm.

Karttunen, Sari. "How to Identify Artists? Defining the Population for 'Status-of-the Artist' Studies." *Poetics* 26 (1998): 1–19.

Katz, Alyssa. "Gentrification Hangover." *American Prospect* 21, no. 1 (January/February 2010): 17–21.

Kerstein, Robert. "Stage Models of Gentrification: An Examination." *Urban Affairs Quarterly* 25, no. 4 (June 1990): 620–39.

Kohn, Margaret. "Toronto's Distillery District: Consumption and Nostalgia in a Post-Industrial Landscape." *Globalizations* 7, no. 3 (September 2010): 359–69.

Kostelanetz, Richard. *Artists' SoHo: 49 Episodes of Intimate History.* New York: Fordham University Press, 2015.

Krätke, Stefan. "Creative Cities and the Rise of the Dealer Class: A Critique of Richard Florida's Approach to Urban Theory." *International Journal of Urban and Regional Research* 34, no. 4 (December 2010): 835–53.

Kromer, David. *Fixing Broken Cities.* New York: Routledge, 2010.

Krumholz, Norman, and Pierre Clavel. *Reinventing Cities: Equity Planners Tell Their Stories.* Philadelphia: Temple University Press, 1994.

Kunstler, James Howard. *The Geography of Nowhere: The Rise and Decline of America's Man-Made Landscape.* New York: Simon & Schuster, 1994.

Lawless, Paul. "Power and Conflict in Pro-growth Regimes: Tensions in Economic Development in Jersey City and Detroit." *Urban Studies* 39, no. 8 (2002): 1329–46.

Lees, Loretta. "A Reappraisal of Gentrification: Towards a 'Geography of Gentrification.'" *Progress in Human Geography* 24, no. 3 (2000): 389–408.

———. "Super-Gentrification: The Case of Brooklyn Heights, New York City." *Urban Studies* 40, no. 12 (November 2003): 2487–509.

———. "Urban Renaissance in an Urban Recession: the End of Gentrification?" *Environment and Planning A* 41 (2009): 1529–33.

Lees, Loretta, Tom Slater, and Elvin Whyly. *Gentrification*. New York: Routledge, 2008.

Legal Services of New Jersey. *Tenants' Rights in New Jersey: A Legal Manual for Tenants in New Jersey*. Edison: Legal Services of New Jersey, 2007.

[Levin, Daniel]. *History of the Powerhouse Arts District*. Unpublished document.

[Levin, Daniel]. *Timeline of 111 First Street & Jersey City's Arts District*. Unpublished document.

Ley, David. "Artists, Aestheticisation and the Field of Gentrification." *Urban Studies* 40, no. 12 (November 2003): 2527–44.

———. *The New Middle Class and the Remaking of the Central City*. New York: Oxford University Press, 1996.

Ley, David, and Cory Dobson. "Are There Limits to Gentrification? The Contexts of Impeded Gentrification in Vancouver." *Urban Studies* 45, no. 12 (November 2008): 2471–98.

Lippard, Lucy R. "Low Life in Lower Manhattan." *Archives of American Art Journal* 49, no. 3/4 (2010): 34–39.

Lloyd, Richard. "The Neighborhood in Cultural Production: Material and Symbolic Resources in the New Bohemia." *City & Community* 3, no. 4 (December 2004): 343–72.

———. *Neo-Bohemia: Art and Commerce in the Postindustrial City*. New York: Routledge, 2006.

Logan, John R., and Harvey L. Molotch. *Urban Fortunes: The Political Economy of Place*. Berkeley: University of California Press, 1987.

Lubrano, Alfred. *Limbo: Blue-Collar Roots, White-Collar Dreams*. Hoboken, N.J.: Wiley, 2005.

Lynch, Kevin. *The Image of the City*. Cambridge, Mass.: Technology Press and Harvard University Press, 1960.

Makagon, Daniel. "Bring on the Shock Troops: Artists and Gentrification in the Popular Press." *Communication and Critical/Cultural Studies* 7, no. 1 (March 2010): 26–52.

Maliszewski, Paul. "Flexibility and Its Discontents." *The Baffler* 1, no. 16 (2004): 69–79.

Manzo, Louis. *Ruthless Ambition: The Rise and Fall of Chris Christie*. Walterville, Ore.: Trine Day, 2014.

Markusen, Ann. "Artists Work Everywhere." *Work and Occupations* 40, no. 4 (November 2013): 481–95.

———. "Urban Development and the Politics of a Creative Class: Evidence from a Study of Artists." *Environment and Planning A* 38 (2006): 1921–40.

Markusen, Ann, and Greg Schrock. "The Artistic Dividend: Urban Artistic Specialization and Economic Development Implications." *Urban Studies* 43, no. 10 (September 2006): 1661–86.

Marquardt, Nadine, Henning Füller, Georg Glasze, and Robert Pütz. "Shaping the Urban Renaissance: New-Build Luxury Developments in Berlin." *Urban Studies* 50, no. 8 (June 2013): 1540–56.

Mathews, Vanessa. "Artcetera: Narrativising Gentrification in Yorkville, Toronto." *Urban Studies* 45, no. 13 (December 2008): 2849–76.

Mele, Christopher. *Selling the Lower East Side: Culture, Real Estate, and Resistance in New York City*. Minneapolis: University of Minnesota Press, 2000.

Muller, Mike. "Artist Displacement." *Gotham Gazette*, November 21, 2006.

Murdie, Robert, and Carlos Teixeira. "The Impact of Gentrification on Ethnic Neighborhoods in Toronto: A Case Study of Little Portugal." *Urban Studies* 48, no. 1 (January 2011): 61–83.

NJN News. "Solid State Opening at 111 First St." NJN, November 24, 1995. http://www.youtube.com/user/underdevelopmentTV#p/u/38/nPdI_c0QDUk.

111 First Street: From Paris to Jersey City, They Showed No Love. Directed by Branko. 2013.

Osman, Suleiman. *The Invention of Brownstone Brooklyn: Gentrification and the Search for Authenticity in Postwar New York*. New York: Oxford University Press, 2013.

Panetta, Roger, ed. *Dutch New York: The Roots of Hudson Valley Culture*. New York: Fordham University Press, 2009.

Pashup, Jennifer. "Searching for the New Bohemia: Gentrification and the Life Course Dynamics of Neighborhood Change." Annual Meeting of the American Sociological Association, San Francisco, Calif., 2004.

Pattaroni, Luca, Vincent Kaufmann, and Marie-Paule Thomas. "The Dynamics of Multifaceted Gentrification: A Comparative Analysis of the Trajectories of Six Neighbourhoods in the Île-de-France Region." *International Journal of Urban and Regional Research* 36, no. 6 (November 2012): 1223–41.

[P. Lorillard Company]. *Lorillard and Tobacco: 200th Anniversary, P. Lorillard Company: 1760–1960* [Greensboro, N.C.: P. Lorillard Company, 1960].

Podmore, Julie. "(Re)Reading the 'Loft Living' *Habitus* in Montréal's Inner City." *International Journal of Urban and Regional Research* 22, no. 2 (1998): 283–302.

Porter, Michael. "The Rent Gap at the Metropolitan Scale: New York City's Land-Value Valleys, 1990–2006." *Urban Geography* 31, no. 3 (2010): 385–405.

Powers, Madelon. *Faces Along the Bar: Lore and Order in the Workingman's Saloon, 1870–1920.* Chicago: University of Chicago Press, 1999.

Pratt, Andy C. "Urban Regeneration: From the Arts 'Feel Good' Factor to the Cultural Economy: A Case Study Study of Hoxton, London." *Urban Studies* 46, no. 5/6 (May 2009): 1041–61.

Prior, James T. "Jersey City: America's Golden Door." *New Jersey Business* 45, no. 1 (January 1999): 30–46.

Putnam, Robert. *Bowling Alone: The Collapse and Revival of American Community.* New York: Simon & Schuster, 2000.

Rérat, Patrick, Ola Söderström, and Etienne Piguet. "New Forms of Gentrification: Issues and Debates." *Population, Space and Place* 16 (2010): 335–43.

Rodwell, William. *Timeline: 111 First Street, Jersey City, NJ: 1866–2005.* Unpublished document.

Rodwell, William. *Working Here: Art at 111.* Jersey City: Composition Printing, 2001.

Rose, Damaris. "Discourses and Experiences of Social Mix in Gentrifying Neighbourhoods: A Montréal Case Study." *Canadian Journal of Urban Research* 13, no. 2 (2004): 278–316.

Rounds, Kate. "The Fate of 111 First Street: Artists, Development, and the Destiny of a City." *Jersey City Magazine* 6, no. 2 (fall/winter 2009/2010): 52–57.

Rybczynski, Witold. *Makeshift Metropolis: Ideas about Cities.* New York: Scribner, 2010.

Schwartz, Madeleine. "The Art of Gentrification." *Dissent* (winter 2014): 5–8.

Seigel, Jerrold. *Bohemian Paris: Culture, Politics, and the Boundaries of Bourgeois Life, 1830–1930.* New York: Viking, 1986.

Seman, Michael. "How a Music Scene Functioned as a Tool for Urban Redevelopment: A Case Study of Omaha's Slowdown Project." *City, Culture, & Society* 1, no. 4 (December 2010): 207–15.

Shaw, Samuel. "White Night": Gentrification, Racial Exclusion, and Perceptions and Participation in the Arts." *City & Community* 10, no. 3 (September 2011): 241–64.

Sherman, Ted, and Josh Margolin. *The Jersey Sting: Chris Christie and the Most Brazen Case of Jersey-Style Corruption—Ever.* New York: St. Martin's Griffin, 2012.

Shkuda, Aaron. "The Art Market, Arts Funding and Sweat Equity: The Origins of Gentrified Retail." *Journal of Urban History* 39, no. 4 (July 2013): 601–19.

Shorto, Russell. *The Island at the Center of the World: The Epic Story of Dutch Manhattan and the Forgotten Colony That Shaped America.* New York: Doubleday, 2004.

Slater, Tom. "The Eviction of Critical Perspectives from Gentrification Research." *International Journal of Urban and Regional Research* 30, no. 4 (December 2006): 737–57.

———. "Looking at the 'North American City' Through the Lens of Gentrification Discourse." *Urban Geography* 23, no. 2 (2002): 131–53.

———. "Municipally Managed Gentrification in South Parkdale, Toronto." *Canadian Geographer* 48, no. 3 (Fall 2004): 303–25.

———. "North American Gentrification? Revanchist and Emancipatory Perspectives Explored." *Environment and Planning A* 36 (2004): 1191–213.

Smith, Heather, and William Graves. "Gentrification as Corporate Growth Strategy: The Strange Case of Charlotte, North Carolina and the Bank of America." *Journal of Urban Affairs* 27, no. 4 (2005): 403–18.

Smith, Neil. "New Globalism, New Urbanism: Gentrification as Global Urban Strategy." *Antipode* 34, no. 3 (2002): 427–50.

———. *The New Urban Frontier: Gentrification and the Revanchist City*. London: Routledge, 1996.

Stanger, Ilana. "The Gentrification Game: Are Artists Pawns or Players in the Gentrification of Low-Income Urban Neighborhoods?" *Mn Artists*, April 22, 2004. http://www.mnartists.org/article/gentrification-game.

Stapinski, Helene. *Five-Finger Discount: A Crooked Family History*. New York: Random House, 2001.

State of the Arts. "Studio Tour 2000." NJN, [autumn 2000]. http://www.youtube.com/user/underdevelopmentTV#p/u/20/1VzzmhCq3oo.

Stern, Mark J., and Susan C. Seifert. "Cultural Clusters: The Implications of Cultural Assests Agglomeration for Neighborhood Revitalization." *Journal of Planning Education and Research* 29, no. 3 (2010): 262–79.

Strom, Elizabeth. "Artist Garret as Growth Machine? Local Policy and Artist Housing in U.S. Cities." *Journal of Planning Education and Research* 29, no. 3 (2010): 367–78.

———. "Converting Pork into Porcelain: Cultural Institutions and Downtown Development." *Urban Affairs Review* 38, no. 3 (September 2002): 3–21.

Sweetser, Moses Foster. *King's Handbook of the United States*. Buffalo, N.Y.: Moses King Corp., 1892.

Tumber, Catherine. *Small, Gritty, and Green: The Promise of America's Smaller Industrial Cities in a Low-Carbon World*. Cambridge, Mass.: MIT Press, 2011.

Urban Land Institute. "Learn About ULI." http://www.uli.org/LearnAbout ULI.aspx.

———. "The Mission and Priorities of ULI." http://www.uli.org/LearnAbout ULI/WhatWeDo/MissionandPrinciples.aspx.

Vernon, Leonard F. *The Life & Times of Jersey City Mayor Frank Hague: I Am the Law*. Charleston, S.C.: History Press, 2011.

Wacquant, Loïc. "Relocating Gentrification: The Working Class, Science and the State in Recent Urban Research." *International Journal of Urban and Regional Research* 32, no. 1 (March 2008): 198–205.

Watson, S. "Gilding the Smokestacks: The New Symbolic Representations of Deindustrialised Regions." *Environment and Planning D: Society & Space* 9 (1991): 59–70.

WPIX Channel 11 News. "The New SoHo." November 11, 1996. http://www.youtube.com/watch?v=SWLldtUUsv4&feature=related.

Wicks, Hamilton S. "American Industries—No. 1." *Scientific American* 11, no. 2 (January 11, 1879): 17.

Wordsworth, William. "The World Is Too Much with Us." In *The Norton Anthology of English Literature*, ed. M. H. Abrams, 6th ed. New York: Norton, 1996.

Wyly, Elvin K., and Daniel J. Hammel. "Islands of Decay in Seas of Renewal: Housing Policy and the Resurgence of Gentrification." *Housing Policy Debate* 10, no. 4 (1999): 711–71.

Yoon, Heeyeun, and Elizabeth Currid-Halkett. "Industrial Gentrification in West Chelsea, New York: Who Survived and Who Did Not? Empirical Evidence from Discrete-Time Survival Analysis." *Urban Studies* 52, no. 1 (January 2015): 20–49.

Zukin, Sharon. "Changing Landscapes of Power: Opulence and the Urge for Authenticity." *International Journal of Urban and Regional Research* 33, no. 2 (June 2009): 543–55.

——. *The Culture of Cities*. Cambridge, Mass.: Blackwell, 1995.

——. "Gentrification: Culture and Capital in the Urban Core." *Annual Review of Sociology* 13 (1987): 129–47.

——. *Loft Living: Culture and Capital in Urban Change*. Baltimore: Johns Hopkins University Press, 1982.

——. *Naked City: The Death and Life of Authentic Urban Spaces*. New York: Oxford University Press, 2011.

——. "New Retail Capital and Neighborhood Change: Boutiques and Gentrification in New York City." *City & Community* 8, no. 1 (March 2009): 47–64.

Index

111 1st Street, 9–10, 21–22, 28, 83–84, 111; afterlife of, 129; as artistic center, 1–2, 26–28, 30, 39, 68, 113, 115; artists dispersed after demolition, 80, 115, 117; built in Greek Revival style, 9; as cautionary tale, 110–11; community spirit in, 40–41, 65, 85, 110; criminal activity in, 46–47, 55; curfew imposed on, 41, 43, 50–52, 55, 72, 147n14; decline in artists morale, 42, 80; demolition of building, 1, 5–7, 63, 73, 77–80, 101, 113; erasure from Jersey City history, 113, 122–23; eviction of artists from, 1, 3, 6–7, 63, 79; failure of politicians to support artists, 117; fires in, 58, 75; as frontier, 53; historic significance of, 111–13; illegal residents, 43–44, 65; lack of memorial, 113; missed opportunity for relocation, 116; part of historic district, 70, 75, 86, 90; plans for new Koolhaas building, 100–3, 106; renamed "Arts Center on First," 30–31; repairs ordered, 77–78; rezoning for artists studios, 35–36; Russian immigrants, 47; settlement with tenants, 79–80, 90; smokestack, 16, 88; tenants' association, 50, 52, 54, 63, 65, 70, 81–82, 87, 117,

148n1; tenants' plans for retrofitting, 65–67; uniformed off-duty police as security guards, 72–73, 76; women had little influence, 81. See also *arts grants agencies*; Goldman, Lloyd; New Gold Equities; Pro Arts; Tedesco, Gennaro; WALDO

111 First Street: From Paris to Jersey City, They Showed No Love, 4

Adolph and Esther Gottleib Foundation, 134

AEG (Anschutz Entertainment Group), 119

affordable housing, 69, 108, 157nn62–65, 158n8; for artists, 23, 56–57, 74, 87, 93, 105, 117, 121, 145n43, 152n5

Akmanov, Rashid, 131

Albany, NY, 98

American Revolution, 11, 112

Anasi, Robert, 151n39

Andrews, Marnie, 131

anti-Catholicism, 4–5

anti-Semitism, 4–5

Arning, Bill, 131

artists, 1, 79–80, 115; arts neighborhoods, 30, 125–26, 151n30; community-building, 110, 119, 127, 129, 150n30;

171

Jersey City Medical Center, 67
Jersey City municipal government, 30,
32, 51–52, 67, 72, 97; arts district
ordinance, 36–37; attempt to take over
Loew's Wonder Theatre, 119; corporate,
hierarchical mentality of, 118–19; City
Planning Department, 35, 37, 67, 95,
99, 107; conflict between short- and
long-term plans, 97; concessions to de-
velopers, 96, 101, 106, 115–16; Depart-
ment of Public Works, 119; Division
of Cultural Affairs, 61; and eminent
domain, 45, 70–71, 73, 77, 118; failure
to keep promises of support to artists,
117; Fire Department, 58, 75–76;
granted variance to New Gold for
high-rise, 108; Historic Preservation
Commission, 5, 86–87, 89, 91–92,
157n61; Housing, Economic Develop-
ment, and Commerce Department,
67; landmarked Powerhouse Arts
District buildings, 73–74, 107, 157n61;
Planning Department, 37; Police
Department, 47, 55, 72–73, 76, 78,
86, 153n22; relations with New Gold
Equities, 45–46, 60, 67–70, 73–75, 80,
92, 107–8, 118; sued by Goldman, and
countersuit, 92; values of, 110, 116;
zoning ordinances unenforced, 95–96,
106. *See also* WALDO (Work and Live
District Overlay)
Jersey City Mural Arts Program, 38, 119
Jersey City Museum, 38, 68, 83, 98
Jersey City neighborhoods: Commu-
nipaw, 81; downtown, 3, 25, 52, 71,
121, 148n10; Exchange Place, 2, 36;
Gold Coast, 150n18; Greenville, 25;
Hamilton Park, 25; Harborfront, 52;
Harsimus Cove, 25; Heights, the, 16,
25, 59; Journal Square, 121; Marion, 20;
Newport, 25, 29, 36; Paulus Hook, 25;
Van Vorst Park, 25, 32; Village, the, 25;
Wall Street West, 150n18; warehouse
district, 26, 29, 35, 52, 157n61; water-
front, 150n18. *See also* Powerhouse Arts
District (PAD); WALDO (Work and
Live District Overlay)
Jersey City Observer, 2
Jersey City Redevelopment Agency, 102

Jersey City Reporter, 73
Jersey Journal, 85–86
Jersey Shore, the, 25, 146n52
Joan Mitchell Foundation, 134
Johnson, Nancy Jo, 132
Jones, David, 132

Kenny, Kay, 36, 107, 119, 130, 132, 134
Kerstein, Robert, 142n11
Kessler, Charles, 1–3, 95, 102
Kheyman, Boris, 132
Khvostenko, Alexey, 132
Kim, Beom, 132
Kim, Hyun Gum, 132
Knerr, Erika, 132
Koolhaas, Rem, 98–101, 106
Kostelanetz, Richard, 142n12
Kotler, Arkady, 132
Krasner, Jenny, 132, 134
Krause, Tina, 132
Kruskopf, Karrie, 132

Lambert, Jim, 132
Lancaster, PA, Lorillard warehouses in, 112
Landes, Barbara, 79
landmarking, 5, 12, 73–74, 86, 88, 96, 107,
112, 114, 123, 157n61. *See also* Jersey
City Landmarks Conservancy
Langatta, Gianfranco, 132
Lees, Loretta, 148n10, 149n16
Lenard, Jessica, 132
Lenni Lenape, viii, 112
Leonard, Alex, 132
Lesko, Antal, 132
Lesnewski, Chris, 132, 134
Levin, Daniel, 95, 97, 115, 119
Ley, David, 142n11
Li, Jennifer, 132
Liberty State Park, voters refuse casino in,
153n26
Lobe, Robert, 132, 134
Long Branch, NJ, 20
Loew's Wonder Theatre, 119
Lorillard family: Anna Catherine (née
Mohr), 11; interest in conservation,
112; George, 11–12; George Lyndes,
112; Peter, 11–12; Pierre, 11, 112;
Pierre IV, 112. *See also* P. Lorillard
Tobacco Company

certification for, 37, 54; attracted New York artists, 44; curfew in, 43–44, 48, 50–51, 55, 72, 147n14; opposition to, 45, 57–58, 67; preserved industrial buildings, 52; proposed extension of arts zone, 45; renamed Powerhouse Arts District, 57–59; Urban Land Institute study, 55–58. *See also* 111 1st Street

Walentas, David, 96

Washington, D.C., 158n8. *See also* September 11, 2001

Whitney, Eric, 133

Whittey, Chris, 133

Williamsburg. *See* Brooklyn: Williamsburg

Williams, Paul, 79

Williams, Robert, 133

Winkelman, Craig, 133

Winn, Bruce, 133

Wolf, Ralph, 133

Wood, Greg, 133

Wordsworth, William, 126

World Trade Center, 29, 35. *See also* September 11, 2001

WPIX-TV, 39

Wyly, Elvin, 142

Yee, Fred, 133

Yentus, Gleb, 133

Yun, Michael, 144n27

zoning, 53, 87, 90, 93, 117; allowing artists' studios and housing, 35, 74, 86; commercial, 56, 58; creating arts district, 36–37, 67, 98, 105; developers empowered to change, 80, 95, 101; industrial, 54; mixed zoning policy, 37, 46; violations of, 43, 90. *See also* WALDO (Work and Live District Overlay)

Zukin, Sharon, 142n12

Zunz, Thelma, 133

ESE SELECT TITLES FROM EMPIRE STATE EDITIONS

Robert Weldon Whalen, *Murder, Inc., and the Moral Life: Gangsters and Gangbusters in La Guardia's New York*

Joanne Witty and Henrik Krogius, *Brooklyn Bridge Park: A Dying Waterfront Transformed*

Sharon Egretta Sutton, *When Ivory Towers Were Black: A Story about Race in America's Cities and Universities*

Britt Haas, *Fighting Authoritarianism: American Youth Activism in the 1930s*

Pamela Hanlon, *A Worldly Affair: New York, the United Nations, and the Story Behind Their Unlikely Bond*

For a complete list, visit www.empirestateeditions.com.